VINTAGE CHICAGO

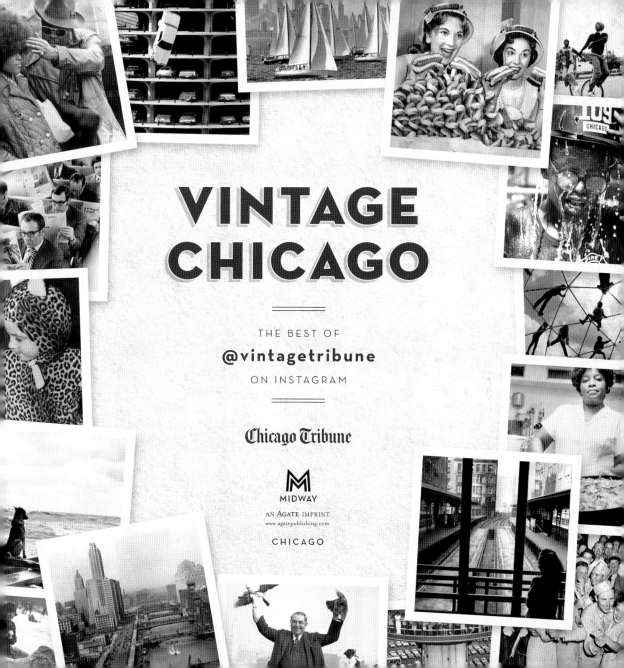

VINTAGE CHICAGO

THE BEST OF
@vintagetribune
ON INSTAGRAM

Chicago Tribune

M
MIDWAY

AN AGATE IMPRINT
www.agatepublishing.com

CHICAGO

Chicago Tribune: R. Bruce Dold, Publisher & Editor-in-Chief; Peter Kendall, Managing Editor; Christine W. Taylor, Managing Editor; Amy Carr, Director of Content; Marianne Mather, Photo Editor; Kathleen O'Malley, Copy Editor.

Printed in China

Vintage Chicago
ISBN 13: 978-1-57284-259-5
ISBN 10: 1-57284-259-8
First printing: November 2018

10 9 8 7 6 5 4 3 2 1 18 19 20 21 22

Midway Books is an imprint of Agate Publishing. Agate books are available in bulk at discount prices. For more information, visit agatepublishing.com.

CONTENTS

A NOTE ON THE PHOTOGRAPHY

Many of the historical photos in this book have deteriorated
over time, so you'll see images that are scratched, broken, faded
or painted on by long-ago newspaper retouchers.

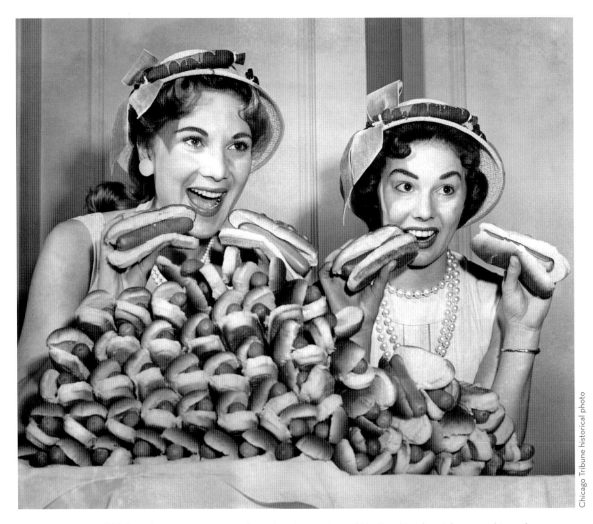

Chicago's Marion Todd, left, and Marge Kraus were ambassadors during National Hot Dog Month in July 1957 and toured the nation to promote the beloved frankfurter. Here, they pose with a plate of 60 hot dogs, which at the time represented what the average American ate in a year. Their lovely hats were accented with a band of hot dogs smothered with mustard. **#hotdog #frankfurter #baseballdogs #noketchup**

FOREWORD

It started with a hot dog photograph.

Photo editor Marianne Mather and I were researching the Tribune archives for significant historic images, and we kept coming across "one-offs"—feature photographs that were intriguing, shocking or just plain fun.

The hot dog image grabbed us. It was from July 1957, and it showed two young women who were ambassadors for National Hot Dog Month. They toured the nation promoting the noble frankfurter, wore hats banded with hot dogs that were smothered in mustard and posed with 60 hot dogs, the average yearly intake of a single American.

So many of these fun photos were sprinkled throughout our archive, and we wanted to share them with our readers.

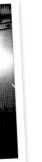

Chicago Herald and Examiner

We decided to launch an Instagram account as a way to share them, unsure what the response would be. It was overwhelming—and before long our Instagram audience was busy helping us identify faces, places and events. People found their parents, grandparents and even themselves.

Sometimes the original captions contained wrong (or horribly inappropriate, by today's standards) information. Our Instagram fans have helped us correct our archives with names, addresses, years and additional context.

Since our first post on July 1, 2014, (John Wayne arriving in Chicago, left), we've shared more than 5,000 photos and grown our audience to more than 83,000 Instagram fans. Now, we're bringing these images back to print once again, with this collection of 300 of our favorites.

The past never gets old. It informs the future. And sometimes, like a picture of a hot dog on a hat, it's good for a laugh.

—Robin Daughtridge

Former associate managing editor for photography, Chicago Tribune

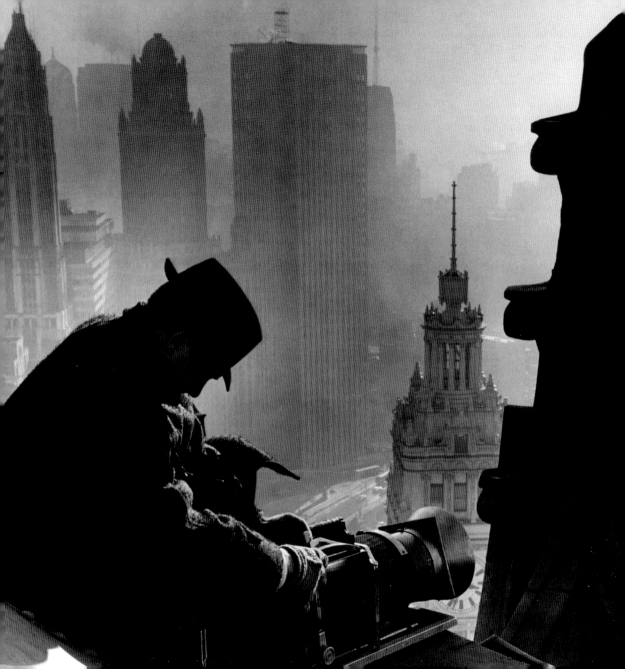

INTRODUCTION

Five stories below Michigan Avenue, deep within the recesses of the Tribune Tower, a subterranean vault stored hundreds of thousands of images representing Chicago's photographic history.*

Glimpses of our collective past have recently surfaced, largely through the efforts of Tribune editors Robin Daughtridge and Marianne Mather, who bundled up, dipped down into the vault and emerged to post the photographs on Instagram as @vintagetribune. Almost immediately, burgeoning smartphone photographers noticed something different in their midst.

I'm a third-generation Chicagoan, and I've been an avid follower of @vintagetribune since its inception in 2014, around the same time that I joined the ranks of Instagram users. The Tribune's stark black-and-white photographs stood out in the field of digitally manipulated color images. Almost immediately, Instagrammers began tagging each other, asking "Have you seen this?" and "You should follow this feed," eventually leading to responses like, "Yes, I already am!" Within the first year, @vintagetribune accumulated 35,000 followers, and their ranks have steadily grown.

The vivid images appear in a random flow as they emerge from the cold storage of the archive, also known as "the morgue." Spanning nearly 100 years, and unlike their original halftone newsprint reproductions, the scans look surprisingly fresh on our devices' bright screens. And while some scenes look ancient, others—although more than 30 years old—feel impossibly recent to be considered vintage.

Instagram's photo-sharing platform provides the opportunity for conversation surrounding the photographs. Sometimes users recognize portrait subjects, and experts emerge to help explain details or fill in missing dates. Captions' #hashtags provide searchable keywords and sometimes editorial asides. The copy accompanying a 1926 photo of a backstage showgirl includes the descriptors #vintagetheater, #vaudeville, #showgirls and #wishweknewmore.

This book has gathered some of the best images from @vintagetribune, separating them into themes that sometimes converge. Entertainment, politics and fashion thread through depictions of the illustrious, the notorious and the curiously unfamiliar. You may be surprised by what once drew crowds, like the opening of

◀ The view from the top of Tribune Tower as heavy fog moves into the city in 1962. Tribune photographer Jack Mulcahy was setting up a long-range camera when this picture was taken by another Tribune photographer, Phil Mascione. The Wrigley Building is at center. **#tribunetower #wrigleybuilding #chicagoskyline**

Phil Mascione/Chicago Tribune

the Outer Drive Bridge and nylon stockings. Other activities may feel more recognizable: We Chicagoans apparently love beaches, dancing and roller skating. Also, we adore our cats and dogs: Within these pages you'll find felines Polly Pat, Mr. Bones, Bum and Manny the Great Lover Cat; along with canines Lucky, Pete, Dandy, Snowball and an unnamed black collie being wheeled in a baby buggy.

If you've been around long enough, some of this history is your own. You'll recognize neighborhoods, attractions and the city's extreme weather. Or your parents may have told you of some things that you're seeing here for the first time, like Maxwell Street, Riverview Park or the Blizzard of '67. One photograph combines several familiar and foreign elements: A woman reads a newspaper in a phone booth during a springtime blizzard.

Many pictures need an explanation, some of which are now lost; and some scenes' captions are at odds with the images. A 1922 photo shows two women playing leapfrog at the Wind Blew Inn, which was raided by the police, who explained, "When we arrived we found men and women singing and shouting. Bottles whose contents and labels were peculiarly pre-Volsteadian were in evidence. So we pinched the joint." Sometimes a dictionary comes in handy, too.

Some pictures seem plucked from the cinema, or exude a Hollywood sheen. One photo looks like a tableau from a literary thriller: A man with a lantern recedes into fog on a cobblestone street. And a few of them compare with the medium's masters in capturing "the decisive moment," like the shot of a businessman gracefully leaping over a slushy puddle.

We don't often think about the person behind the camera when we look at photographs. Indeed, most press photographers weren't credited through the 1950s, and even later. But it is through their eyes that these scenes were witnessed. They covered the famous and infamous; celebrations and tragedies; and sometimes each other, in shots that remind us of their presence.

In addition to thousands of boxes of photographs and news clippings, the Tribune archive includes 300,000 4×5-inch negatives, 62,000 of those on glass plates from the earliest press cameras. The handlers of these apparatuses got one chance to catch their shot. Imagine the audacity of the photographer who approached Sarah Bernhardt in the 1910s, foreshadowing later paparazzi, or the blend of skill and luck involved in suspending that moment when Chicago's fire horses charged out of the station on their last run in 1923. Over the years, cameras got smaller, technology advanced and the heft of the physical archive transitioned to digital storage—leading eventually to Instagram and the unearthing of these photographs.

Chicago's lakefront, neighborhoods and ubiquitous landmarks appear throughout this book as backdrops to our city's stories. We were the stories. As generations walked past Michigan Avenue's Tribune Tower, our visual history accumulated beneath our feet. This book celebrates all of us.

—Pamela Bannos

Professor of photography in Northwestern University's department of art theory and practice and author of Vivian Maier: A Photographer's Life and Afterlife

*Change being inevitable, in 2018, after 93 years, the newspaper's offices, along with the entire photographic archive, left the Tribune Tower for other locations.

CITY
SCENES

IF THESE STREETS COULD TALK

A favorite view of Chicago, looking west from State Street, circa 1930. **#chicagoriver #1930s #downriver #skyline**

BOGART

IN PERSON
& COMETS
s PEGGY KING

CHICAGO

SCREEN 'WE'RE NO ANGELS' HUMPHREY BOGART ALSO DE
IDMARK
F GOLD
OO CARTOON
STAGE · BILL HALEY & COMETS GEORGE PRINCE & PEGG KING

State Street, looking south from Lake Street in July 1955.
#loopdreams #1950s #statestthatgreatst

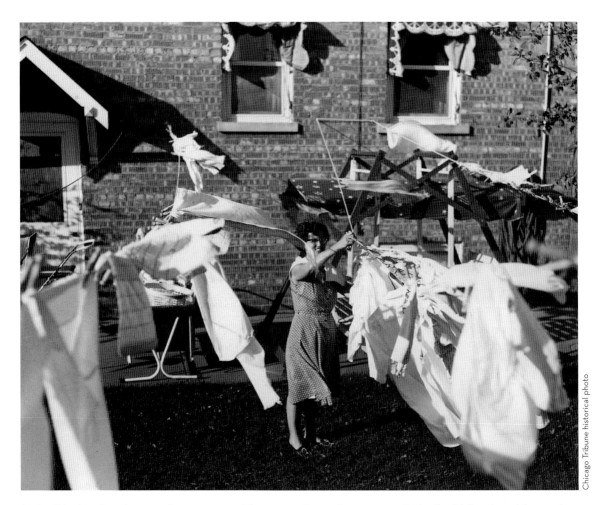

Sophie Kalemba takes advantage of some unseasonably warm weather on Oct. 11, 1962, to dry her family's laundry on West 62nd Street. You can hear the clothes whipping in the wind and smell the October air. Or at least that's how @vintagetribune imagines it. **#laundry #windycity #nostarch**

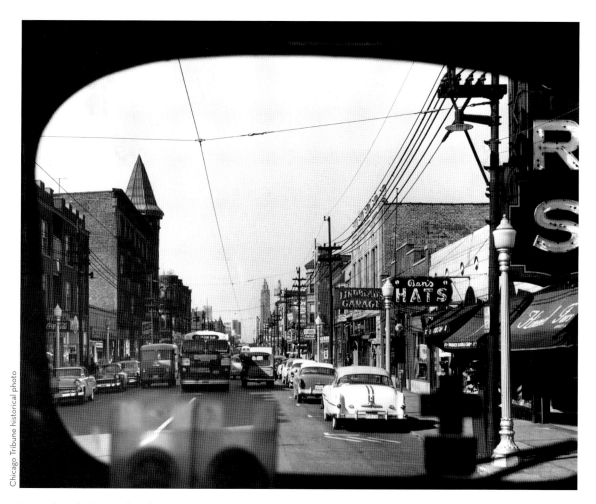

A view through a bus window shows the crowded and vibrant Englewood shopping district on 63rd Street near Halsted Street in 1956.
#englewood #englewoodshoppingdistrict #63rdstreet #thrivingenglewood #rebuildenglewood

Sunlight streams into the concourse of Chicago's Union Station in September 1957. The concourse was demolished in 1969.
#chicagoarchitecture
#unionstation
#chicagogone
#meandmyshadow

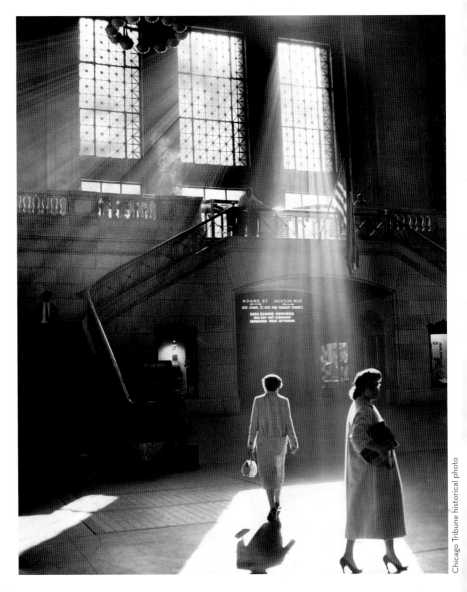

Chicago Tribune historical photo

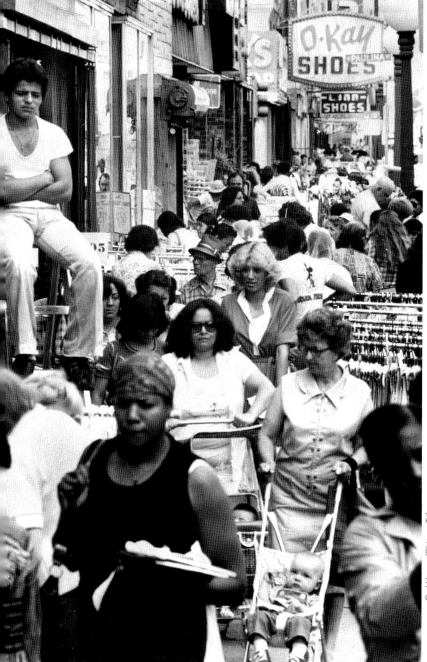

Shoppers stroll a crowded sidewalk in 1979 during a sale along Chicago and Ashland avenues sponsored by the Chicago-Ashland Businessmen's Association. *#1970s #sidewalksale #bargainsgalore*

Carl Hugare/Chicago Tribune

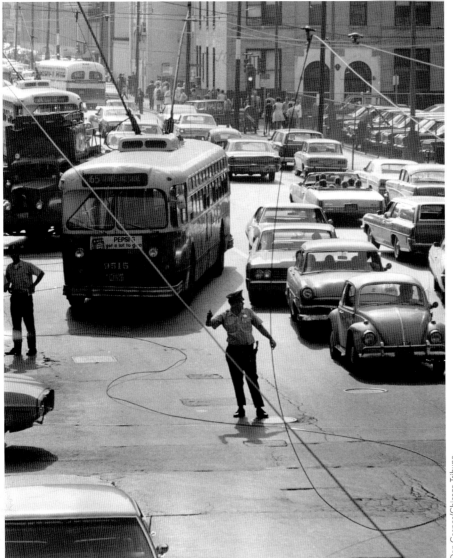

Overhead trolley wires snapped at Grand and Rush streets July 13, 1970, stopping traffic at rush hour. **#snarled #1970s #rushst**

▶ Steamy cityscape, January 1982. **#chicagoweather #bittercold #steaming #1980s**

Don Casper/Chicago Tribune

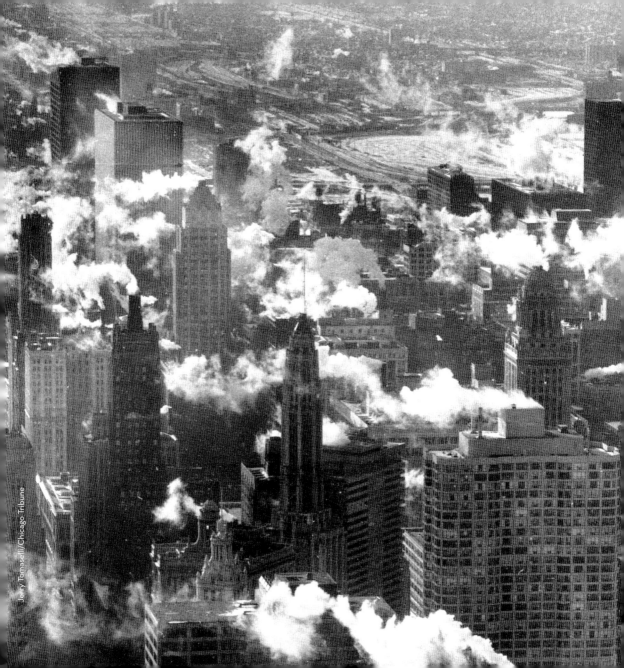

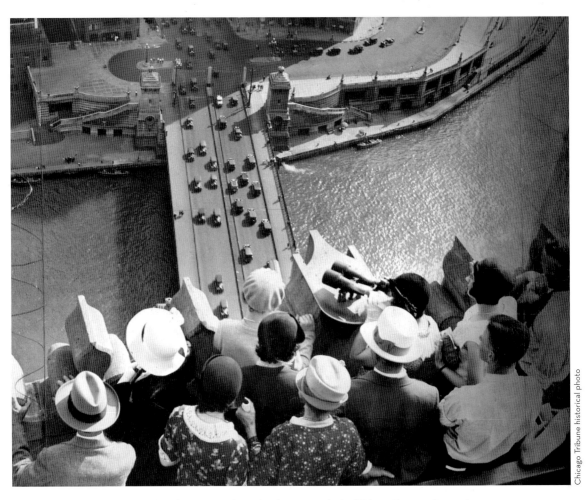

Holiday crowds view the city and the Chicago River from the observation deck of Tribune Tower in September 1931.
#tribunetower #beautyshots #chicagoriver #afraidofheights

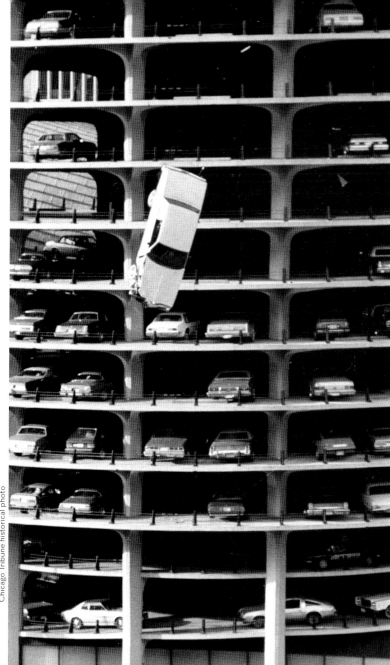

A sedan plunges from the 15th-floor level of Marina City's parking garage into the Chicago River in 1979. It was a stunt for the Steve McQueen movie "The Hunter," which was released the following year. **#1970s #taoofsteve #action #marinacity**

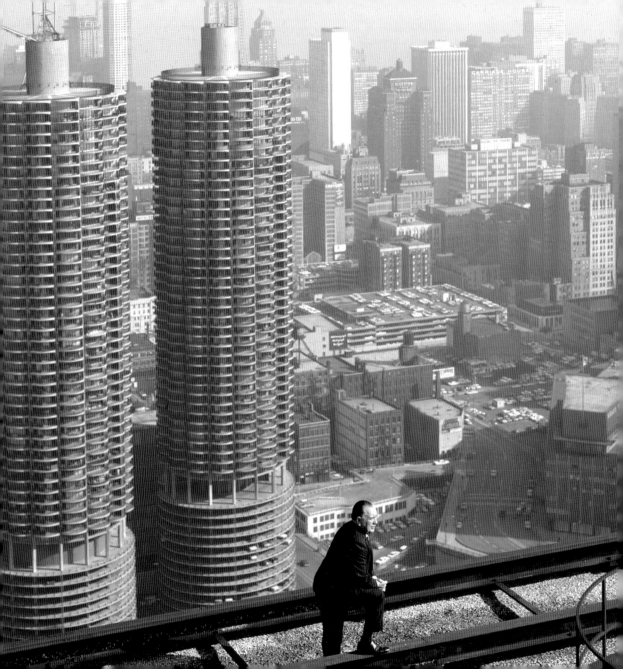

Walter Kale/Chicago Tribune

Chicago Mayor Richard J. Daley
surveys the city March 17, 1966.
Marina City looms in the background,
while the Chicago Sun-Times and
Daily News building is a squat
presence on the Chicago River, lower
right. That spot is now occupied
by Trump Tower. **#1960s #damare
#chicagomayors #daleydynasty**

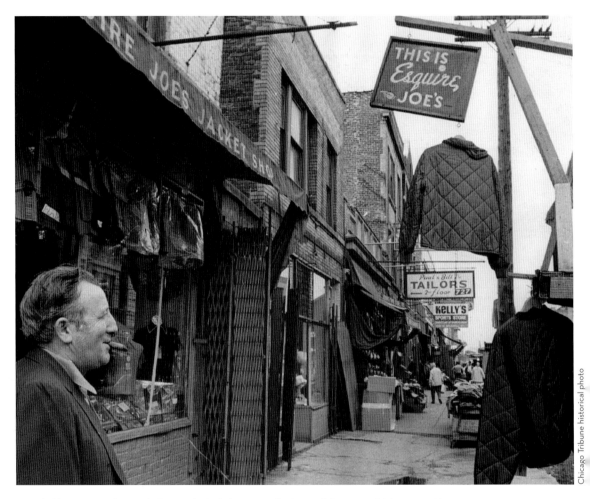

Joseph Glassman stands outside Esquire Joe's clothing store, his Maxwell Street establishment, in May 1970.
#maxwellmemories #esquirejoe #fashionfiles #stogie #1970s #gonebutnotforgotten

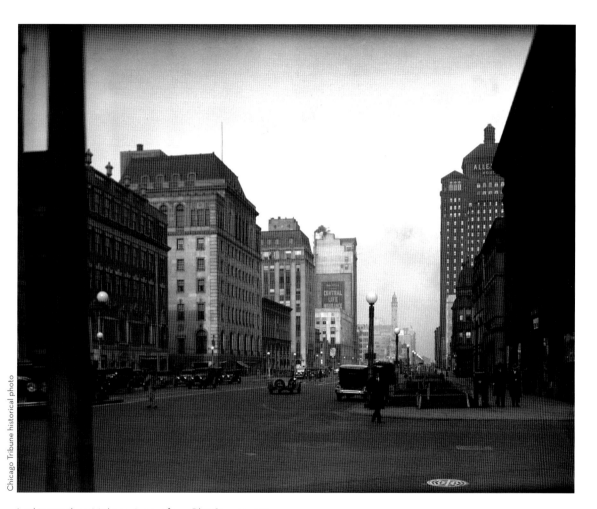

Looking north on Michigan Avenue from Ohio Street in 1931.
#michiganavenue #themagnificentmile #allertonhotel #tiptoptap

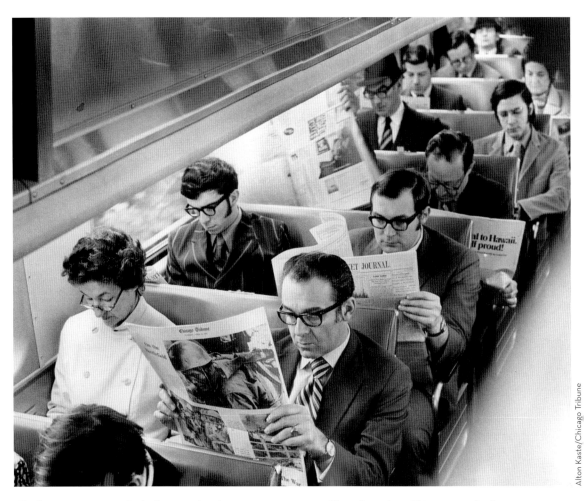

"The favorite occupation of suburbanites riding the commuter trains to and from their jobs in Chicago is reading," the Tribune reported July 19, 1970. This photo was taken on the Chicago and North Western Railway.
#newspaperswereking #readingthepaper #metra #chicagocommuters #commuting #thosepicturesarehuge

Alton Kaste/Chicago Tribune

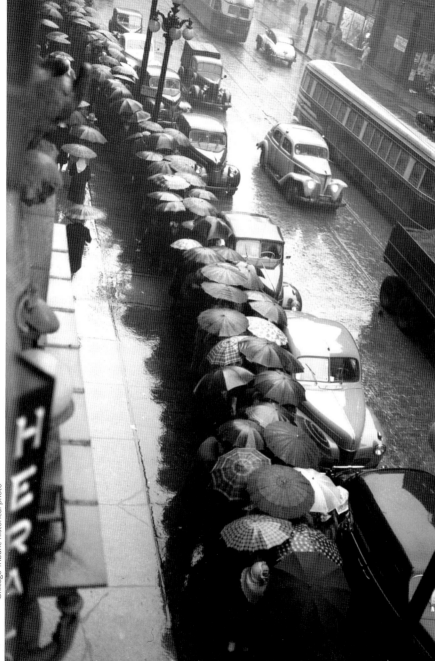

People wait in line in the rain for nylons outside the Hearst Building in Chicago on April 9, 1946. During World War II, nylon manufacturers turned their attention to helping the war effort, which created a black market for stockings. When the war ended in 1945, manufacturers couldn't keep up with demand and women rioted across the United States, well into 1946. **#nylonriots #worldwarll #nylonshortage #blackmarket**

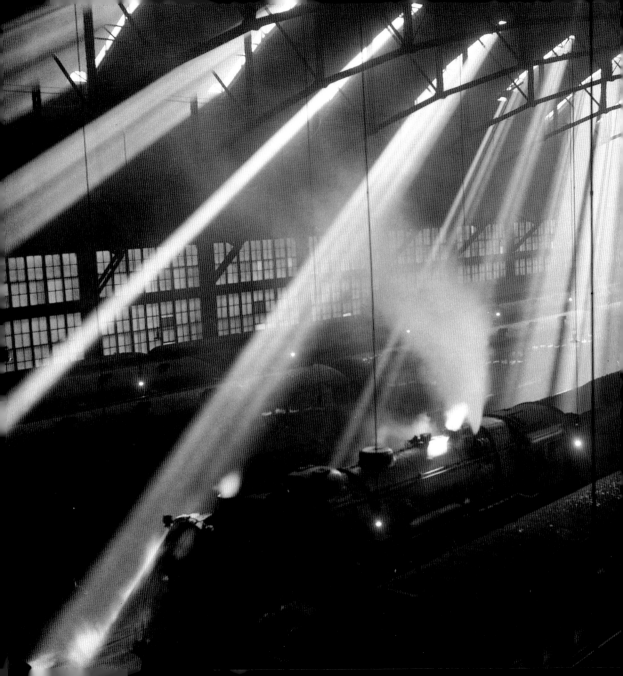

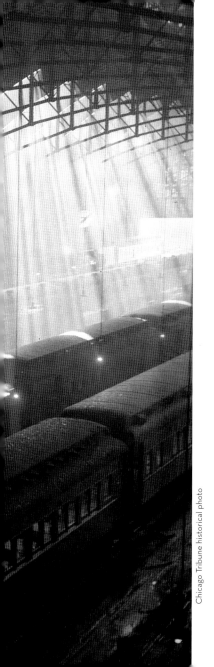

Chicago Tribune historical photo

Light and shadow at LaSalle Street station, circa 1931. Beware of overheated prose from the original caption: "Quivering lances of golden radiance pierce the gloomy vault of the LaSalle St. Station train shed as the Twentieth Century Limited, panting from the exertions of its mile-a-minute speed, draws to a stop. A last hiss of steam, a last note from the brazen bell, the expiring sigh of compressed air, and the 1,000-mile race against time is won. On parallel tracks under the dancing sunlight are other great trains, in from far horizons or ready to roar to distant cities." **#adjectiveoverdose #lasalleststation #railroad #steampower #1930s**

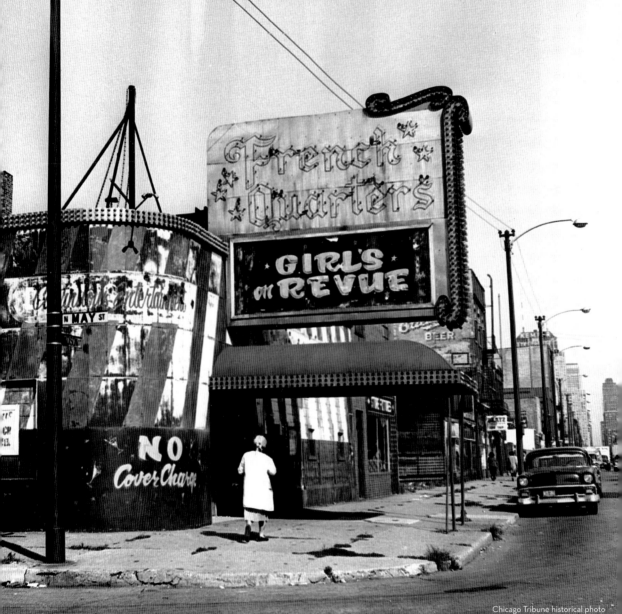

◄ A shuttered strip club on Madison and May streets was one of many businesses in the area folding by September 1964, with the Madison Street skid row vanishing, bit by bit. **#skidrow #1960s #stripclub #frenchquarters #girlsonreview**

Chicago Tribune historical photo

Two fishermen haul in their net near the Adler Planetarium in April 1972. The two were fishing for smelt in Lake Michigan. **#fishinghistory #lakemichigan #adlerplanetarium**

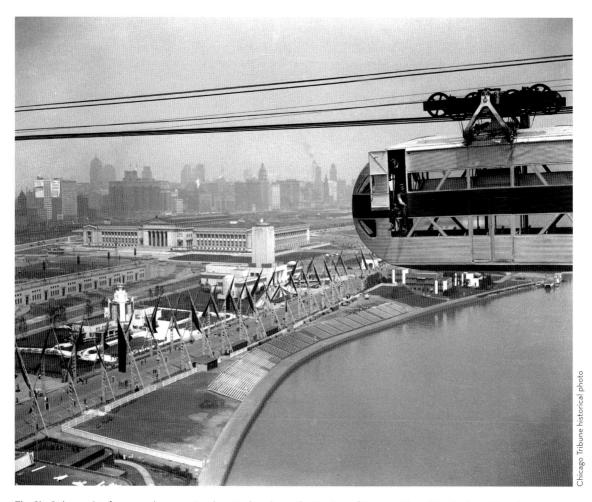

The Sky Ride, used to ferry people across Burnham Harbor during the Century of Progress Exposition, is shown Nov. 16, 1933. The Field Museum is at middle left. **#fieldmuseum #centuryofprogress #chicagomuseums #wildride**

A girl looks at the empty tracks at the Aurora and Elgin Railroad terminal at Wells and Jackson streets on Oct. 1, 1946, after a strike halted operations of the suburban line. **#trainhistory #auroraelginline #interurban #wellsandjackson #trainstrike**

Workers tear down the remaining section of the discontinued Humboldt Park branch of the former Chicago Rapid Transit Company in 1961. No trains had operated over the structure since May 3, 1953, when "L" service on the branch was shut down. **#humboldtpark #cta #ctatrains #theL #wouldbenicetohaveitnow**

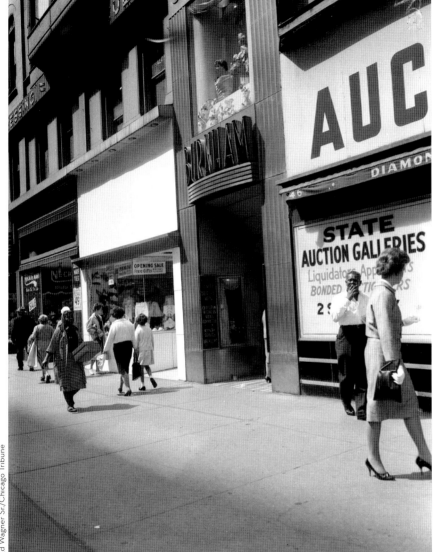

A view of the infamous Block 37 on May 18, 1961, shows the Burnham Building entrance at 140 N. State St. before it was demolished in the late 1980s. The Chicago Tribune's Blair Kamin wrote, "The tortured tale of this block (named for its city plat number) stretches back to the early 1970s when the late Mayor Richard J. Daley envisioned breathing new life into the then-seedy North Loop. As the center of retail gravity shifted to North Michigan Avenue and new office towers sprouted in the West Loop, city officials declared several blocks, including Block 37, 'commercial blight.' That paved the way for Mayor Richard M. Daley's administration in 1989 and 1990 to raze the block's shabby but lively potpourri of old buildings, which once housed everything from a gourmet Stop & Shop to movie theaters that showed 'blaxploitation' films." **#burnhambuilding #statestreet #urbanrenewal #block37**

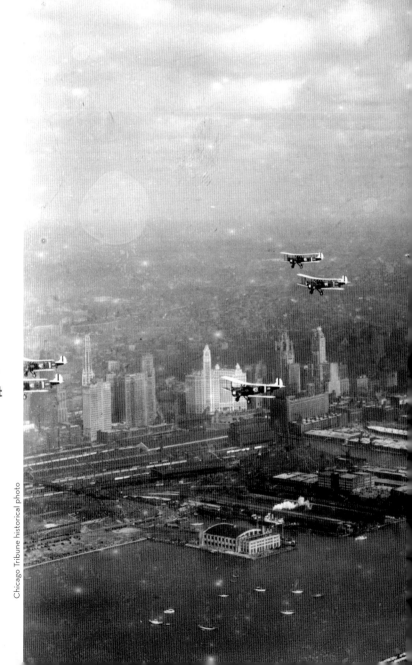

Countless eyes were turned toward the sky as 650 planes roared along Chicago's lakefront in maneuvers conducted by the Army Air Corps in May 1931. **#chicagoskyline #army #chicagoslakefront #lakemichigan #stunning**

Chicago Tribune historical photo

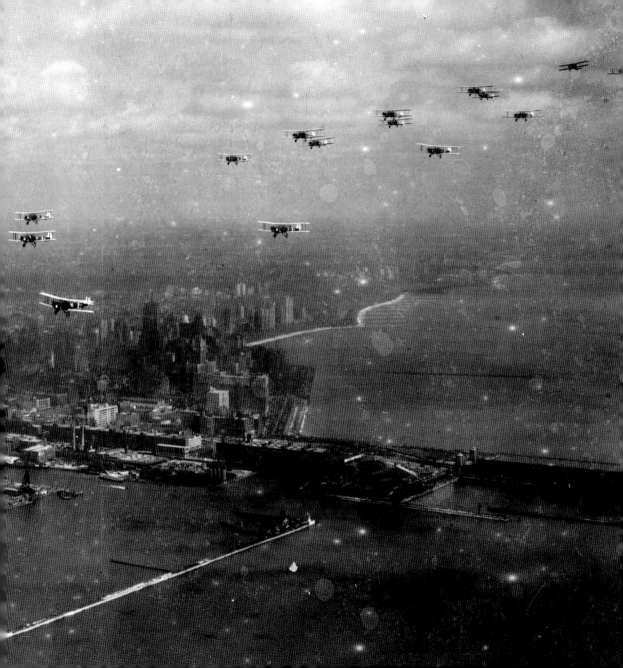

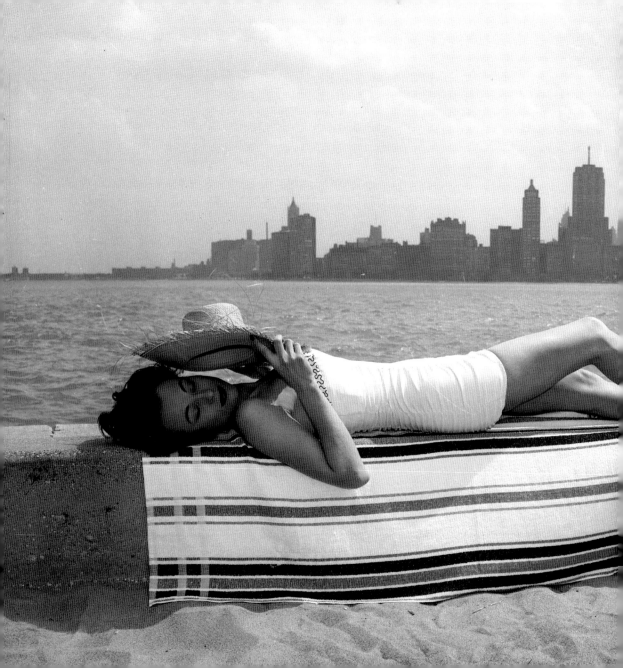

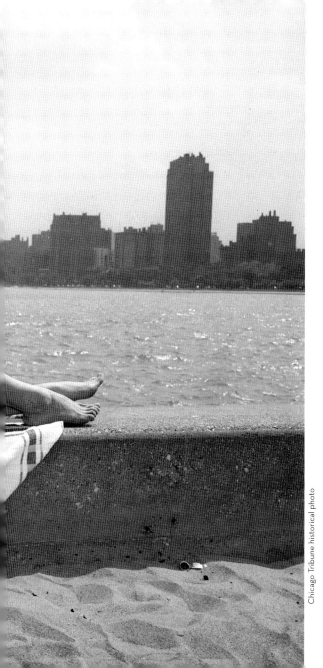

Chicago Tribune historical photo

We can't get enough of Dorothy Duncan modeling the latest beach fashion for the newspaper in 1953. **#beachfashion #chicagosummer #chicagoskyline**

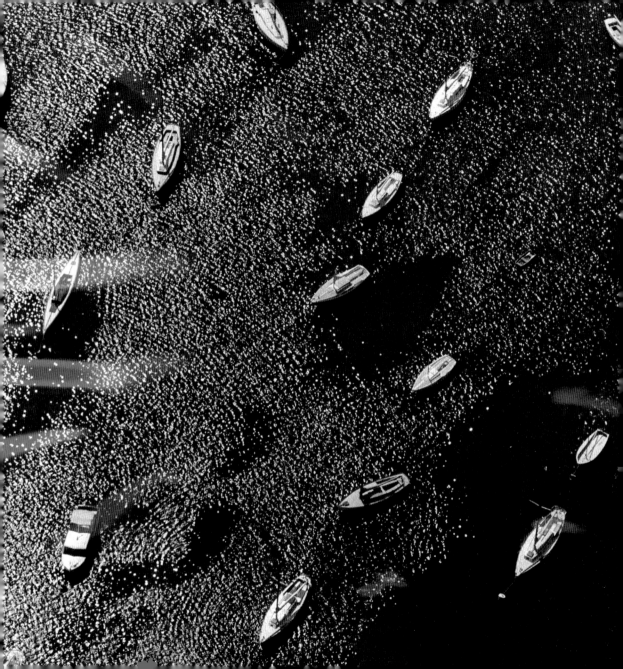

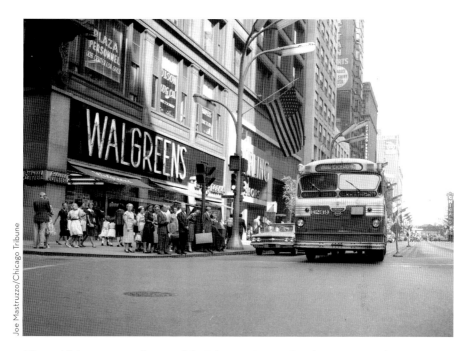

"The world's busiest corner," reported the Tribune, at State and Madison streets in Chicago in 1960.
#stateandmadison #chicagotraffic #worldsbusieststreet #walgreens #sweetbus

◄ The sun glistens on Belmont
Harbor in this aerial view from
July 1967. **#belmontharbor #1960s
#chicagofromthesky #tinyboats**

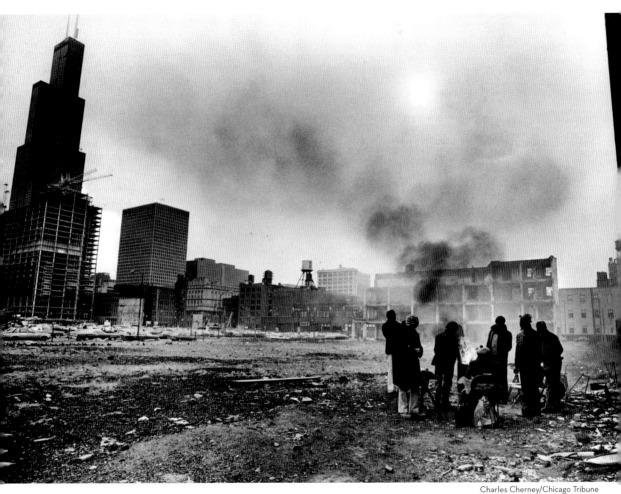

A group of homeless men gathers around a fire in a vacant lot in 1983. This appears to be on the Near West Side, but we can't nail down the precise location. **#homeless #1980s #community**

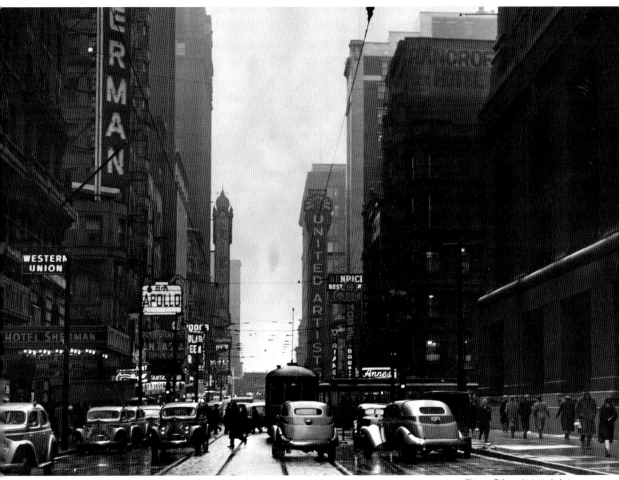

A view east down Randolph Street from LaSalle on March 5, 1941, shows the collection of movie palaces.
#chicagomarquees #chicagotheaters #randolphst

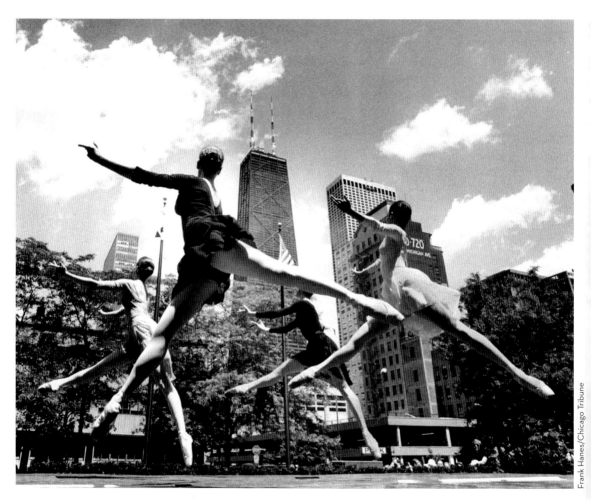

Members of the Chicago City Ballet perform the opening of Summer Dance 1981 at St. James Episcopal Cathedral plaza at Huron and Rush streets. **#happyfeet #chicagosummer #1980s #chicagocityballet**

Frank Hanes/Chicago Tribune

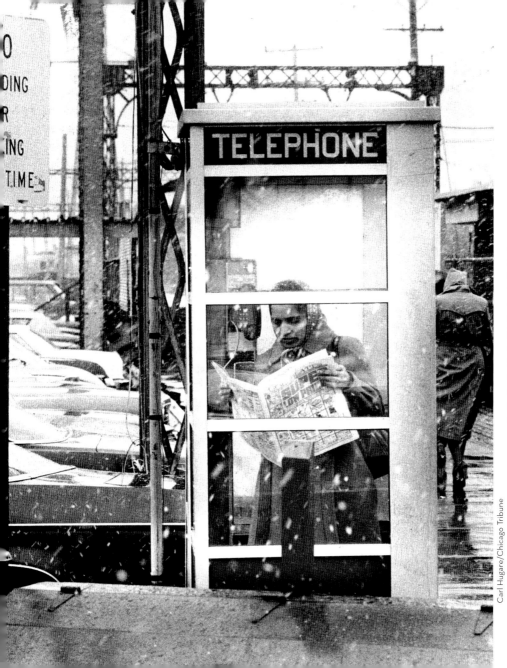

A phone booth proved a handy shelter in April 1980, when sudden snow flurries slowed the commute at the Skokie Swift station. **#illinoisbell #1980s #chicagoweather #skokieswift**

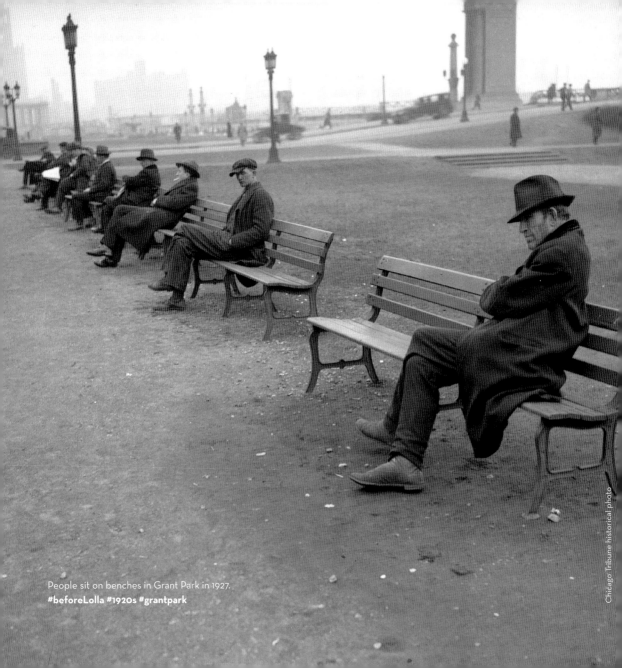

People sit on benches in Grant Park in 1927.
#beforeLolla #1920s #grantpark

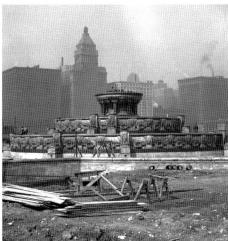

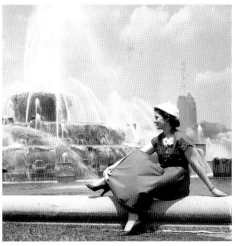

The Clarence F. Buckingham Memorial Fountain, one of the largest in the world, opened in 1927 in Chicago's Grant Park. Donated by Kate Buckingham in honor of her late brother, Clarence, the fountain was designed by architect Edward H. Bennett, with sculptures produced by French artist Marcel Loyau. **#buckinghamfountain #grantpark #chicagobeautiful**

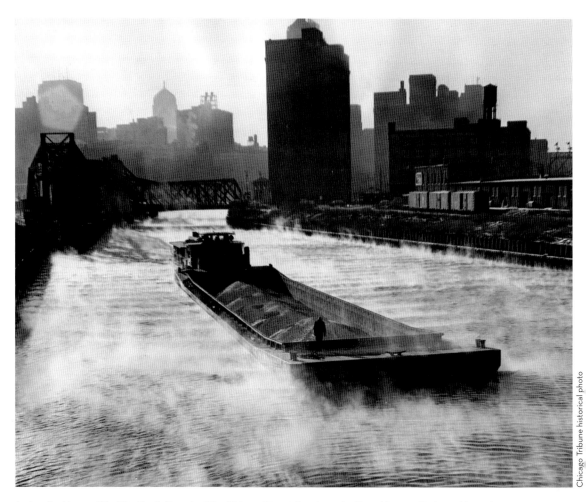

A view (looking south) of the North Branch of the Chicago River, taken from the Grand Avenue Bridge in November 1964.
#chicagoriver #bargingin #1960s

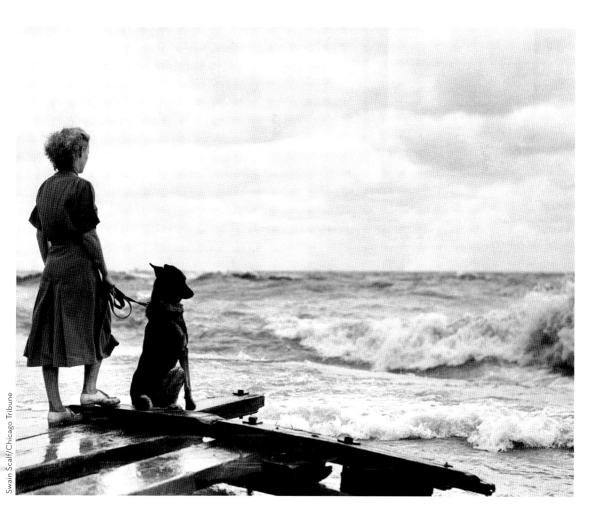

Jean Anderson and her dog, Lucky, watch the waves roll onto the beach at Division Street on Sept. 5, 1937.
#chicagoweather #surfsup #1930s #lakeeffect

Flags fly from every house in the 7100 block of South Wabash Avenue on July 4, 1961. In the foreground are Elmer Myer, from left, Sybil Myer and Mrs. Ernest Wash with her children Paula, 2, and Lonnie, 1. Elmer Myer was a veteran and the vice president of the block club responsible for the flags.
#fourthofjuly
#julyfourth
#americanflag
#oldglory

George Quinn/Chicago Tribune

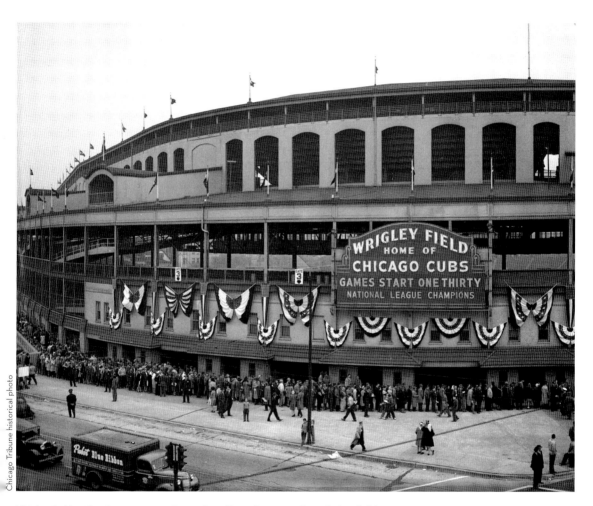

Wrigley Field in October 1945. **#gocubsgo #friendlyconfines #wrigley #clarkandaddison**

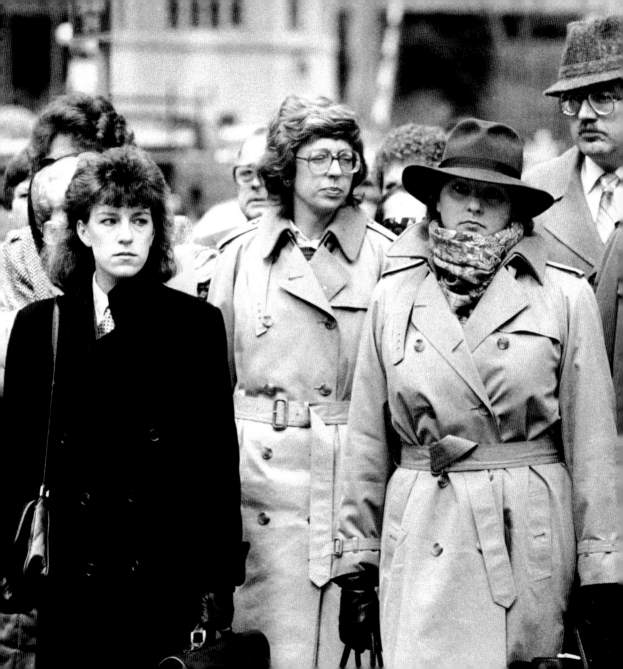

Frank Hanes/Chicago Tribune

Morning commuters bundle up against the cold April 22, 1986, as the mercury started a slow rise from a low of 24 degrees at O'Hare International Airport. **#chicagoweather #1980s #trenchcoats #commuters**

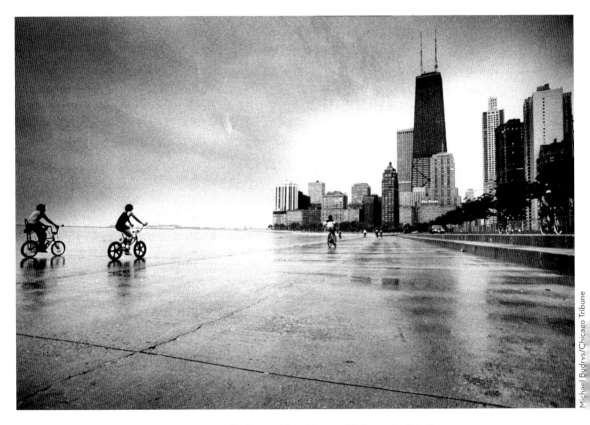

Racing against an incoming storm, participants in a fundraising bike-a-thon pedal along rain-slicked concrete at the lakefront in June 1980. **#chicagoweather #lakeeffect #1980s #cycling**

Michael Budrys/Chicago Tribune

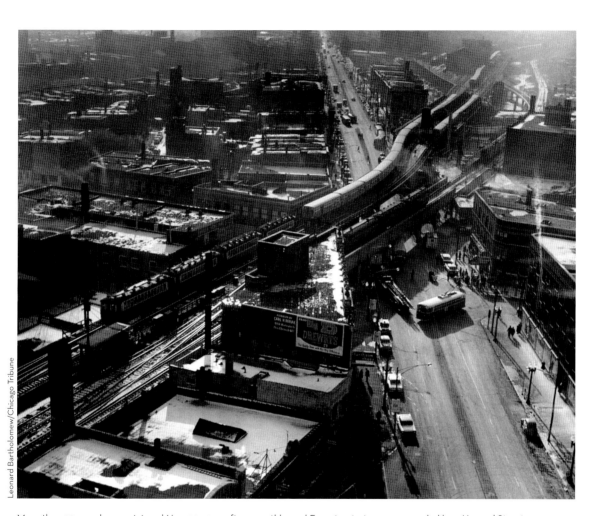

More than 50 people were injured Nov. 30, 1959, after a northbound Evanston train was rear-ended by a Howard Street train moving out of the Wilson Avenue station. Firefighters worked for a half-hour to free the motorman of the second train.
#cta #broadway #1950s #chicagotransportation

A group dines on the Tavern
Club's outdoor terrace
in 1957. Many of the city's
architects, artists and
literati belonged to the club,
which opened in June 1928
at 333 N. Michigan Ave.
#tavernclub #333nmichigan
#chicagoarchitecture

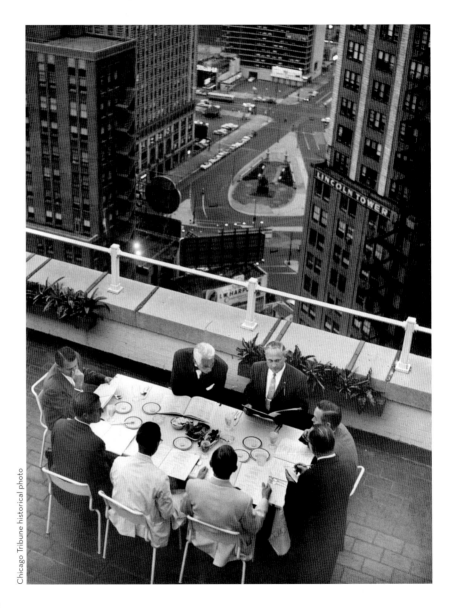

Chicago Tribune historical photo

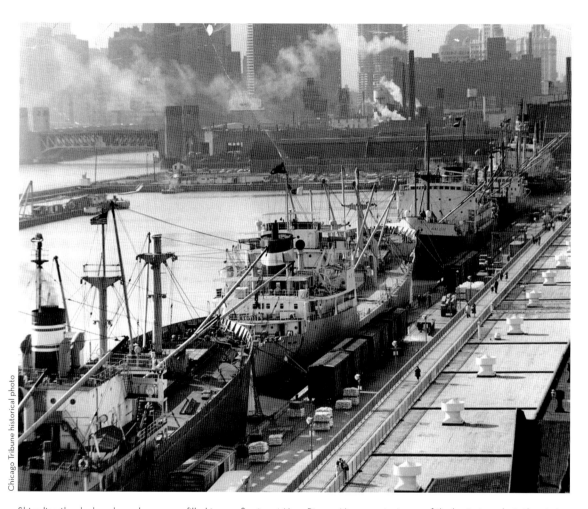

Ships line the dock and warehouses are filled to overflowing at Navy Pier on Nov. 10, 1962, in one of the busiest weeks in the pier's history. Ships in line are the Sanmar (Greece), from left, Gilsand (England), King City (England), Fair Head (Northern Ireland) and Takeshima (Japan). **#vintageships #navypier**

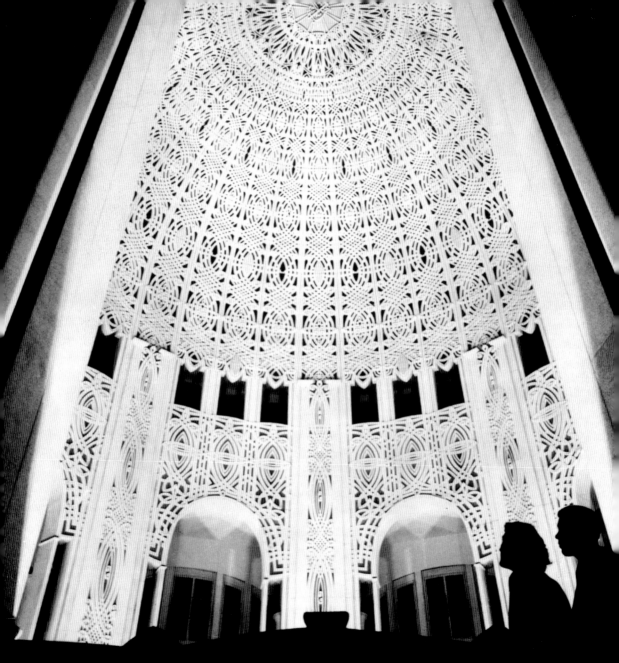

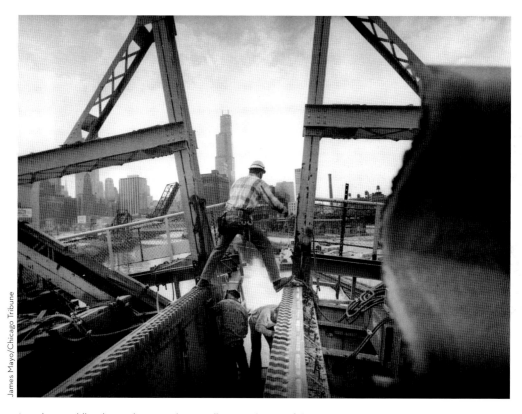

A worker straddles the gap between the partially opened spans of the Grand Avenue Bridge over the North Branch of the Chicago River on June 23, 1973. Welders were below repairing girders. **#isntitgrand #bridgework #1970s**

◀ An interior view of the Baha'i temple dome in Wilmette in the 1950s. The ornate temple was designed by architect Louis Bourgeois and opened in 1953. **#architecturalwonder #bahai #1950s #northshore #wilmette**

An entire fleet of
Chevrolet Corvettes,
44 of them to be
exact, sweeps down
Lake Shore Drive near
the Chicago River en
route to the General
Motors Motorama
at the International
Amphitheatre in April
1954. This was a year
after their 1953 debut.
#chevycorvette
#1953corvette
#lakeshoredrive
#motorama

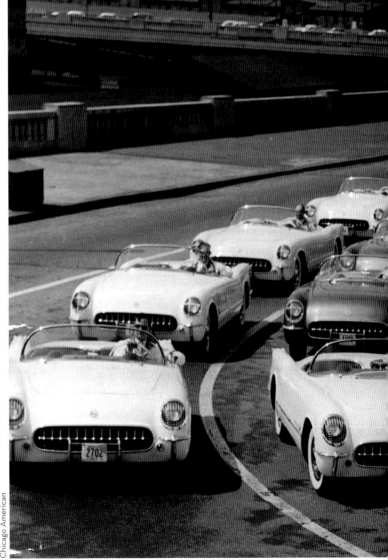

Chicago American

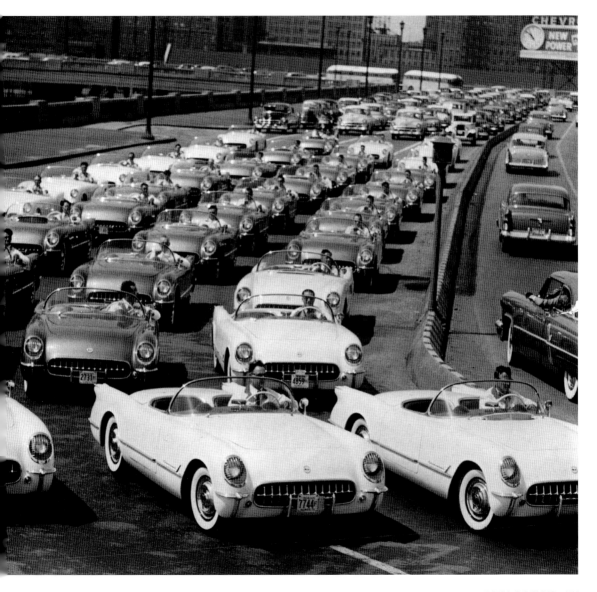

In 1978, Rush Street activity was described as "from top-drawer to tawdry."
#rushstreet #goldcoast #Vtriangle #1970s

Don Casper/Chicago Tribune

▶ The finishing touches are put on a heart at the intersection of State and Madison streets in 1953, marking the spot where north, south, east and west begin in Chicago.
#heartofchicago #statestthatgreatst #chicagoneighborhoods #deadcenter

Chicago Tribune historical photo

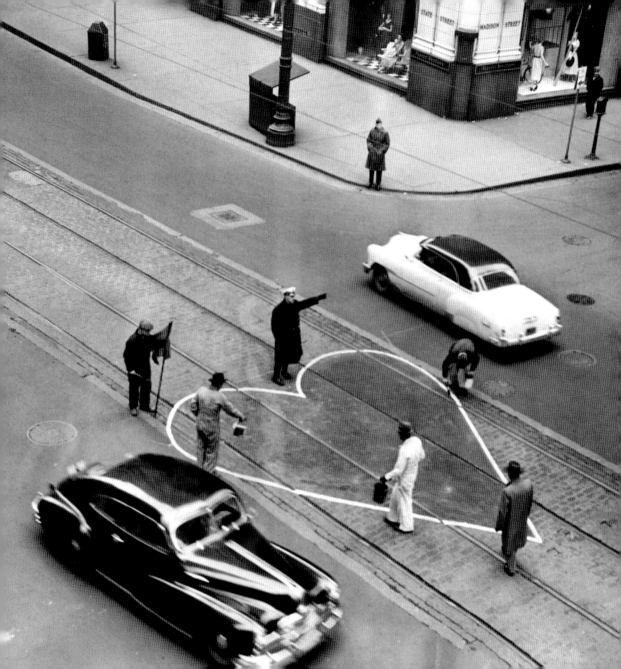

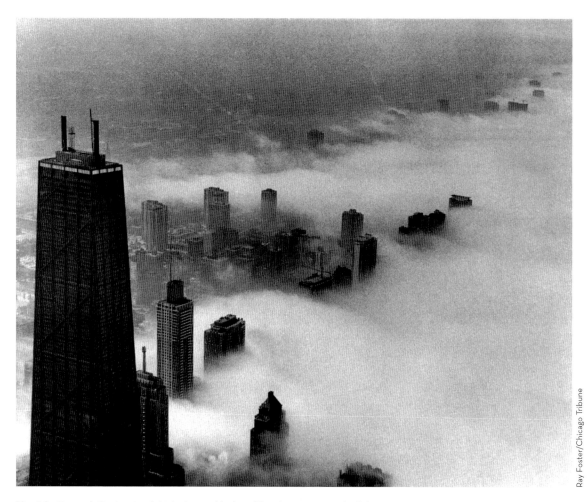

The John Hancock Center stands high above a blanket of fog that covers much of the city in May 1969.
#hancockbuilding #chicagoweather #chicagoicon

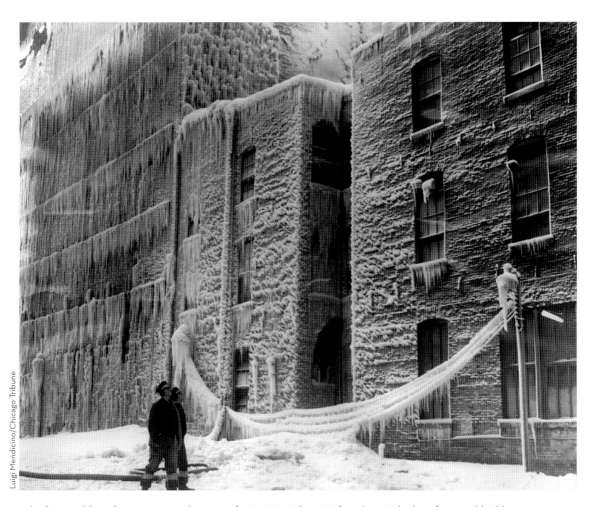

Luigi Mendicino/Chicago Tribune

Mike Gavin and Dave Bassett pause at the scene of a New Year's Day 1958 fire where icicles hang from an old cold storage plant and nearby wires at 54 E. Hubbard St. **#chicagofire #winterfire #chicagofiredepartment #cfd**

A nighttime view of the main Chicago Public Library stacks from the center courtyard in 1970. The library, at Michigan Avenue and Randolph Street, is now the Chicago Cultural Center. **#cpl #1970s #culturalcenter #stacked**

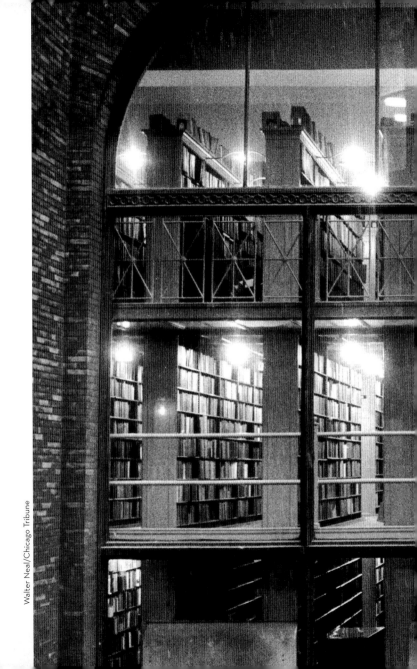

Walter Neal/Chicago Tribune

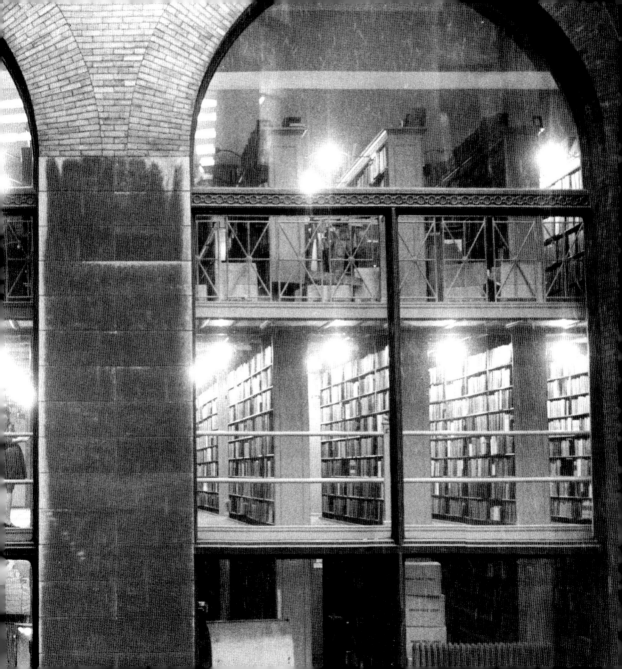

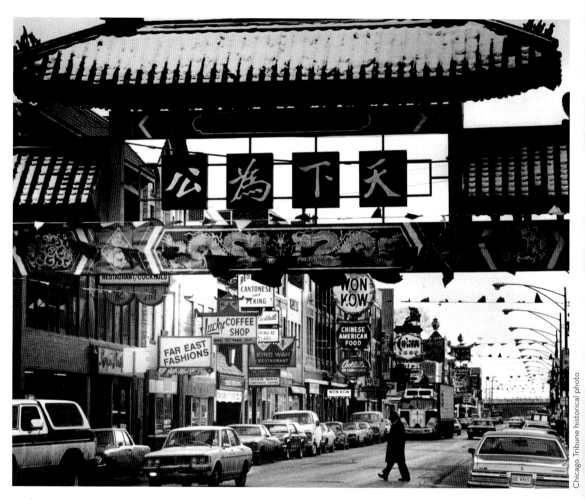

公為下天

Chicago's Chinatown in 1981. *#onleong #wentworth #1980s #southside #chinatown*

Michigan
Avenue circa
1926-28,
looking north
from the
Art Institute
of Chicago.
#1920s
#boulmich
#ontheavenue

A pedestrian does his best to leap over a river of slush at Rush and Huron streets Feb. 18, 1986.
#chicagowinters
#1980s

Carl Hugare/Chicago Tribune

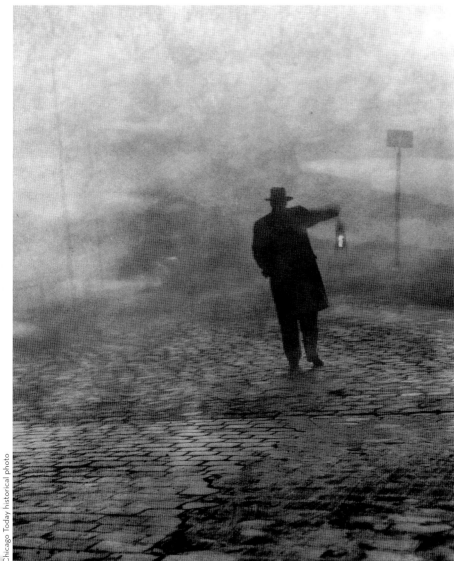

London or Chicago? A motorist carries a lantern while looking for his car on Lower Wacker Drive at Michigan Avenue in February 1951. **#foggy #murky #cobblestones #1950s**

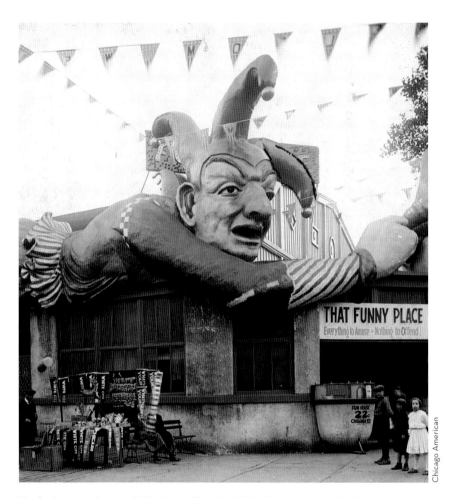

Chicago American

The fun house, aptly named "That Funny Place," at White City Amusement Park in June 1921. The amusement park, at 63rd Street and South Park Way (now King Drive), opened in 1905. **#whitecity #funhouse #chicagoneighborhoods #63rdst**

▶ Sailboats move up the Chicago River in October 1987, headed for a long winter in dry dock. **#chicagoriver #marinacity #1980s**

Phil Greer/Chicago Tribune

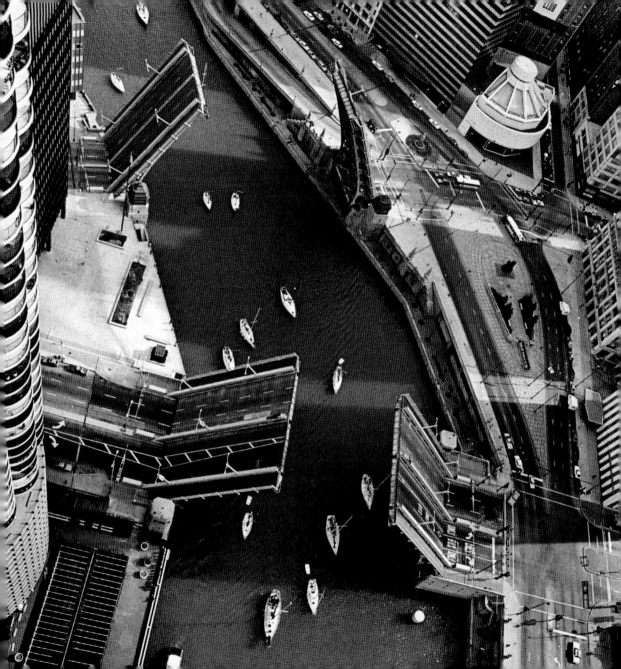

Twenty-three inches of snow fell on Chicago during the Blizzard of 1967, leaving streets like Cermak Road, shown Jan. 27, 1967, impassable. **#blizzard #chicagowinters #blizzardof67 #thatsalottasnow**

Michael Budrys/Chicago Tribune

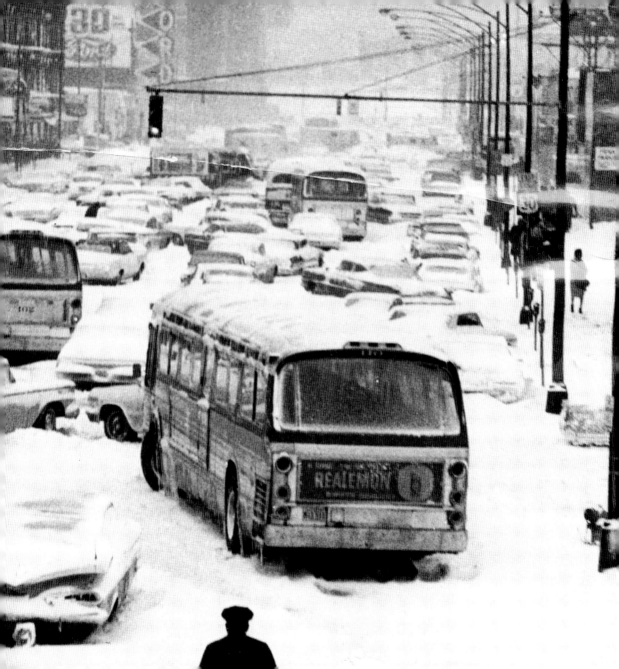

Strolling along the water's edge at North Avenue Beach in August 1969. **#lakeeffect #chicagoskyline #northave #1960s**

CRIME

COMMON, CLASSIC AND CURIOUS

Chicago police officers take George Hoffman into custody in August 1930. Hoffman killed a bartender at 569 W. Madison St. and barricaded himself in the saloon, defying police orders to come out. The siege ended soon after officers tossed a tear gas container into the bar. **#madisonst #1930s #cpd #teargas**

Chicago Herald and Examiner

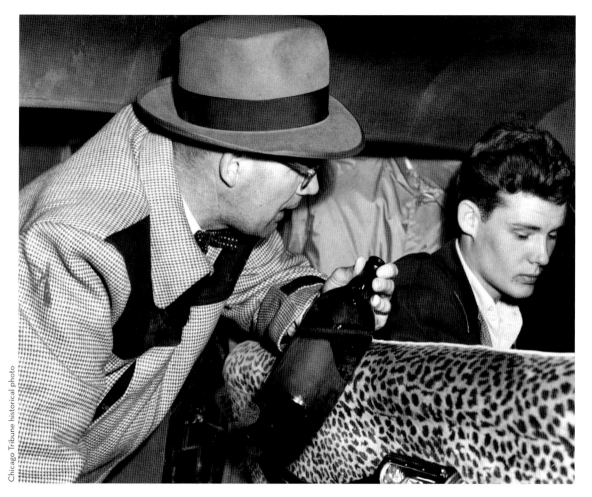

Police Officer Maurice McCarthy questions James Foy about a bottle of beer found in his car at a checkpoint in September 1954.
#1950s #leopardprintseats #thatjacket

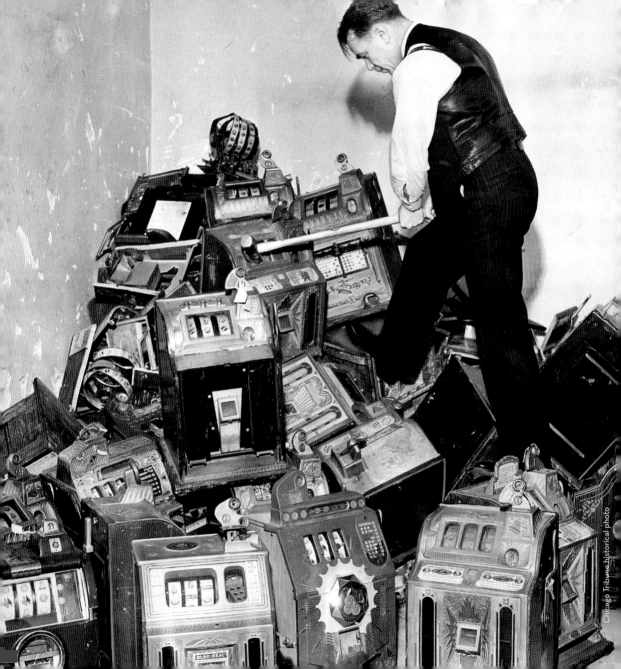

◄ Sgt. John Healy of the Cook County police takes a sledgehammer to 50 slot machines seized in raids in February 1939. **#gambling #vice #slots #1930s**

The original caption from the 1920s reads: "A school boy buying booze from a store keeper." We suspect it's a setup. **#vice #minor #gangstersandgrifters #1920s #booze**

Chicago Evening American

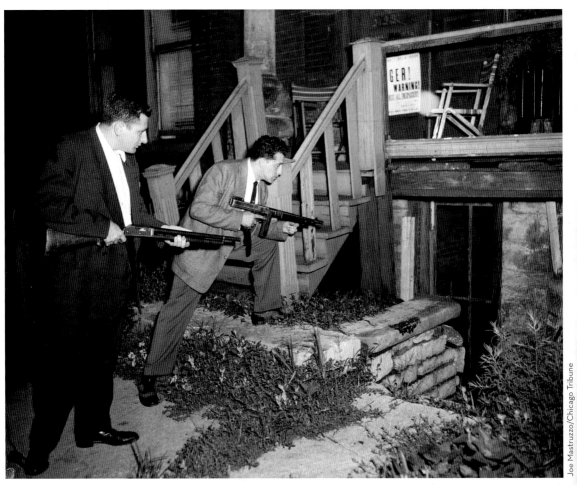

Joe Mastruzzo/Chicago Tribune

Chicago police Detectives Leonard Schwartz and Sam Canzoneri search for Lawrence Neumann, a suspect in the "tavern massacre case," in August 1956. Neumann was apprehended in a backyard at 2216 W. Harrison St. and confessed to the June 1956 murder of three people at the Miracle Lounge, 1114 Argyle St. Slain were: Max Epstein, 50, a part owner of the tavern; Lois Gates, 27, described as a "dice girl"; and John Keller, 49, a new vendor. **#tavernmassacre #gangstersandgrifters #CPD #1950s**

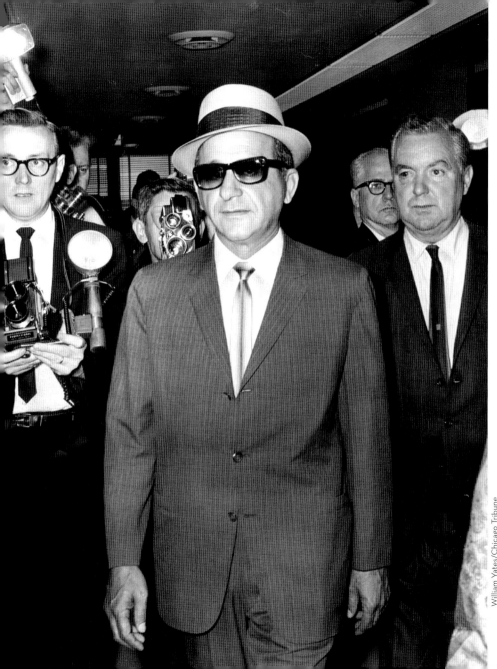

Sam "Momo" Giancana leaves a Chicago courtroom after appearing before Judge Campbell, who ordered the infamous mob boss to jail June 1, 1965. **#chicagomob #mobboss #samgiancana #momo**

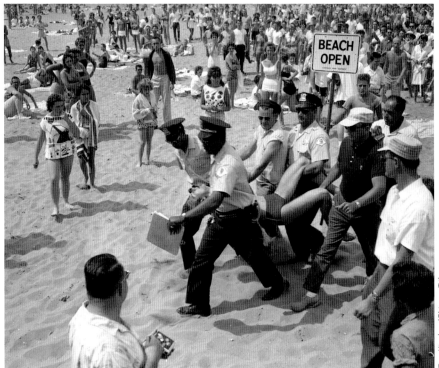

Patrick Kennedy, 19, of Chicago, is carried off Rainbow Beach by police officers after attempting to slug Capt. James P. Hackett during a wade-in July 16, 1961. The Tribune reported, "Violence erupted between police and white bathers yesterday afternoon at Rainbow beach, scene of recent 'wade-in' demonstrations by integrated groups, but not until almost all the freedom waders had left the beach. There were no reports of fighting between whites and Negroes. Police arrested 11 white persons, one of whom was carried away unconscious after he attacked a policeman. . . . Earlier in the day, some 175 Negroes appeared at the beach, at 75th street and the lake, but no trouble developed." The summers of 1960 and '61 saw many wade-ins for racial equality at Rainbow Beach. This photo is one of several recently discovered in our archives from that historic summer. It has most likely not been viewed since then. **#vintagechicago #rainbowbeach #cpd #summerof1961 #wadeins #racialequality #civilrights**

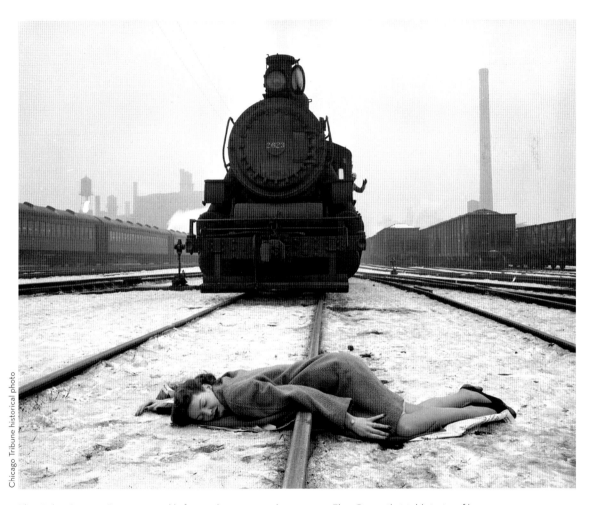

The "Police Reporter" series, a weekly feature by veteran police reporter Elgar Brown that told stories of how reporters were instrumental in solving high-profile crimes, often included photo re-enactments. The feature ran Sundays for at least two years in 1942 and '43. **#filmnoir #railroad #traintracks #policereporter**

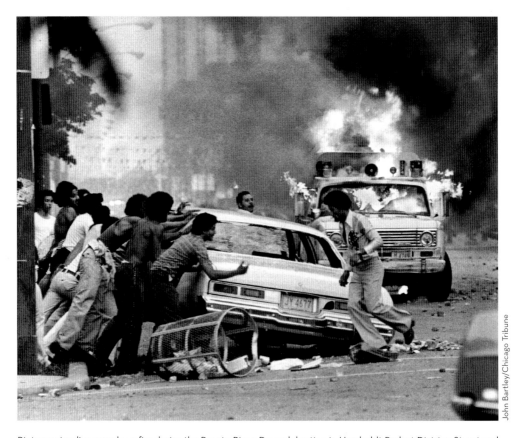

Rioters set police squads on fire during the Puerto Rican Day celebration in Humboldt Park at Division Street and California Avenue on June 4, 1977. During several days of rioting involving more than 3,000 people, three were killed and hundreds were shot at and injured. Festering resentment of police from a 1966 riot, coupled with poor housing conditions, lack of educational opportunities and a feeling of neglect, created the rise of activism in the community. "Police attempted to close the park, but were turned back by crowds hurling bricks, bottles, rocks, sticks, chairs and other debris," the Tribune reported. **#humboldtpark #puertoricoinchicago #paseoboricua**

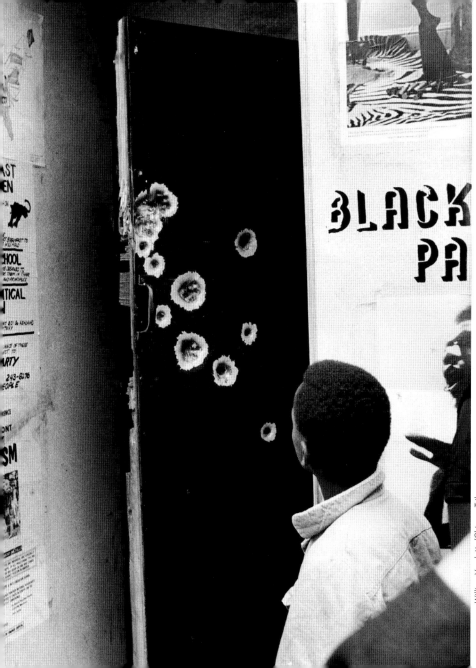

A young man examines bullet holes at the Black Panther Party headquarters at 2350 W. Madison St. on July 30, 1969. A gunfight between three members of the organization and Chicago police officers occurred at the location early that morning. **#blackpanthers #chicagopolice**

William Vendetta/Chicago Tribune

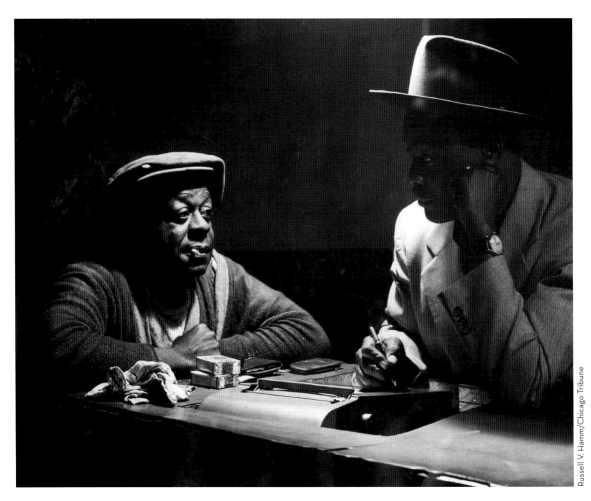

Original caption from 1951: "In the darkened basement of the Chicago av. police station, 113 W. Chicago av., Detective Dan Jackson (right) takes personal data from a man held on suspicion of running policy slips. The prisoner's belongings are laid out before him. He'll keep the cigarets, but the rest goes into the safe until the case is closed." **#cpd #1950s #vice**

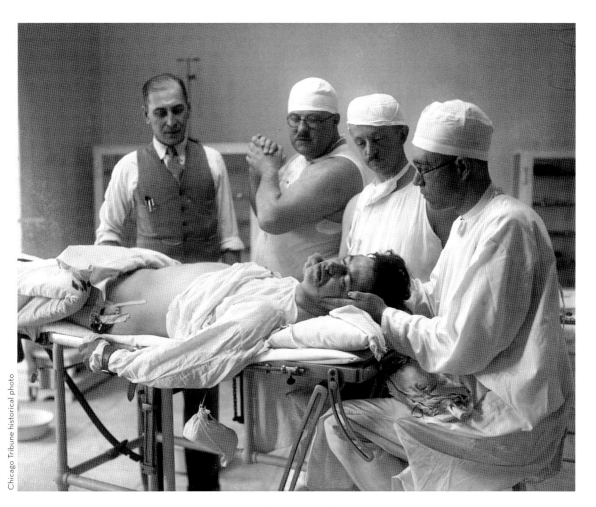

Dr. Frank Fortelka, Dr. Charles Best, Dr. Frank J. Jirka, the former head of the Illinois Department of Health, and Dr. J.R. Finkel remove slugs from Ed Cumming in 1927. **#surgeryhistory #chicagomedicalhistory #illinoisdepartmentofhealth**

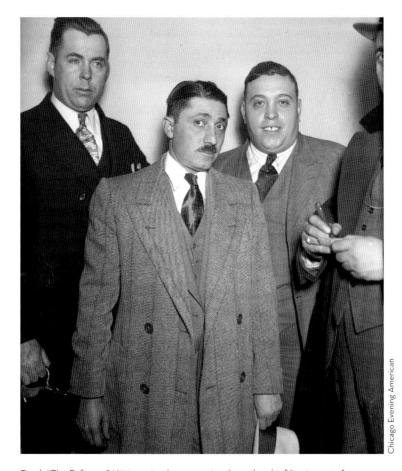

Chicago Evening American

Frank "The Enforcer" Nitti, center, known variously as the chief lieutenant of Al Capone's Outfit and as the real power of the gang "of which Capone is but a figurehead," was arrested in 1930 by agents of the Internal Revenue Service. Nitti was born in southern Italy, came to Chicago and met Capone. By the time Capone was put in jail by the IRS, Nitti was in charge of the organization. **#franknitti #theenforcer #alcapone #chicagogangs #theoutfit #chicagomob #theIRSalwayswins**

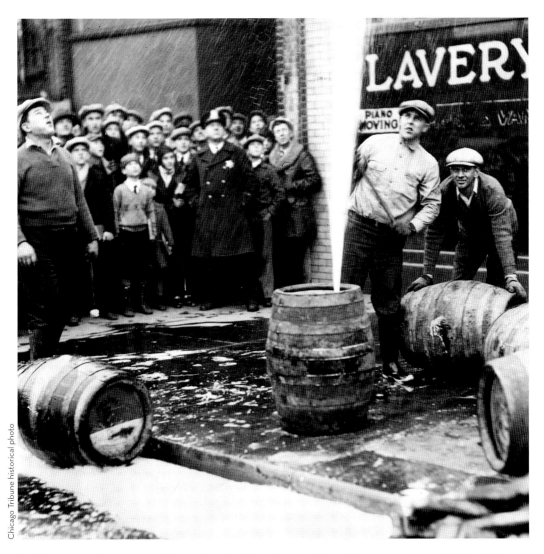

Prohibition agents bust up some of the 537 barrels of beer they seized in a raid on a garage at 5041 S. Halsted St. in Chicago on Jan. 11, 1932. At the time, the beer was worth $29,000. **#beer #prohibition #chicagoneighborhoods #halsted**

Women picked up in a raid at an American Legion post arrive at the 18th Police District on Oct. 1, 1966. The women were arrested by vice detectives at a "wild party." **#americanlegion #vice #wildparty #hairgoals**

James O'Leary/Chicago Tribune

84

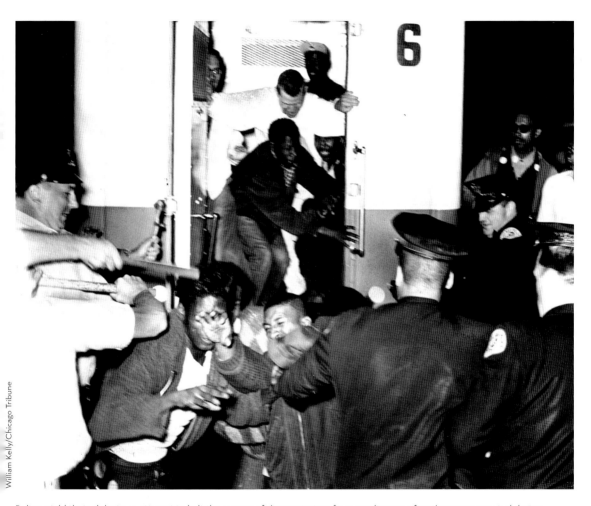

Police wield their clubs in an attempt to halt the escape of demonstrators from a police van after they were arrested during civil rights demonstrations at the intersection of Sheridan Road and Bryn Mawr Avenue on Aug. 31, 1965. Several people were taken to Weiss Memorial and Edgewater hospitals for treatment. **#civilrights #chicagoraceriots #1960s**

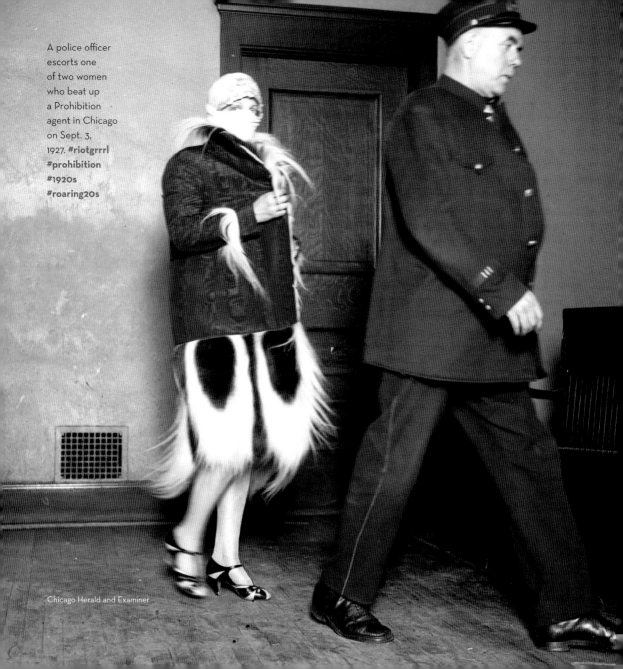

A police officer escorts one of two women who beat up a Prohibition agent in Chicago on Sept. 3, 1927. **#riotgrrrl** **#prohibition** **#1920s** **#roaring20s**

Chicago Herald and Examiner

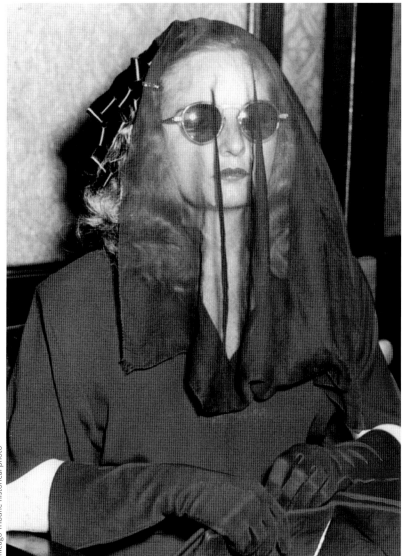

Ila Mangano, widow of slain mobster Lawrence Mangano, attends his inquest in 1944. "Dago" Mangano, a former associate of Al Capone, had been killed by unidentified gunmen in a passing sedan. **#gangstersandgrifters #1940s #mourningclothes #alpal**

Robert Nixon was tried and convicted of the May 27, 1938, rape and murder of Florence Johnson, a white woman and the wife of a Chicago firefighter. The 18-year-old Nixon was a "slow-witted colored youth," according to a Tribune description at the time. He was electrocuted in the Cook County Jail on June 16, 1939. Richard Wright's 1940 classic novel "Native Son" is a fictional story of Bigger Thomas, who was based partially on the Chicago news accounts of Nixon—news accounts that are difficult to read today because of their racist tone. **#nativeson #richardwright #biggerthomas #robertnixon**

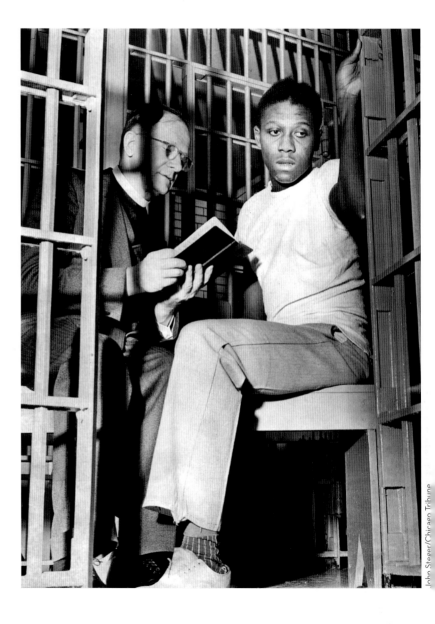

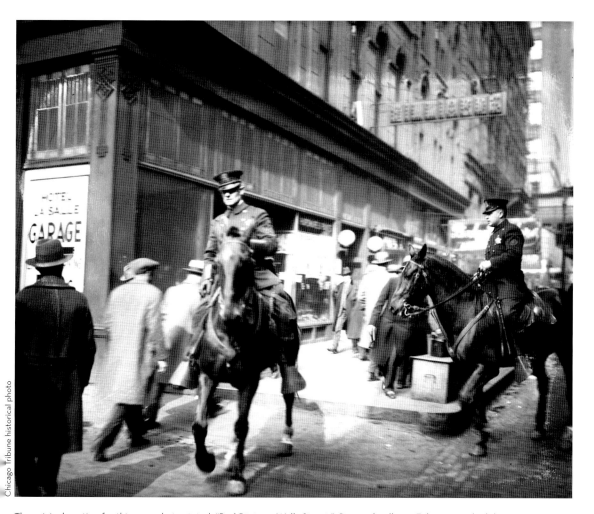

The original caption for this 1930 photo stated, "Red Riots on Wells Street." One such rally, on Feb. 21, 1930, had the newspaper headline, "Parading 'Reds' get their heads whacked in Loop." The Tribune went on to report, "One Thousand young persons, who classify themselves vaguely as radicals . . . succeeded in getting their heads cracked and their backs whacked by police clubs yesterday after their parade had tied up traffic in the streets surrounding the city hall." The "radicals" were protesting unemployment, and many of them were labor union supporters. **#redriots #laborunions #chicagounions #chicagoprotests #greatdepression**

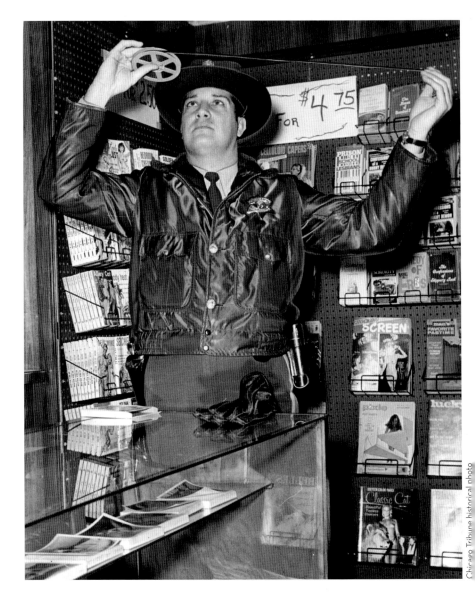

Police Sgt. Frank Gori looks at a suspected pornographic film seized in a raid Dec. 3, 1969, at a bookstore at 9225 S. Commercial Ave. **#narrativethread #itsaraid #1960s #southchicago**

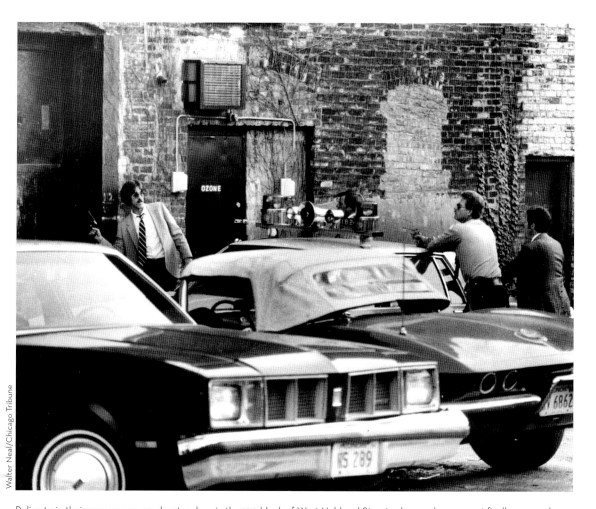

Police train their weapons on an elevator door in the 100 block of West Hubbard Street, where a drug suspect finally emerged. The man was a musician charged with cocaine trafficking in Los Angeles and was arrested in September 1982 in Chicago at the request of the FBI. **#drugraid #chicagopolice #cpd**

Walter Neal/Chicago Tribune

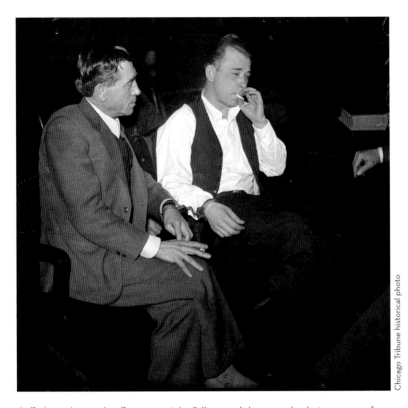

Cuffed to a deputy sheriff, gangster John Dillinger relishes a smoke during a recess from a court hearing in February 1934 in Crown Point, Ind. Dillinger was charged with killing police Officer William O'Malley, 43, during a bank robbery in East Chicago, Ind., the previous month. His trial date was set for March 12, but Dillinger would break out of the Crown Point jail on March 3. **#dillinger #gangstersandgrifters #publicenemy #1930s**

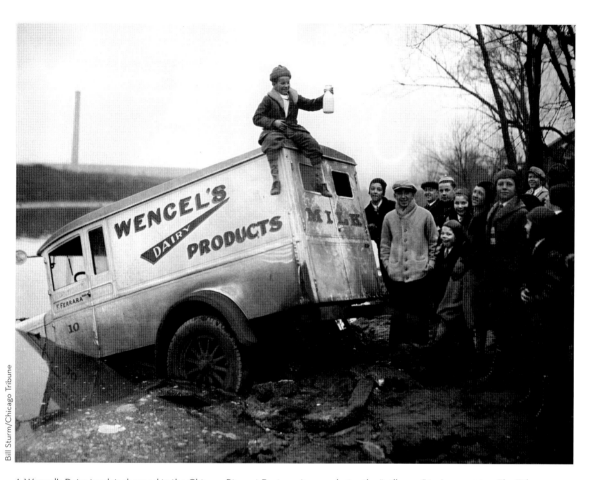

A Wencel's Dairy truck is dumped in the Chicago River at Berteau Avenue during the "milk wars" in January 1934. The Tribune reported, "The campaign of terrorism in the city was directed against independent, cut rate milk distributors who attempted to continue home deliveries. The vandals sank six milk trucks in the Chicago River and set fire to two more. In a score of other cases they beat, threatened, or fired shots at truck drivers, smashed windows, and dumped milk in the streets." Reserve milk supplies were already exhausted in the city of Chicago, and farmers with the Pure Milk Association prowled the Wisconsin-Illinois border, halting any delivery attempts to the city. **#milkwars #dairywars #milkstrike #puremilk**

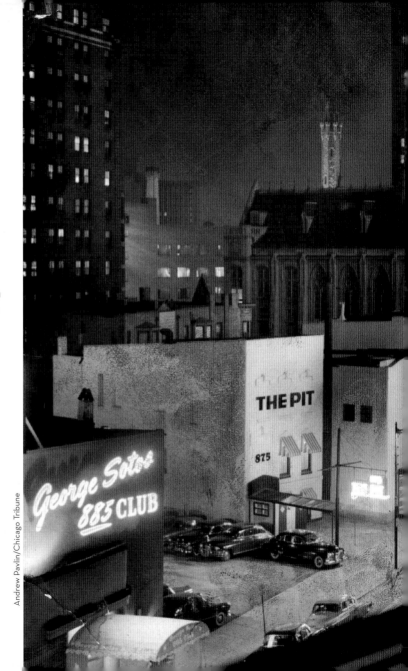

Great original caption alert: Rush Street in the 1950s "was a time when an alcoholic was a 'character,' a stripper was practicing art and a prostitute could garner respect." **#rushstreet**

Andrew Pavlin/Chicago Tribune

Thaddeus Klauss, 15, from left, Curtis Burns, 16, and David Edwards, 16, witnessed a shooting and carried Eugene Stanford to a clinic on Oct. 31, 1958. Stanford, 17, died of his wounds. Louis Shoemate, 41, shot the youth after a shouting match between him and several co-workers and a group of young men at 63rd Place and Central Avenue. Shoemate claimed self-defense after Stanford and his friends "lunged at him after the exchange of remarks," the Tribune reported. "Shoemate said he began carrying the pistol several days ago for protection after other company employees had been molested near the plant. Police said Stanford had a record of arrests on charges of riding in a stolen car and disorderly conduct." **#vintagecrime #theoutsiders #1950s**

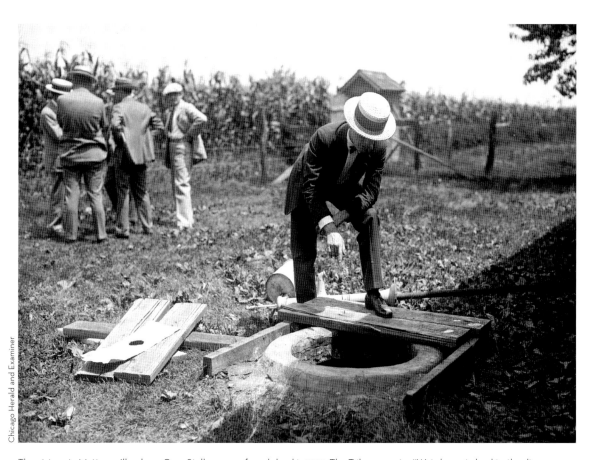

The cistern in Mattoon, Ill., where Cora Stallman was found dead in 1925. The Tribune wrote: "Weird events lead to the discovery of a woman's body in a cistern at the farm house of Mrs. Anna Seaman, near Mattoon, Ill. It was upon the farm of Mrs. Seaman that the cistern in which the body of Miss Cora Stallman, her sister, was found, is located. Miss Stallman lived in a nearby cottage." **#vintagecrime #mattoon #cistern #whodunit?**

◄ Joseph "Diamond Joe" Esposito was a Prohibition-era Chicago politician and gangster who was involved with bootlegging, extortion, prostitution and labor racketeering. There's no date on this photo of the well-loved gangster, but Esposito died in 1928. He had been a Capone rival and was gunned down on the front steps of his home. **#gangstersandgrifters #joeesposito #chicagocrime #mobboss #diamondjoe**

The original caption on this gem said: "Maude Dillon, one-time actress, who is now being entertained by the police" in June 1931 at the West Chicago police station. Dillon died two years later in 1933. She had been an actress in the early 1910s working under her maiden name, Maude May. She appeared in a Shakespearean production with Richard Mansfield and had been in a play at McVicker's Theater. **#policelineup #thisishowifeelonmondaymorning**

Alice Kolski, 25, and Dorothy Hane, 23, were stopped by police Sept. 23, 1948, and were subsequently charged with resisting three officers. The women were both members of the Match Corporation Queens baseball team (known simply as the Queens) of the National Girls Baseball League. **#vintagebaseball #nationalgirlsbaseballleague #thequeens #girlsbaseball #leagueoftheirown**

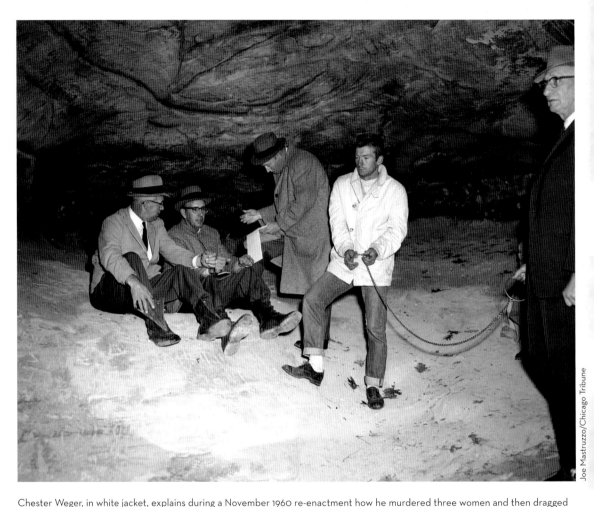

Joe Mastruzzo/Chicago Tribune

Chester Weger, in white jacket, explains during a November 1960 re-enactment how he murdered three women and then dragged their bodies into a cave at Starved Rock State Park. The March 1960 murders of Lillian Oetting, 50, Frances Murphy, 47, and Mildred Lindquist, 50, all of Riverside, were considered at the time the crime of the century. Weger has maintained his innocence since his 1961 trial. He said his detailed confessions the night of his arrest were coerced and his re-enactment the next morning at the state park—in front of several reporters and photographers—was choreographed by the now-deceased police detectives who he said framed him. Weger is serving a life sentence. **#vintagecrime #crimeofthecentury #starvedrock #chesterweger #parole #crime**

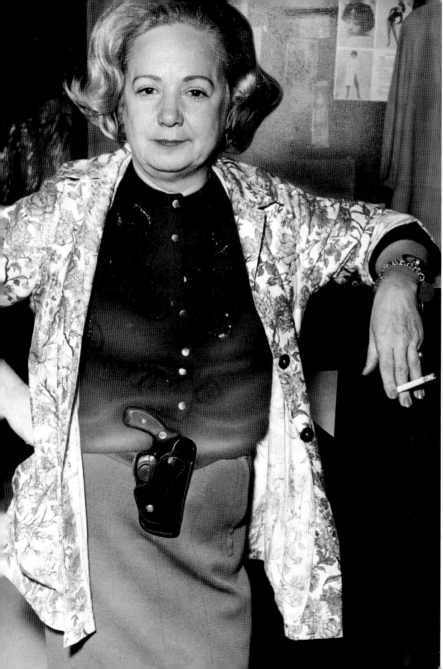

Ann Soloman, proprietor of the Leather and Suede Salon at 333 N. Michigan Ave., displays her gun, which she says is with her 24 hours a day, on Nov. 13, 1964. Soloman told the Tribune, "You can spread the word that I'll be packing this pistol until after the Christmas holidays." Soloman summoned police after four men entered the store and began acting in a suspicious manner. She also revealed that the north window of her salon had been smashed and several items of clothing stolen. "Mrs. Soloman said that altho she called the police she stood in the middle of the salon watching all four men. She said that she had determined to start shooting the first time one of them made a false move." **#pistolpackin #michiganavenue #magmile**

R. Walker/Chicago Tribune

Chicago Tribune historical photo

Parking is at a premium on Rush Street in August 1986, and violations are numerous. A Chicago police officer, complete with cigar, talks to a man with a ticket in his hand. **#rushstreet #chicagopolice #chicagoparking #classiccop**

CHICAGO AT WORK

WHAT 9 TO 5?

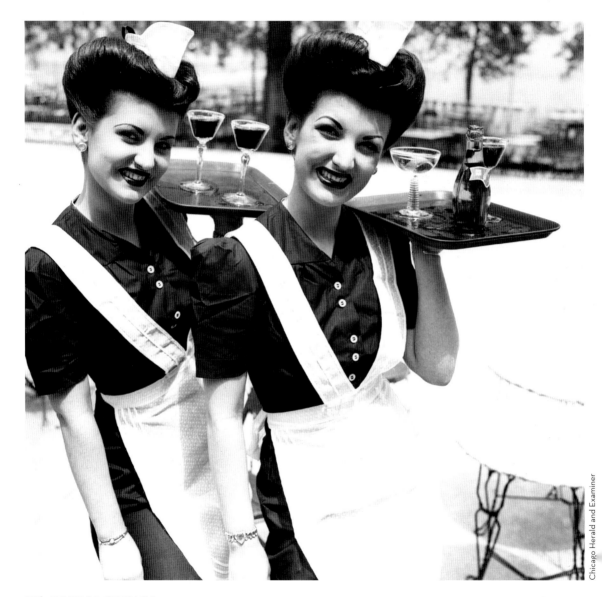

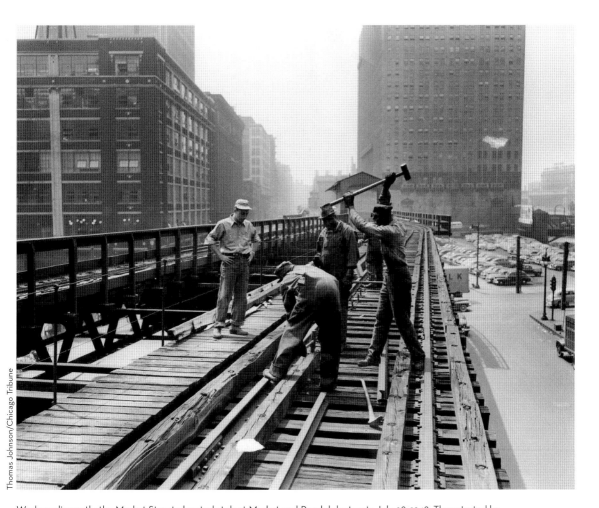

Workers dismantle the Market Street elevated stub at Market and Randolph streets July 28, 1948. They started by wrecking the structure between Randolph and Lake streets. **#cta #chicagotransportation #chicagoworks**

◀ Twins Lou and Lee Lamkins, 20, just after starting jobs as poolside waitresses at the Edgewater Beach Hotel in 1945. **#edgewater #vintageswim #twins**

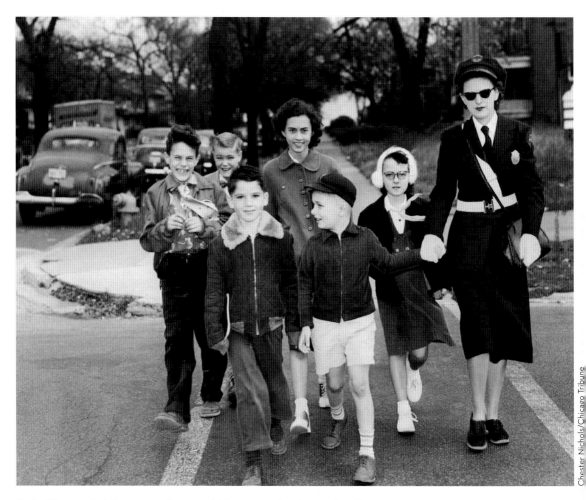

Chester Nichols/Chicago Tribune

Evelyn Wagner, a Park District guard, escorts children across Sheridan Road at Albion Avenue on Oct. 23, 1953.
#sheridanroad #everydayheroes #1950s #rogerspark

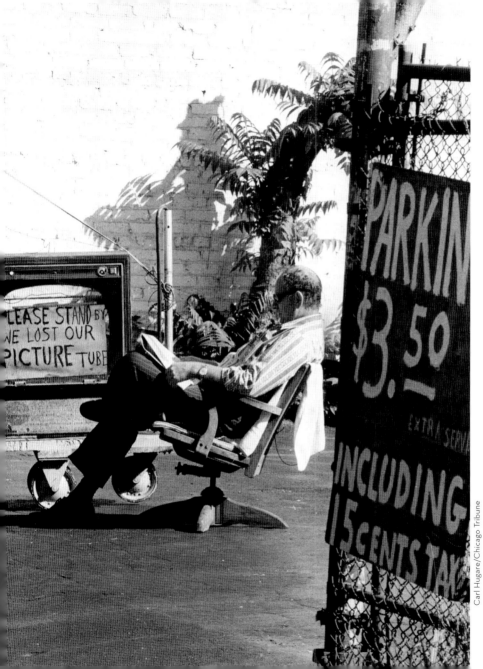

Meyer Reznitsky, owner of M.R. Parking Inc., takes it easy before a game at Wrigley Field in August 1977. Reznitsky listened to the ballgame on the radio inside his tubeless television set. *#wrigleyfield #chicagocubs #sooocheap #parking #picturetube*

Carl Hugare/Chicago Tribune

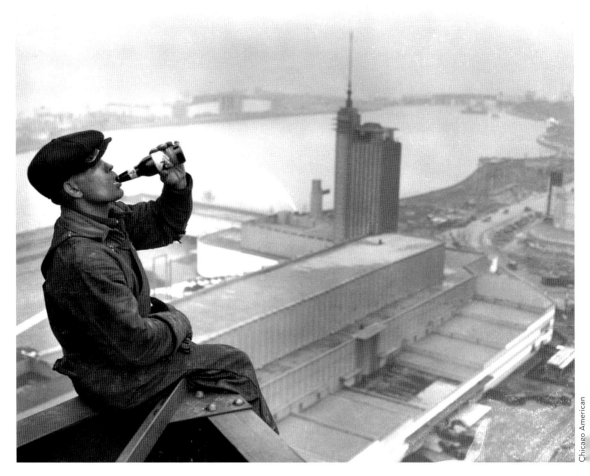

Chicago American

An ironworker, perched on the west tower of the Sky Ride, drinks a beer during construction of the Century of Progress Exposition in 1933. When completed, the Sky Ride consisted of two 625-foot-tall towers that straddled the lagoon between Northerly Island and the lakefront. The ride had rocket-shaped cars that transported 36 fairgoers at a time across the lagoon. **#worldsfair #centuryofprogress #chicagolabor #chicagoworkers #edelweiss #beerforlunch**

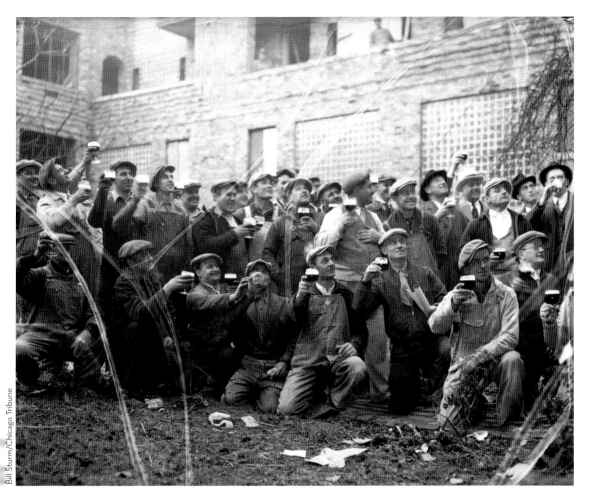

Bill Sturm/Chicago Tribune

Workers celebrate with beer at the opening of a new apartment building at 1209 N. State St. in Chicago. The famous Frank Fisher Apartments (or Fisher Studio House) was designed by Andrew Rebori and Edgar Miller for Frank Fisher Jr. in 1937 and completed in 1938. The 12 apartments are an example of the Art Moderne style and were designated a Chicago landmark in 1996. Fisher was a Marshall Field's executive. This negative has age damage. **#frankfisher #fisherapartments #fisherstudiohouse #andrewrebori #edgarmiller #artmoderne**

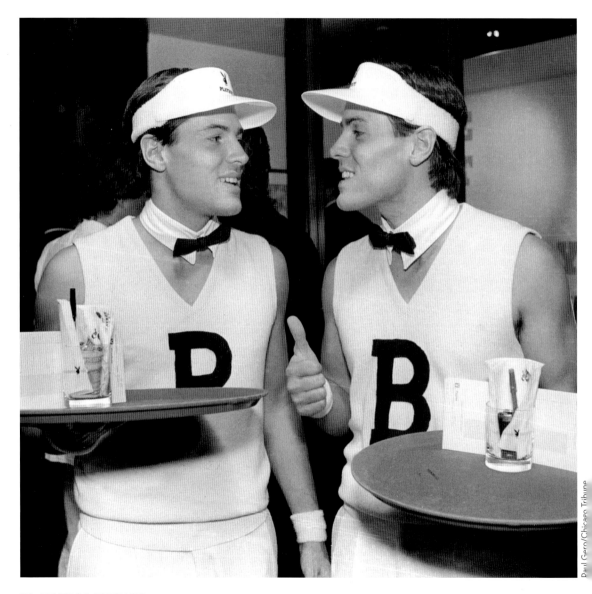

Paul Gero/Chicago Tribune

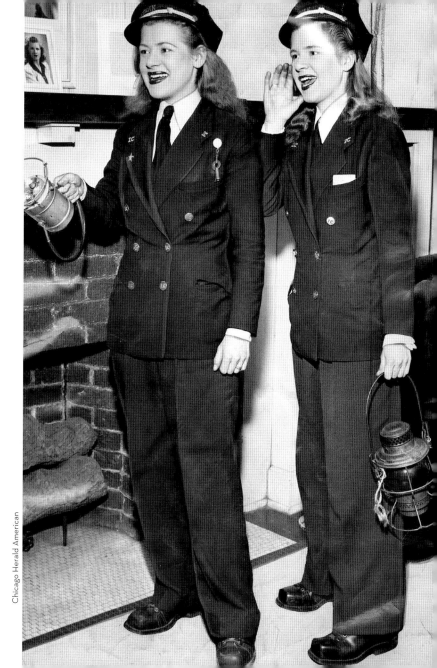

◄ Playboy "rabbits" (and twins) Jeff and Jerry Rector wear matching varsity vests and tennis visors as they greet visitors at the Playboy Club in 1985. **#diversity #rabbits #playboy #1980s**

Peggy Schoenback, left, shows how she "highballs" a train as her identical twin, Bette, demonstrates how she calls a stop on the Illinois Central suburban line in 1943. The original caption says: "Commuters, unable to tell the girl flagmen apart, are usually in a state of bewilderment." **#seeingdouble #wwll #1940s #railjobs #womenatwork**

Chicago Herald American

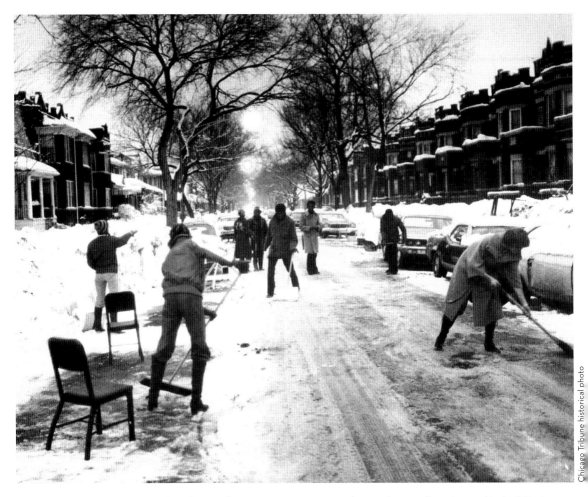

Has "dibs" been around since there have been parking spots? In January 1979, cleaning the snow from the 900 block of North LeClaire Avenue was a communal effort. But dibs were still called. **#polarvortex #chicagoweather #dibs #chicagoneighborhoods**

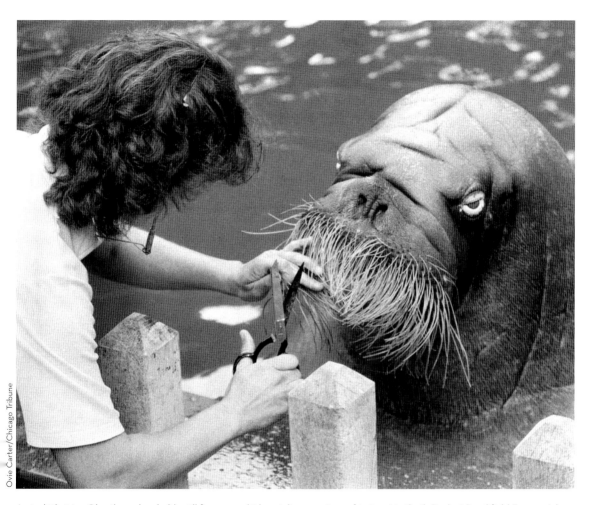

Just a little trim: Olga the walrus holds still for some whisker styling, courtesy of trainer Maribeth Rook at Brookfield Zoo, on July 27, 1984. **#olga #brookfieldzoo #1980s #lineitup**

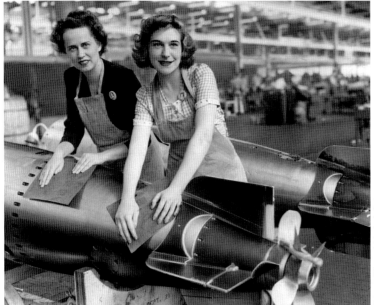

Lenore Radway, left, and Shirley Becker put some elbow grease into polishing a torpedo flask at Amertorp in East Chicago, Ind., in 1943.
#wwII #rosietheriveter #wareffort #eastchicago

▶ Workers replace the surface of the Michigan Avenue Bridge on July 25, 1939, in this view looking north. The Wrigley Building is at left, and the Allerton Hotel is at center right. **#michiganavenue #chicagobridges #chicagoarchitecture #overalls #1930s**

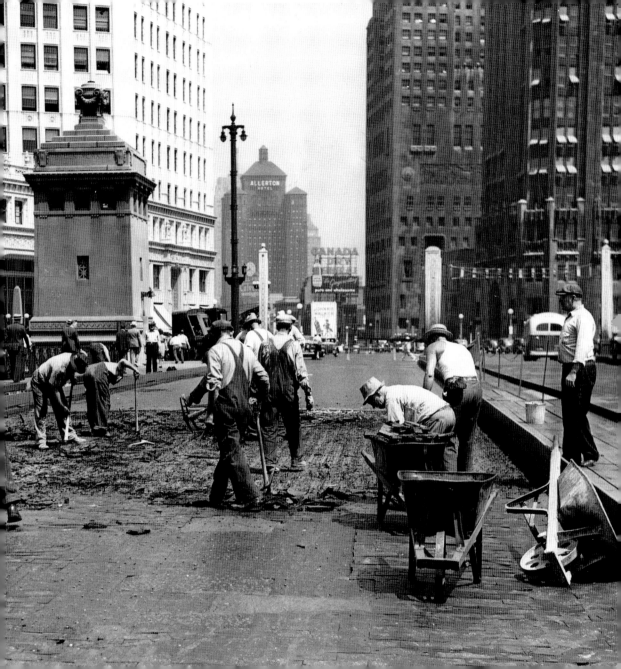

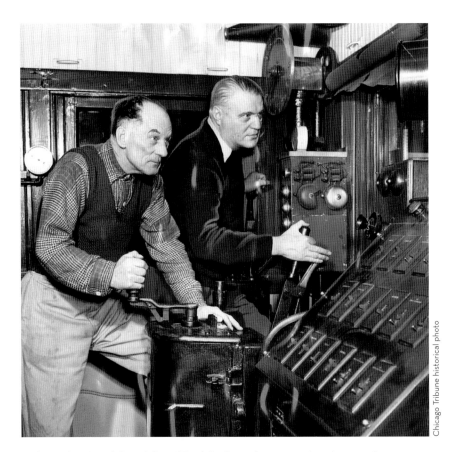

Chicago Tribune historical photo

Bridge tenders Joseph Egan, left, and Frank Duckman demonstrate how the controls work at the southeast tower of the Michigan Avenue Bridge in December 1953.
#magmile #chicagobridges #michavebridge #chicagoriver #donttouchthatbutton

Walter Kale/Chicago Tribune

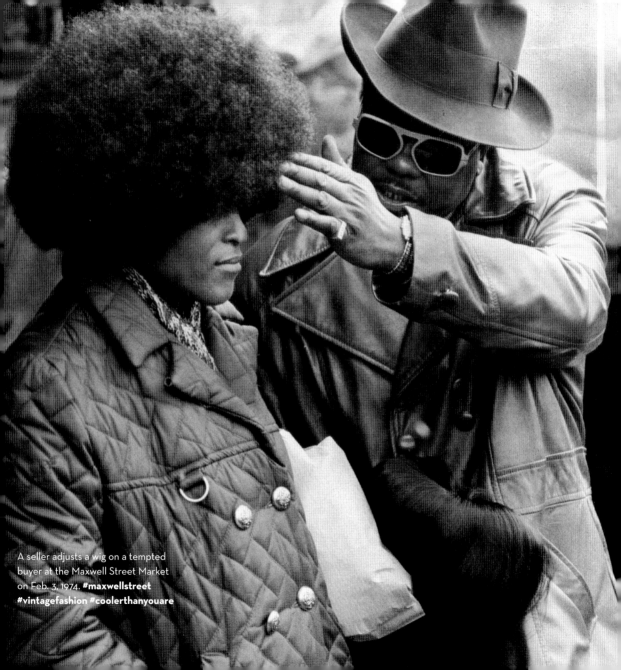

A seller adjusts a wig on a tempted buyer at the Maxwell Street Market on Feb. 3, 1974. **#maxwellstreet #vintagefashion #coolerthanyouare**

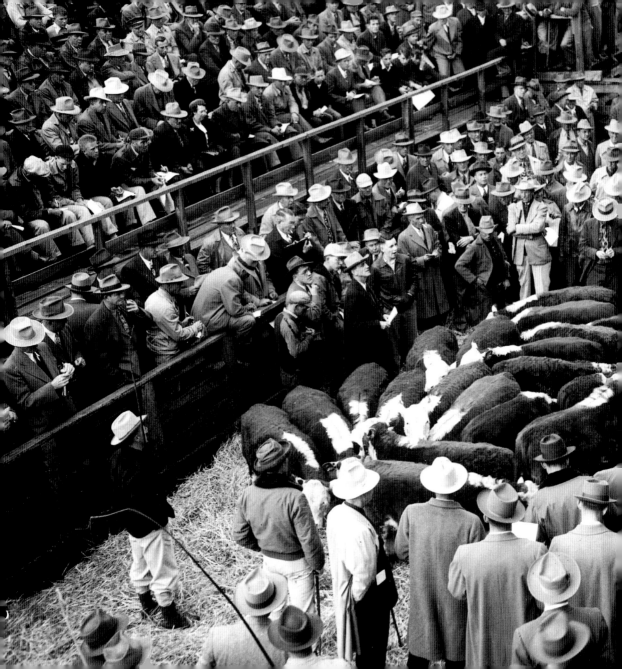

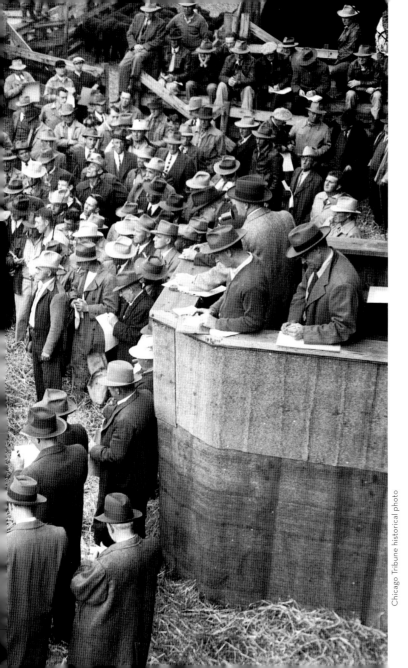

The scene in the auction ring as champion cattle are auctioned off in the Union Stock Yards on Oct. 31, 1947. **#thestockyard #livestock #cattleauction**

Chicago Tribune historical photo

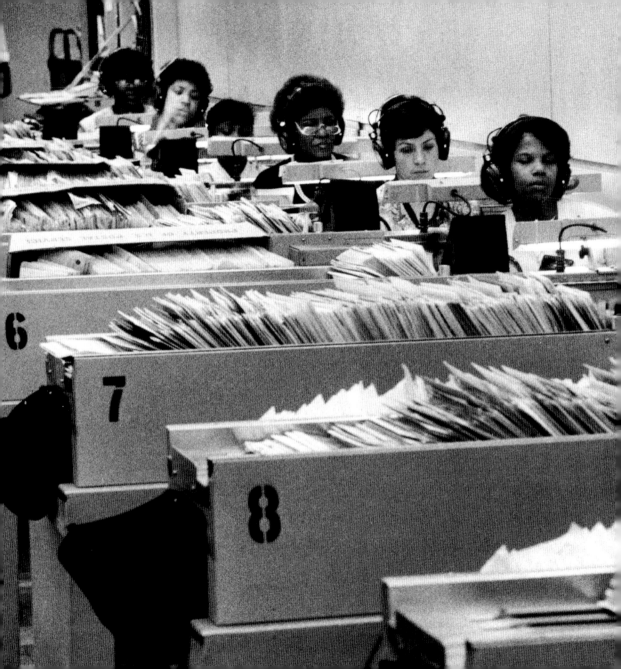

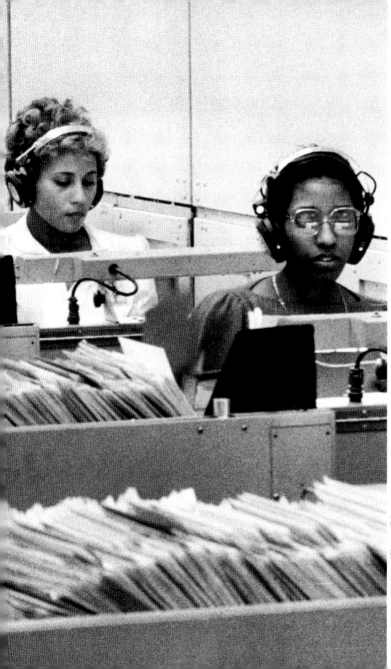

James Mayo/Chicago Tribune

Sorters at Chicago's main post office separate mail by ZIP code in 1982. **#chicagomail #chicagopostoffice #working9to5**

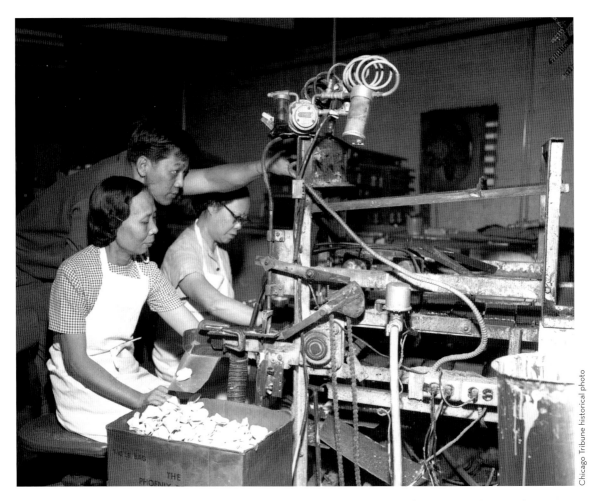

Yau Tak Cheung, a Chinese engineer, watches fortune cookies being made on a contraption of his design in Chicago's Chinatown in September 1966. **#chinatown #chicagoneighborhoods #inventors #fortunecookies**

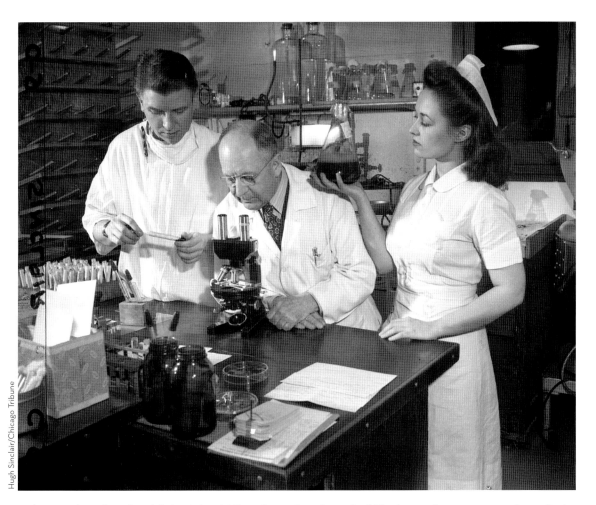

Technician Hale Erickson, from left, Dr. Hjalmar Wallin and nurse Doris Stone check blood counts for storage in an icebox at Cook County Hospital on March 14, 1947. Bernard Fantus established the first blood bank in the United States at the hospital in 1937. **#cookcountyhospital #cookcounty #cooker**

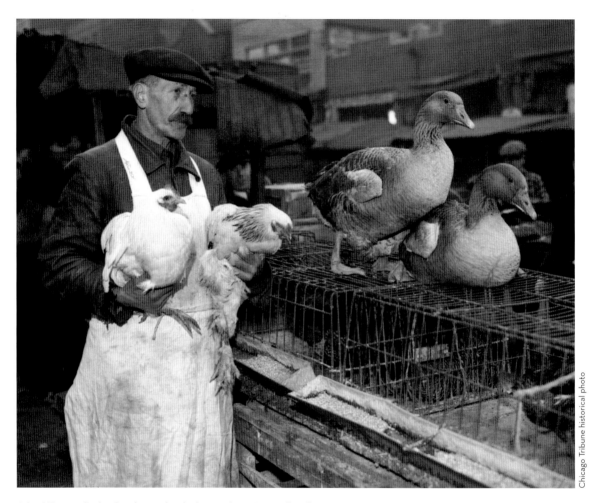

Julius Wiezer, a kosher butcher, in the chicken market at Maxwell and Union streets in 1931.
#maxwellstreet #maxwellmarket #kosher #chicagojews

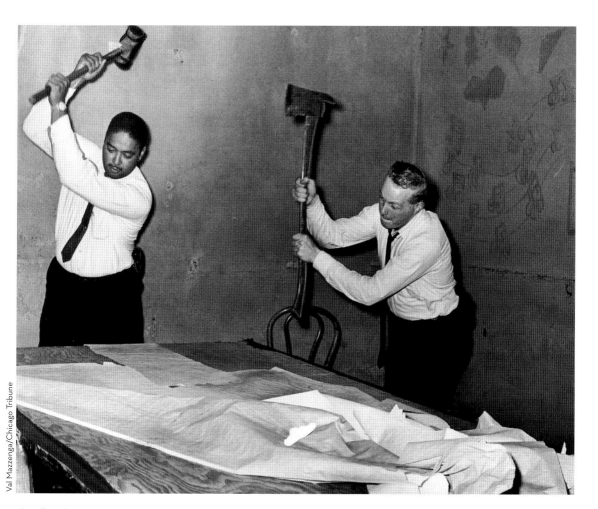

Sheriff's policemen Donald Mayo, left, and Jim Bradician chop up a dice table at the Woodlawn Bridge Club at 6225 S. Cottage Grove Ave. on May 17, 1964. The dice table was among those destroyed by police during a raid.
#dicetable #gambling #gamblingraid

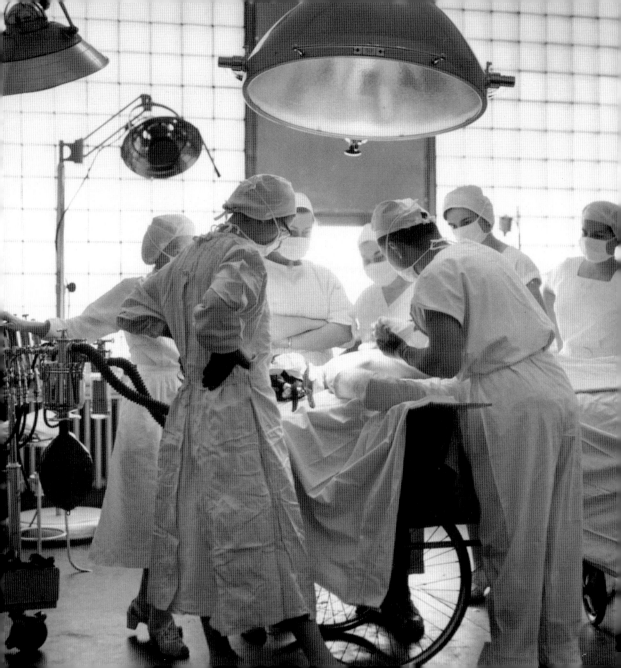

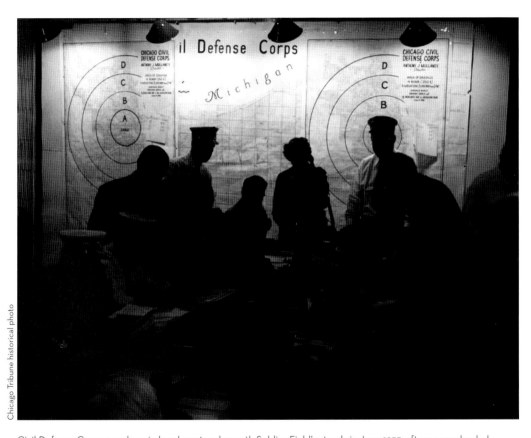

Civil Defense Corps members in headquarters beneath Soldier Field's stands in June 1955, after an overloaded circuit temporarily plunged them into darkness. **#coldwar #1950s #civildefense #soldierfield**

◄ Dr. Louis Dvonch, in short sleeves leaning toward patient, tends to an Our Lady of the Angels School fire burn victim in 1958 at St. Anne's Hospital on the West Side. **#firehistory #chicagofire #tragicfire**

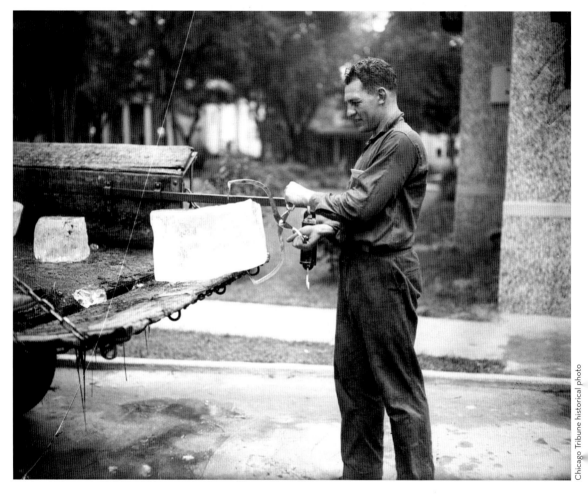

We recently uncovered this photo from the archives, not seen since the 1920s: Harold "Red" Grange on the ice wagon in Wheaton in 1926. The famous football player worked as an ice deliveryman during his summers off from college at the University of Illinois.
#fightingillini #chicagobears #gallopingghost #redgrange #vintagefootball

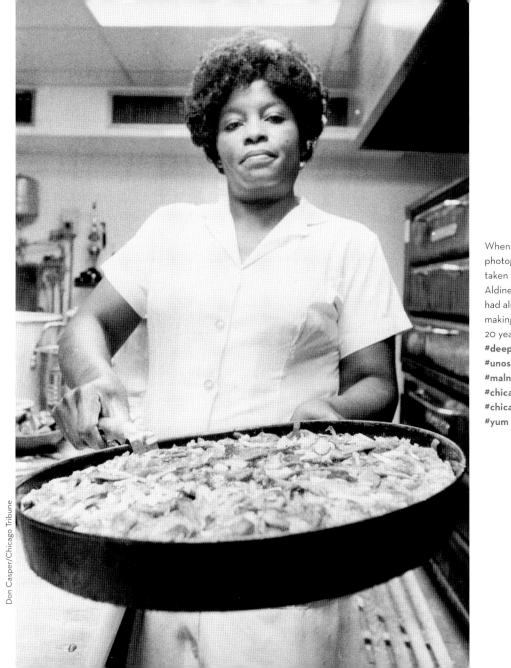

Don Casper/Chicago Tribune

When this photograph was taken in 1976, Aldine Stoudamire had already been making pizzas for 20 years at Uno's. **#deepdishpizza #unos #dues #malnatis #chicagorestaurants #chicagorituals #yum**

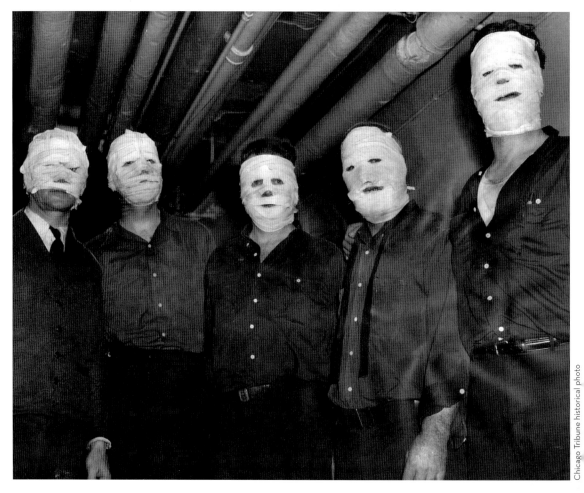

Chicago Tribune historical photo

Bandaged Chicago firefighters pose for a Tribune photographer at Ravenswood Hospital in 1944 after they were injured battling a blaze at a school. **#cfd #bravery #firefighters #photoop**

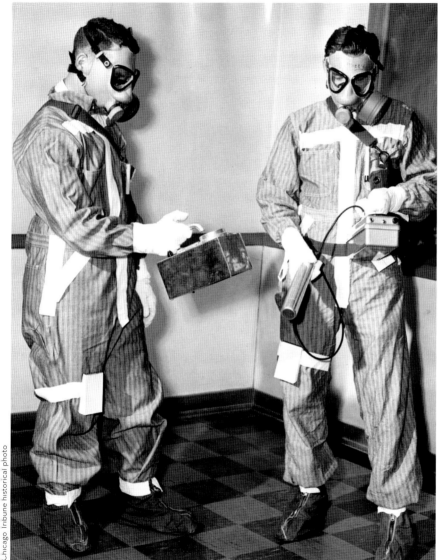

On June 13, 1958, a "radiological survey team" was activated at Argonne National Laboratory to respond to any "radiation accidents" in a 10-state area. The original caption says William B. Grant holds a Samson survey meter and Walter H. Smith holds a gamma survey meter. **#1950s #radiation #argonne #lookslikeabmovie #gammameter**

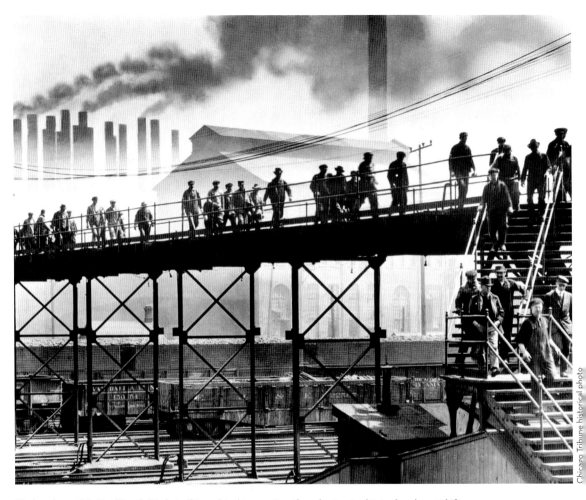

Workers leave U.S. Steel South Works in this undated image. **#southworks #ussteel #steelworkers #shiftover**

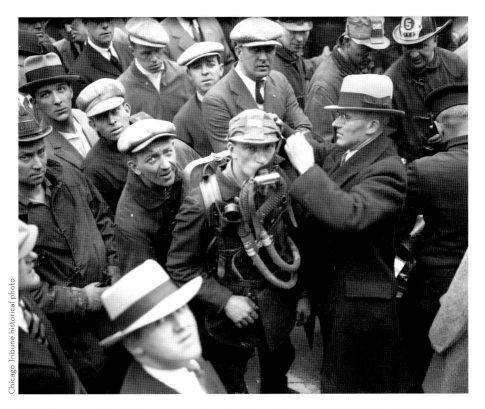

Firefighters are equipped with oxygen masks and sent down into a smoke-filled Sanitary District tunnel April 13-14, 1931. The tunnel, which was under construction at 22nd and Laflin streets, caught fire, trapping workers 35 feet below the surface. Firefighters then attempted to rescue 16 men trapped in the tunnel without masks or equipment. According to the Tribune, "It was impossible, even with the masks, to remain below a half hour. Many firemen overstayed the air limit of twenty minutes in their oxygen containers and were themselves rescued." Eleven men died in the tunnel, including four firefighters. **#tunneldisaster #sanitarydistrict #chicagofirefighters #brave #trappedbelowtheearth**

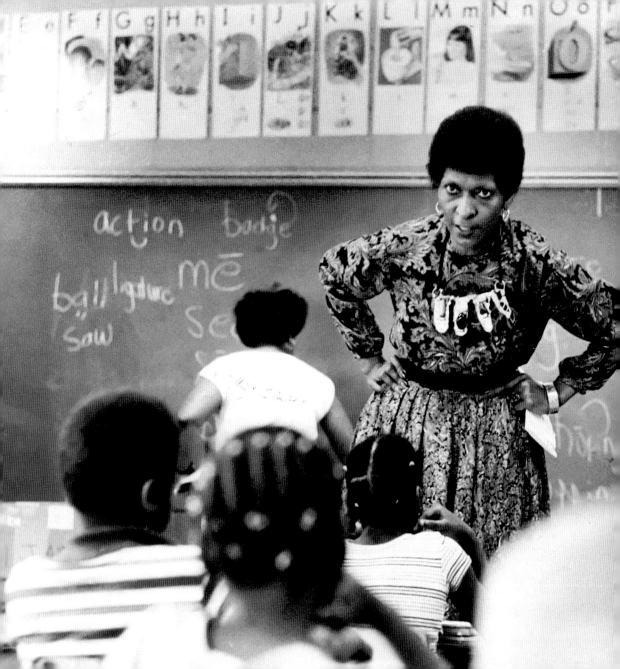

A pioneer in education, Marva Collins conducts lessons at Westside Preparatory School in 1982. Collins started the private school in the impoverished Garfield Park neighborhood to teach students many thought were unteachable. She had great success, and in 1981 her life became the focus of a made-for-TV movie, "The Marva Collins Story." By 1991, she was training 1,000 teachers a year on her methods. Collins died in June 2015. **#marvacollins #marvacollinsprep #westsideprep**

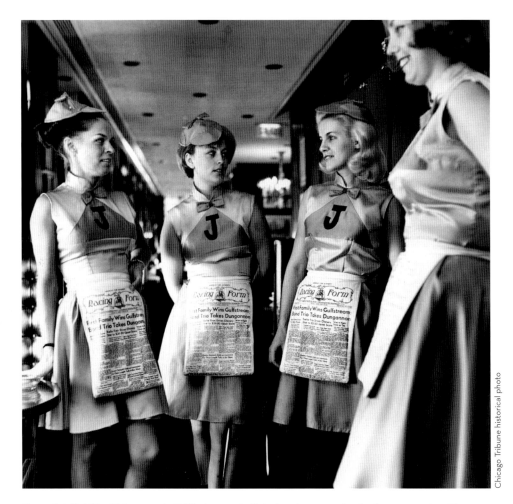

The waitstaff at The Club on 39, at 1 E. Wacker, sport silk jockey dresses and racing form aprons in 1966.
#theclub #racingform

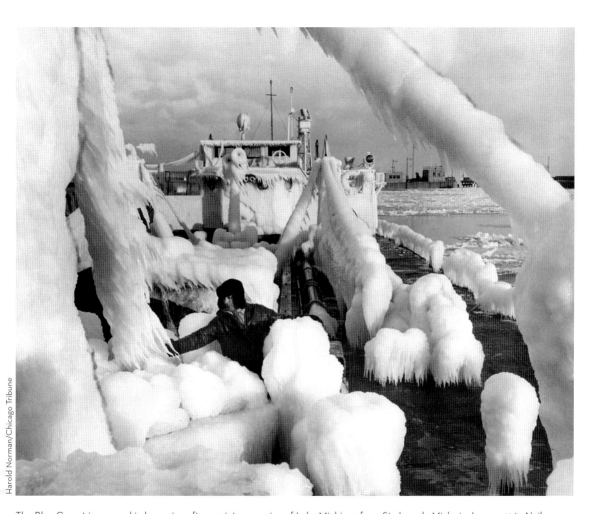

Harold Norman/Chicago Tribune

The Blue Comet is covered in heavy ice after a winter crossing of Lake Michigan from St. Joseph, Mich., in January 1961. Neil Hansen, a member of the crew, was beginning the ice-removal effort so radio antennas could be lowered, enabling the ship to pass beneath Chicago River bridges. **#chicagowinter #lakeeffect #1960s #iceicebaby**

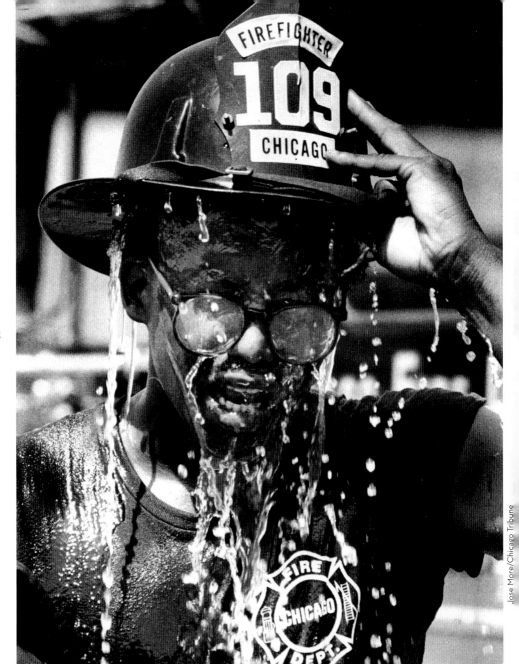

Chicago firefighter Gregg Rock finds relief in a helmet full of water after battling a blaze in 94-degree heat in July 1983. **#cfd #blazes #1980s #doused**

Jose More/Chicago Tribune

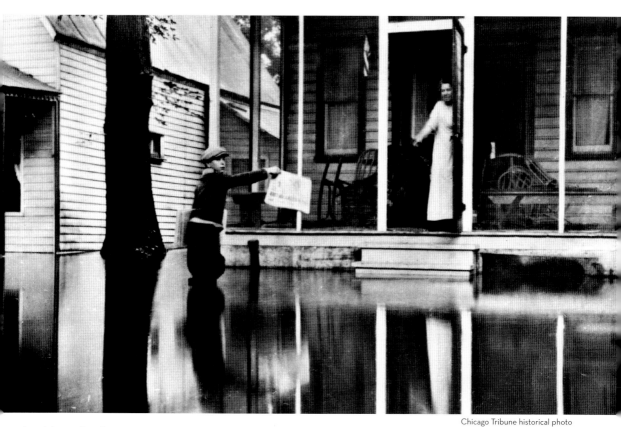

A boy delivers the Chicago Tribune during flooding in 1924.

#1920s #hereyagomaam #newsboy #newscarriers

Chicago Tribune historical photo

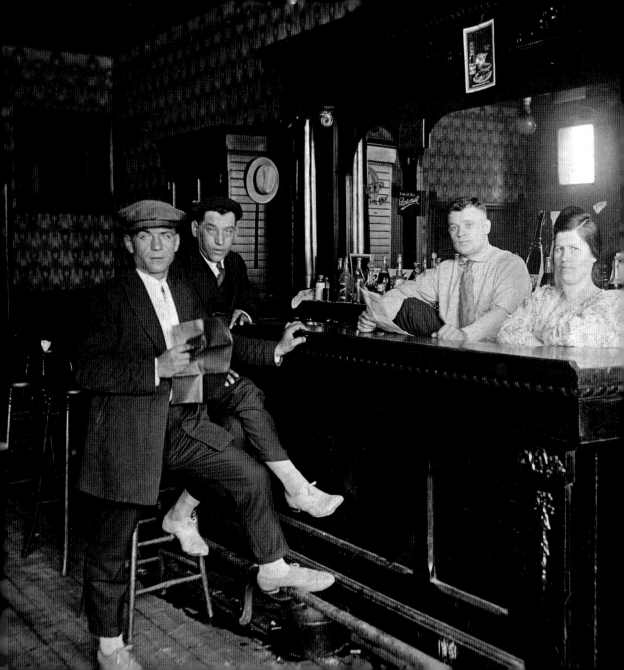

A husband-and-wife team work as saloonkeepers in this turn-of-the-century Chicago neighborhood tavern. **#vintagetaverns #chicagobars #barhistory #chicagotaverns #chicagobarhistory**

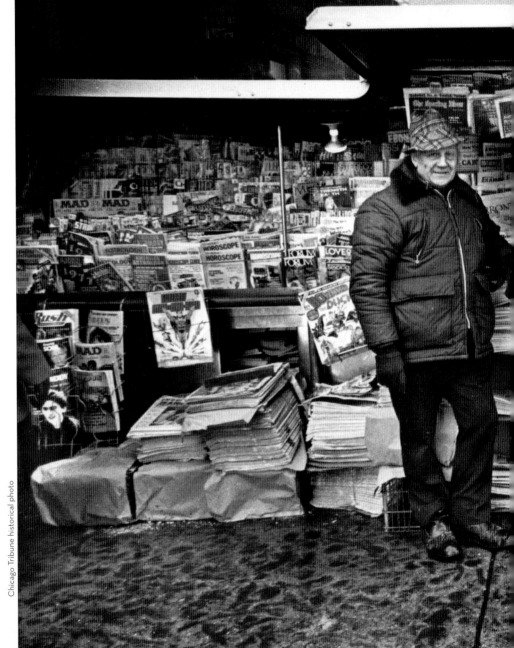

Ed Dzieubla and his son Bob at their newsstand at Randolph and Michigan streets in January 1977, where papers announced President Jimmy Carter's inauguration. **#newsprint #newsstand #1970s**

Chicago Tribune historical photo

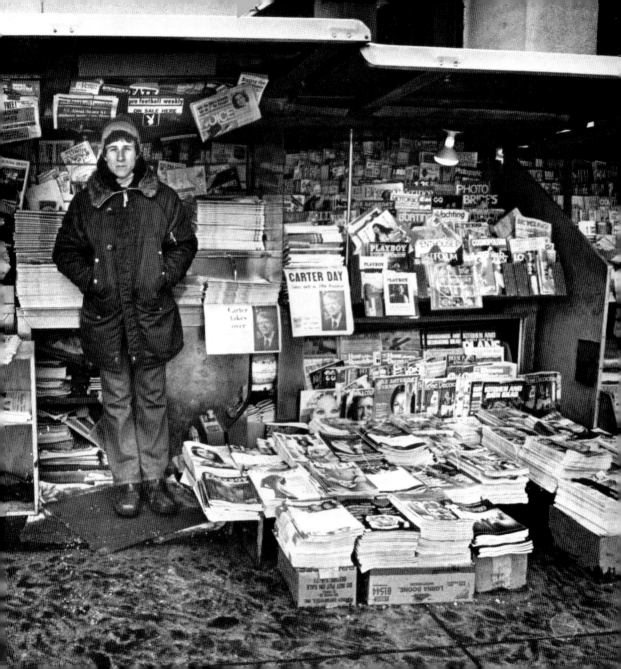

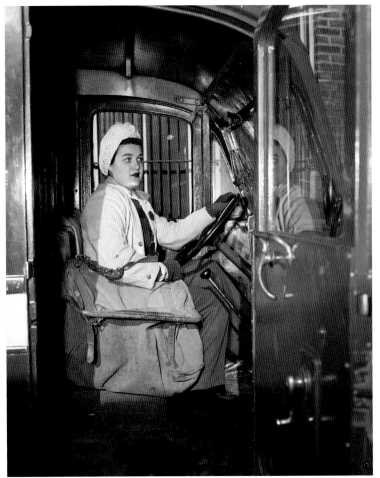

Jeannette Lee, 22, poses Dec. 15, 1944, in the truck she drives to pick up mail. She was the first and only female mail carrier for the city of Chicago in 1944. "Meet Chicago's first woman mail truck driver," the Tribune reported. "She is Mrs. Jeannette Lea, 22, of 6210 Harper Ave., who is attached to the South Shore post office, 2207 E. 75th Street. She started Thursday and yesterday made the collection trip alone. 'I'd like to have more drivers like her,' Superintendent Michael C. McCarthy said. 'She keeps to her schedule and can handle a truck like a veteran. I'm certainly satisfied.' . . . The woman driver is a widow with a 3 year old daughter." The historical record differs on the spelling of her last name, with the Tribune spelling it Lea and the Smithsonian National Postal Museum spelling it Lee. **#firstwoman #chicagopostoffice #womenmailcarriers #mailcarrier #rosietheriveter**

Bill Allison/Chicago Tribune

▶ Firefighter Peter W. Sterling of Engine Co. No. 3 with his shepherd dog, Pete. The dog adopted Sterling as his master after being rescued from a deep sewer in 1931. **#chicagofire #cfd #petethedog**

Chicago Tribune historical photo

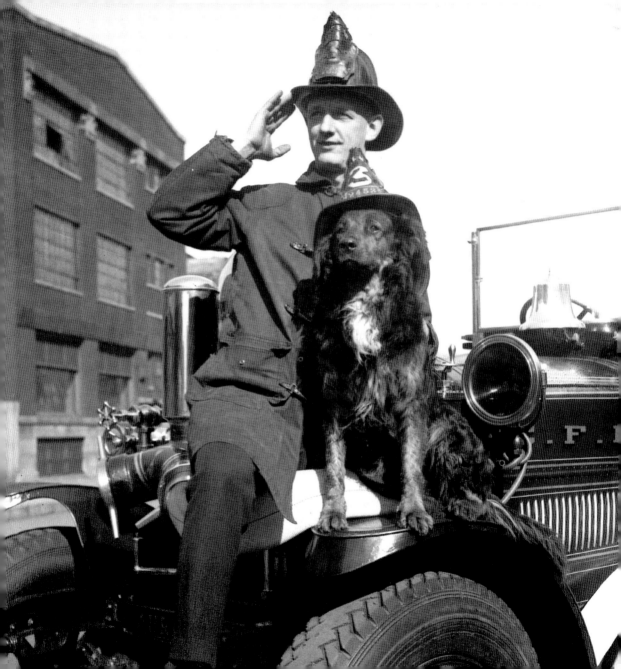

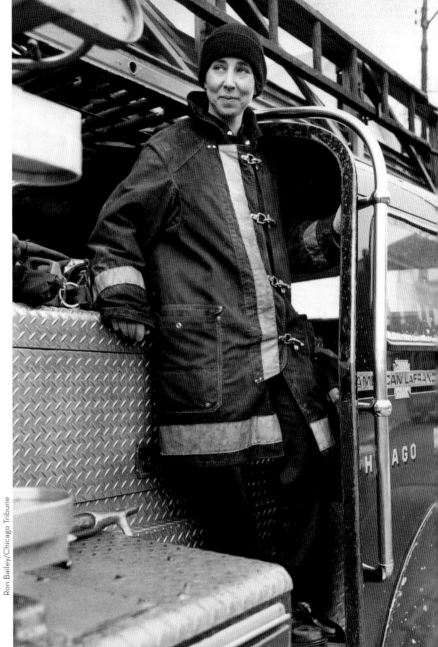

Lauren Howard was Chicago's first female firefighter, joining the department in 1980. Howard broke through the barrier when she was hired as a relief worker during a strike. She had to pass the grueling physical test, which included timed exercises of hanging from a pole, climbing stairs carrying a 60-pound coiled hose and pulling a 150-pound dummy across a room without its feet touching the floor. "I proved to a lot of doubters, not only that I could do it but that women in general could do it," Howard said. She retired as a captain in 2004. Howard is shown here in January 1981. **#laurenhoward #chicagofirsts #cfd #chicagofire #womenfirefighters**

Ron Bailey/Chicago Tribune

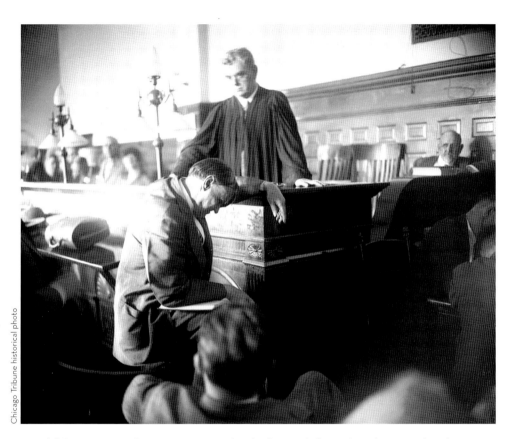

Famed defense attorney Clarence Darrow, seated, makes his case before Judge John R. Caverly in the murder case against Richard Loeb and Nathan Leopold Jr., both 18, in the summer of 1924. Darrow's masterful handling of the case has been the subject of books and movies. University of Chicago graduate students Leopold and Loeb set out to commit the "perfect" crime by killing a random person, Robert "Bobby" Franks, 14. Both Leopold and Loeb were sent to Stateville Prison in Joliet, each receiving a life sentence plus 99 years for kidnapping and murder. Loeb was killed in prison Jan. 28, 1936, and Leopold was released in 1958. **#leopoldandloeb #darrow #crimeofthecentury**

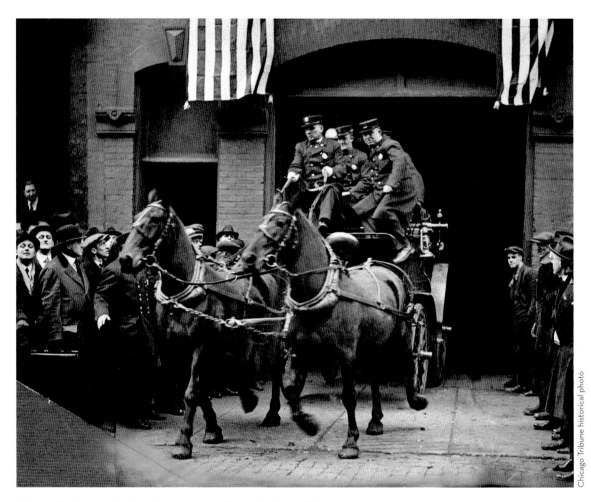

Chicago's fire horses make their last run in 1923. **#blazingfinish #excellentequines**

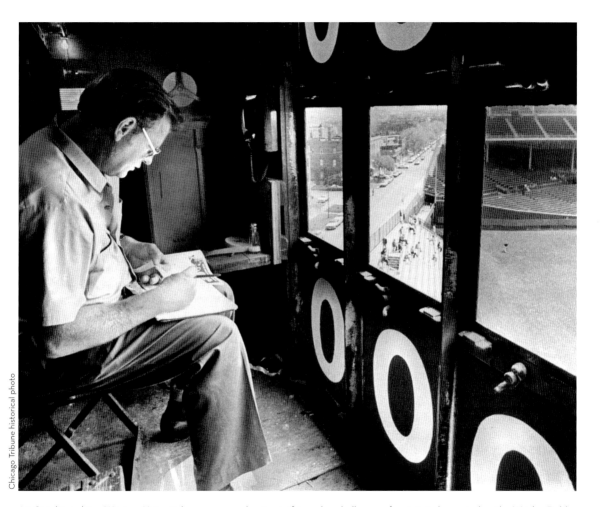

Art Sagel translates Western Union ticker messages about out-of-town baseball games for stats to be posted on the Wrigley Field scoreboard in 1977. *#westernunion #friendlyconfines #wrigley #1970s*

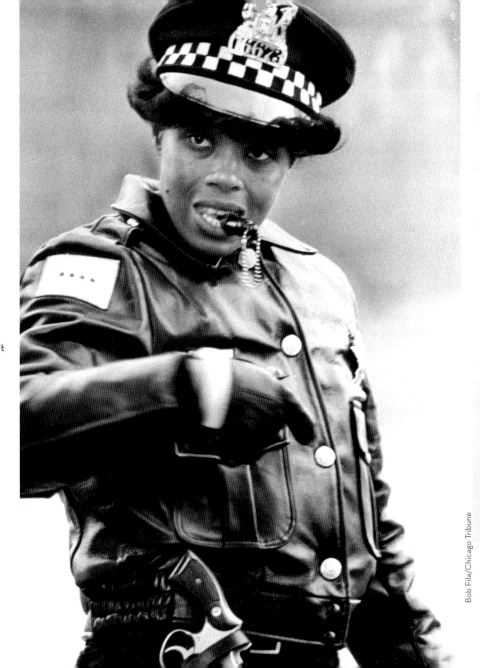

Dorothy Campbell, a Chicago police recruit, directs traffic at Michigan Avenue and Balbo Drive in March 1977. **#1970s #trafficduty #cpd #donteventhinkaboutit**

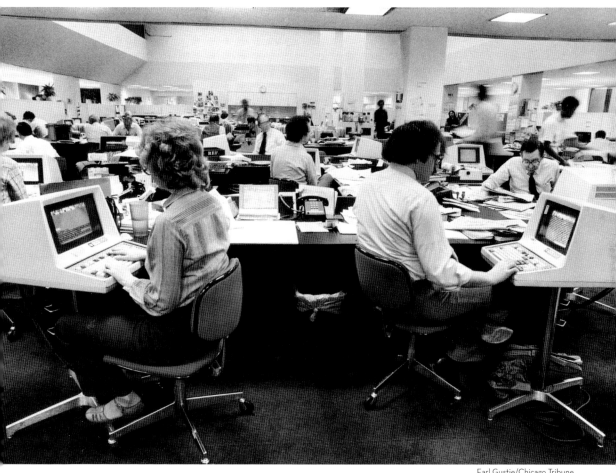

Copy editors work on video display terminals in the city room of the Chicago Tribune in 1981. The terminals were so large that they often had their own moveable stands. **#VDTs #hightech #oldschool #chitrib**

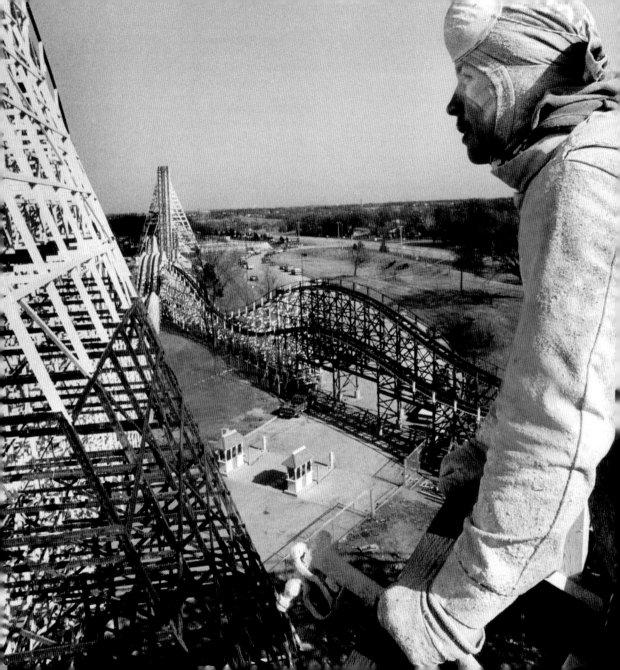

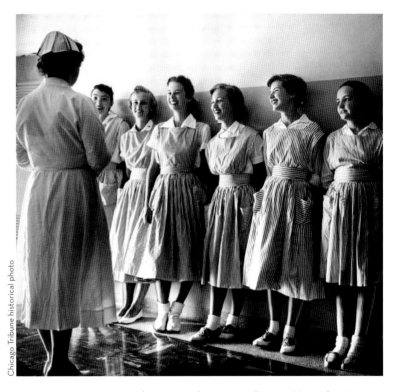

Margaret Armstrong assigns duties to candy stripers at Evanston Hospital on Aug. 22, 1956. **#bobbysoxers #evanston #candystripers #smilesallaround**

◄ Jerry Stockdale takes a break from painting the American Eagle roller coaster at Great America in Gurnee in April 1981. More than 9,000 gallons of white paint spruced up the ride before the season opener in May. **#justatouchup #coasting #1980s #whatajob**

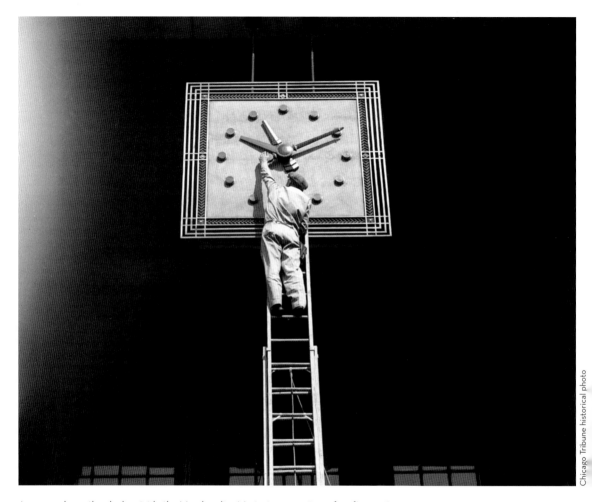

A man works on the clock outside the Merchandise Mart, circa 1941. **#merchandisemart**

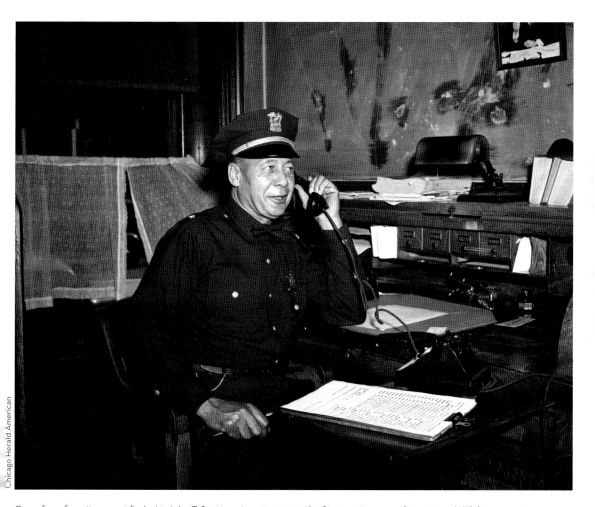

One of our favorite recent finds: Lt. John T. Scott on Aug. 8, 1940, at the Stanton Avenue police station. With his promotion to captain later that year, Scott was the first African-American to hold that rank in the Chicago Police Department and one of only two African-Americans in the country promoted to that rank prior to 1950. **#chicagopolice #cpd #africanamericanfirsts #chicagopd #johntscott #amazingfind**

The Abbott Dancers at Chicago's Palmer House in 1942. The troupe performed in the Palmer House's Empire Room for 24 years. **#dancers**

Chicago Tribune historical photo

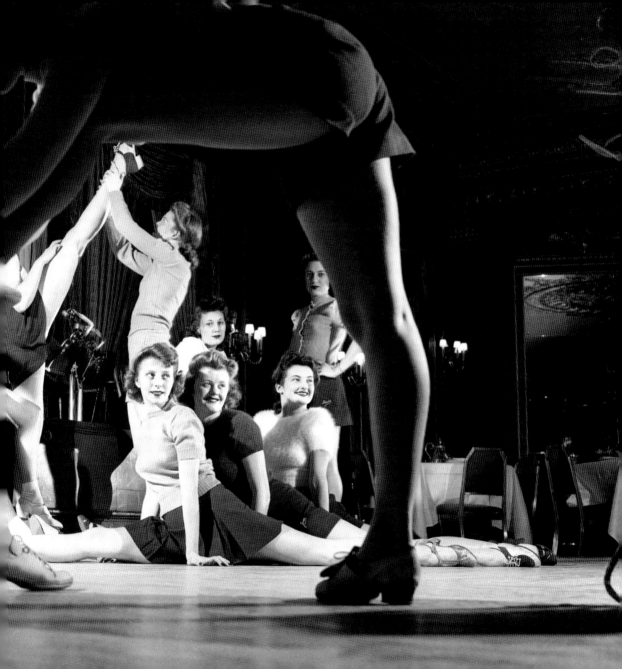

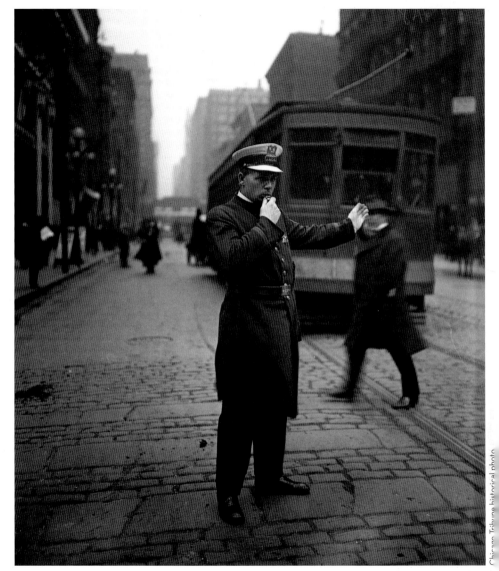

Chicago
police Officer
Kopitke directs
traffic in this
undated photo.
#earlychicago
#cpd #trafficcop
#streetcars

Chicago Tribune historical photo

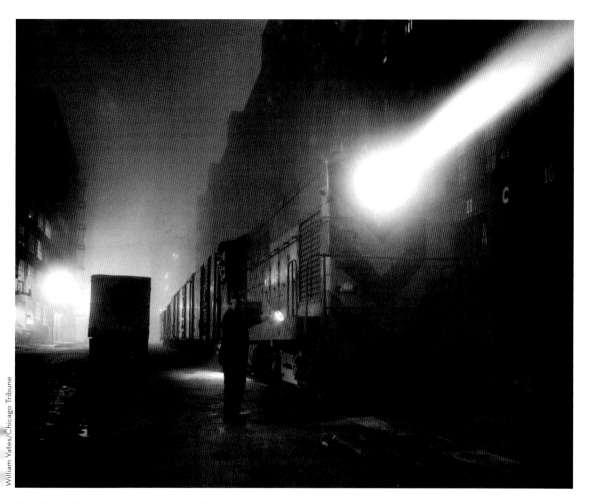

William Yates/Chicago Tribune

Pete Finn, a Chicago and North Western railroad brakeman, swings his lantern in dense fog in February 1955 to signal a train crew along Illinois Street east of St. Clair Street. **#streeterville #1950s #foggy**

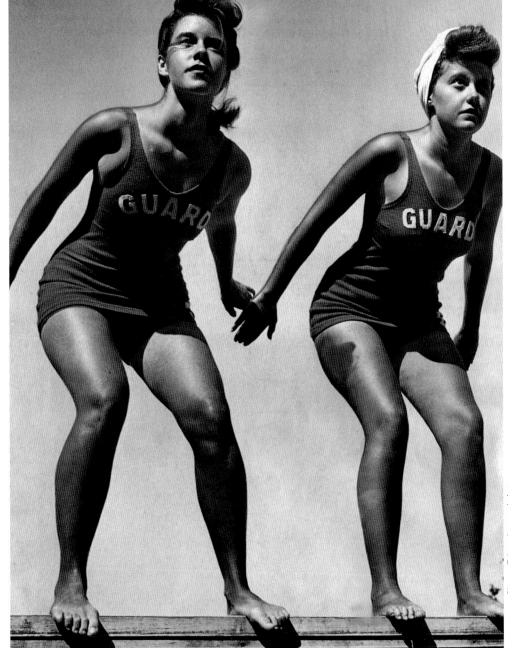

The only
all-female
lifeguard
crew in the
Chicago
area in 1933
worked in
Wilmette.
#lifeguards
#whatapair
#savinglives

Chicago Tribune historical photo

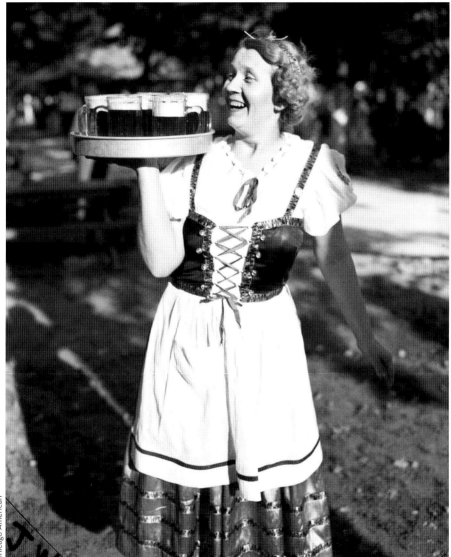

Herta Hadeler, an immigrant from Germany, carries beer at the German picnic at Riverview Park on July 30, 1939, in Chicago. **#germanpicnic #riverviewpark #chicagoimmigrants #oktoberfest**

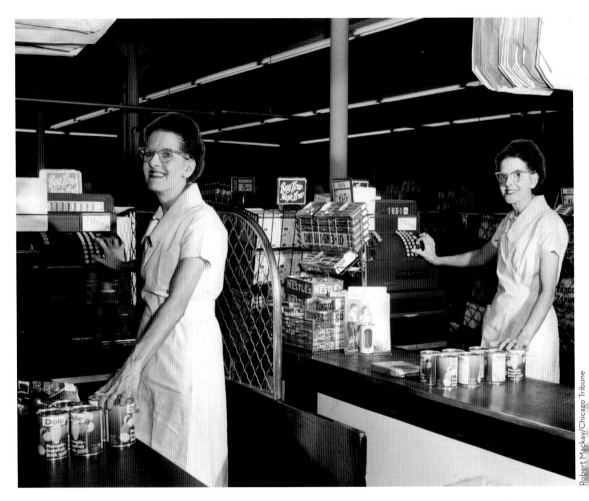

Marge Mielke, left, and her twin sister, Maria, are twin cashiers at adjoining checkout counters at the High-Low Food store at 2000 N. Harlem Ave. in Elmwood Park in 1958.

CHICAGO AT PLAY

THE CITY COMES ALIVE

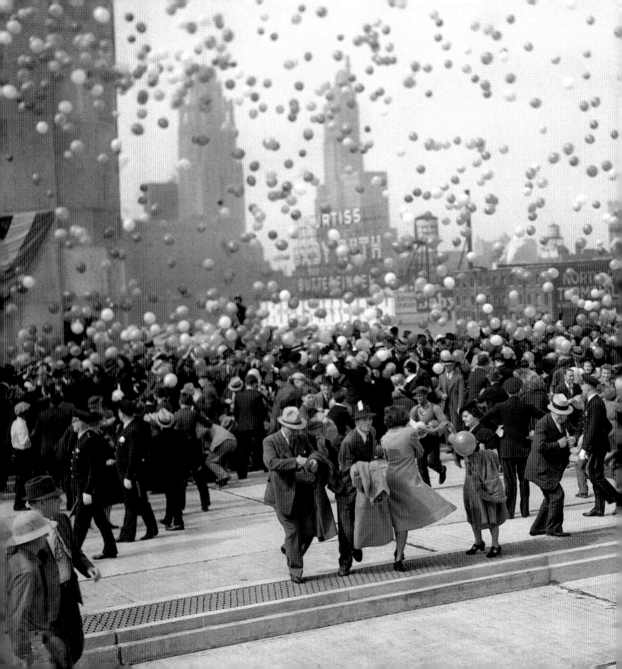

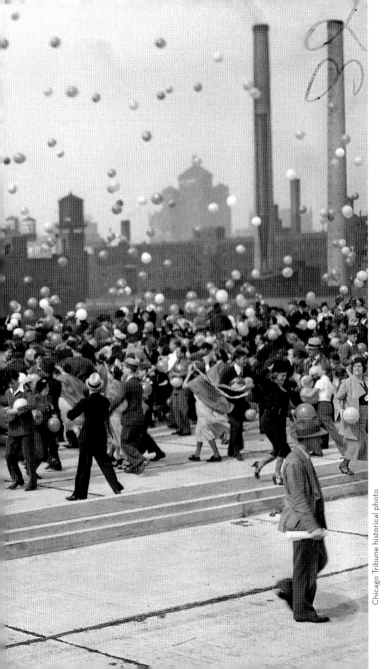

Chicago Tribune historical photo

A magical shot: Thousands attend the opening of the Outer Drive Bridge on Oct. 5, 1937. President Franklin Roosevelt dedicated the bridge, also known as the Link Bridge, in a civic bash the likes of which Chicago had seldom seen. **#outerdrive #lakeshoredrive #linkbridge #FDR #chicagoknowshowtoparty**

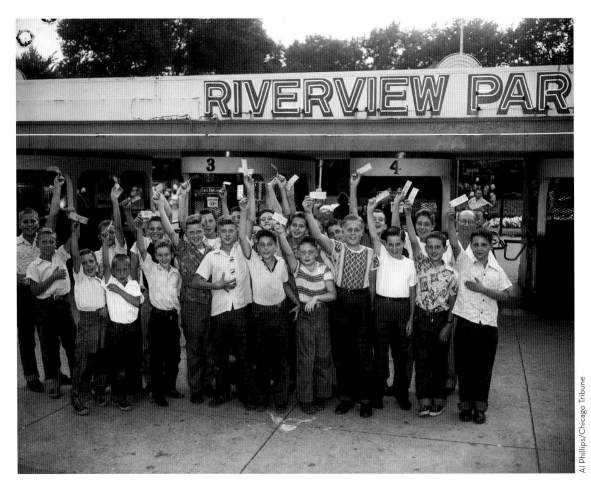

Chicago American news carriers wave tickets for free rides at the entrance to Riverview Park on Aug. 15, 1955. Riverview was one of the great urban amusement parks, opening in 1904 at Western and Belmont avenues on the Northwest Side, and closing in 1967. It featured what some insist was the finest roller coaster of all time, The Bobs. Other popular coasters were The Comet, The Silver Flash, The Fireball and The Jetstream. Aladdin's Castle was a classic fun house with a collapsing stairway and mazes. **#riverviewpark #chicagoamerican #newspaperboys #riverview #amusementpark**

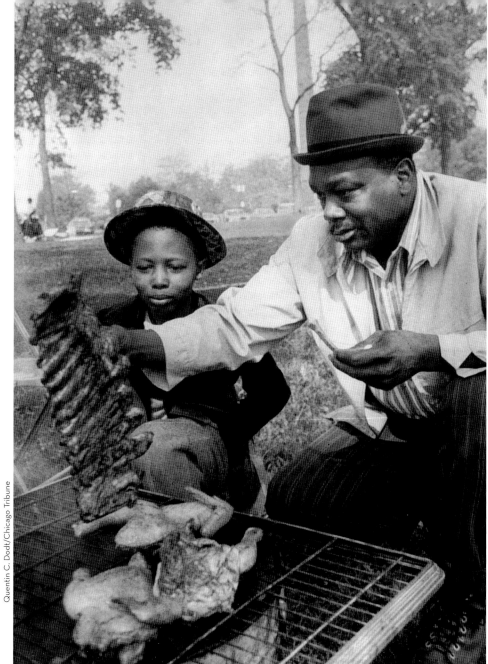

Charlie Toney
and his son
James, 8, cook
chicken and
ribs across from
Lincoln Park
Zoo in May
1973. **#bbqing**
#lincolnparkzoo
#parklife
#chicagoparks
#bbq

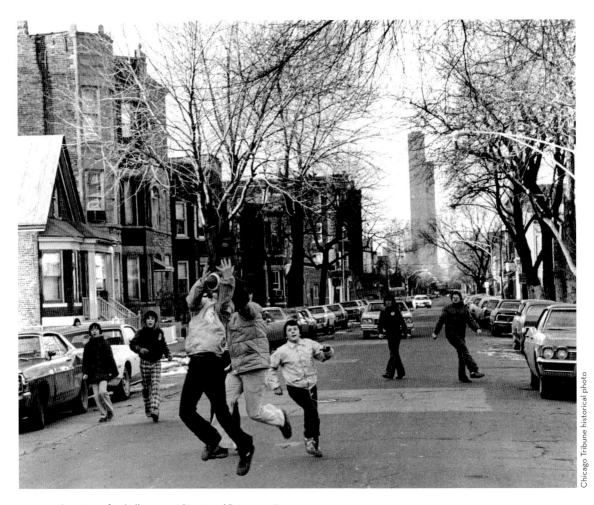

A group plays street football near 31st Street and Princeton Avenue in 1977.
#chicagoneighborhoods #spring #chicagoweather #streetismyplayground #1970s

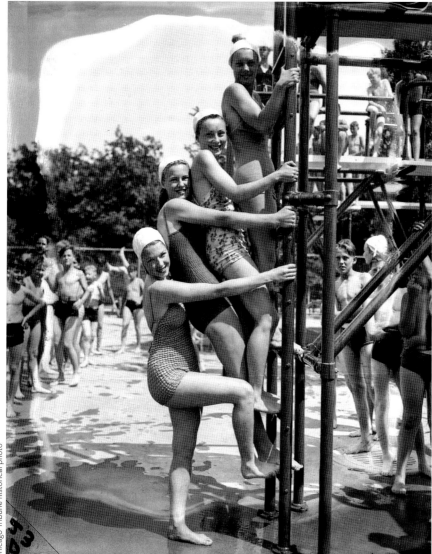

Annette Waddington, from top to bottom, Norma Koerpelson, Lois Clineman and Patricia Kelley are ready for the high dive at Whealan Pool on July 1, 1939. **#vintageswimwear #chicagoparkdistrict #chicagopools #chicagosummer**

A recent glass-plate negative find: Reri the Hawaiian dancer in 1932. **#hawaiiandance #lakemichigan #chicagosummer**

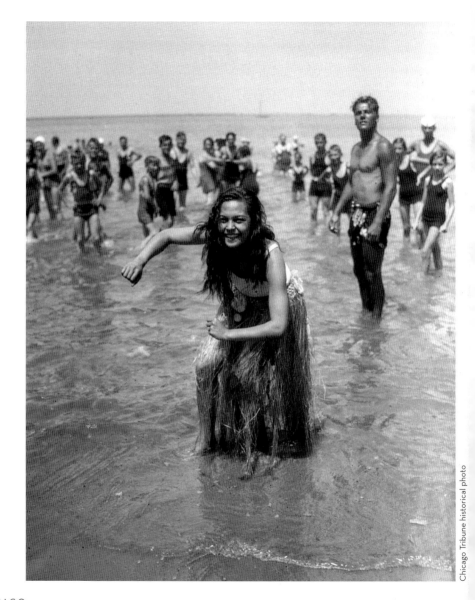

Chicago Tribune historical photo

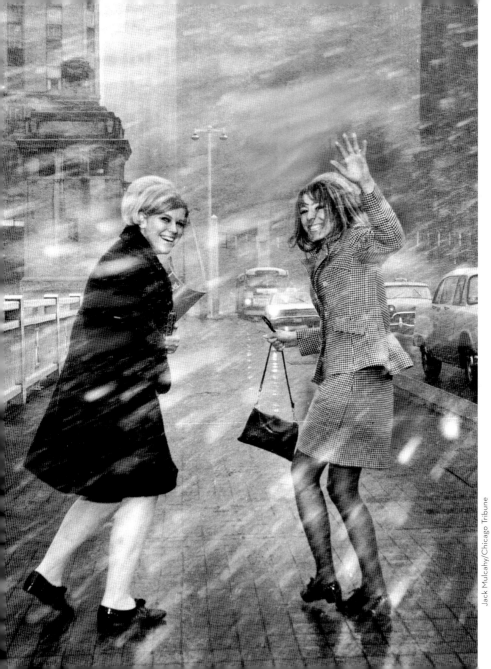

Two women
are caught in a
heavy snowfall
April 24, 1968,
on the Michigan
Avenue Bridge.
#michiganave
#chicagoweather
#chicagosnow
#springsnowstorm

Jack Mulcahy/Chicago Tribune

173

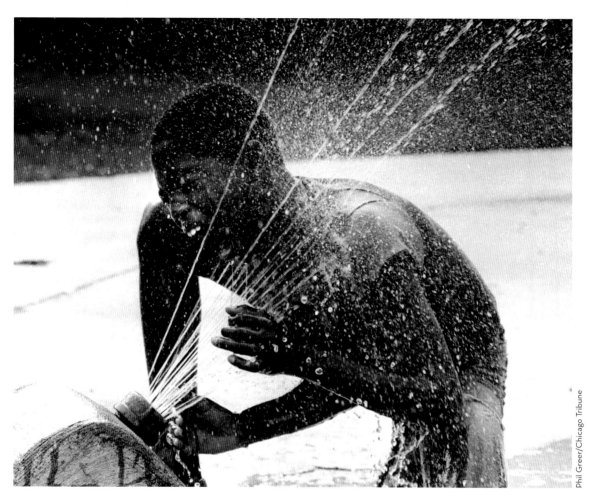

Phil Greer/Chicago Tribune

Jelani Woods faces off with a fountain in O'Hallaren Park at 83rd and Honore streets in September 1985.
#auburngresham #southside #1980s

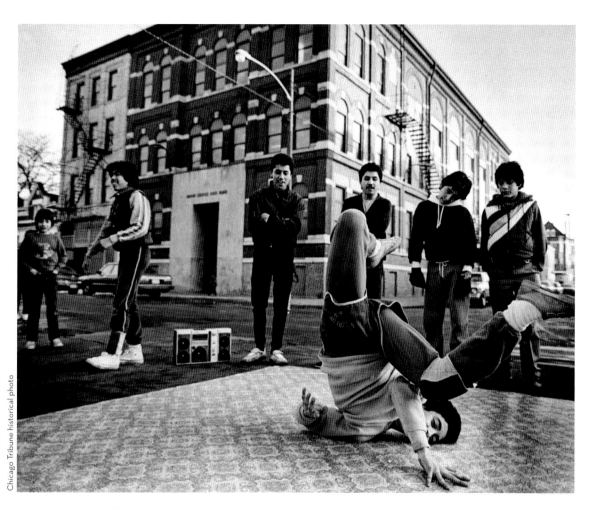

Aww-yeah! Members of the Floor Masters do head spins and pop locks while break dancing in 1984.
#breakdancing #the80s #chicagodance #dotrythisathome #icandothat

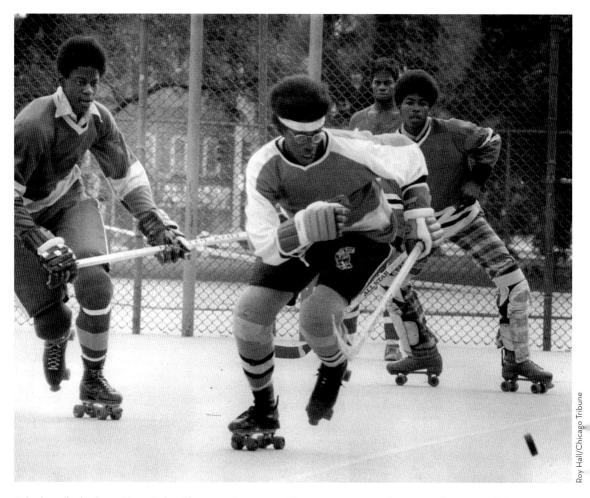

Kids play roller hockey at Union Park in Chicago on Sept. 9, 1973. The team names were the Los Angeles Kings and the Philadelphia Flyers. **#unionpark #rollerhockey #hockey #1970s**

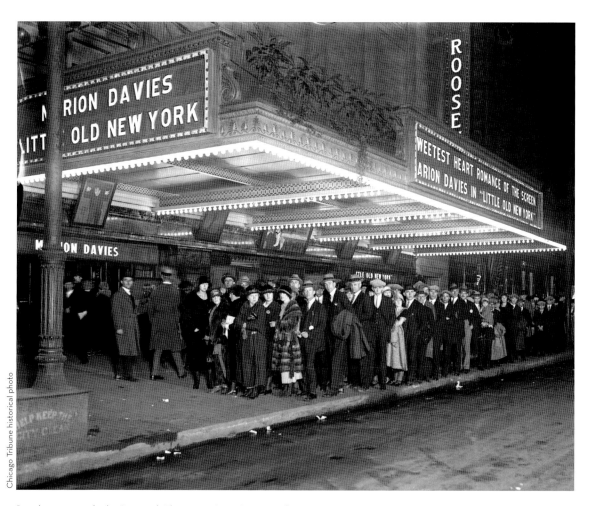

People wait outside the Roosevelt Theatre on State Street in Chicago in 1923 to see actress Marion Davies in the movie "Little Old New York." Block 37 now occupies the site. **#chicagohistory #roosevelttheatre #statestreet #theaterhistory #block37**

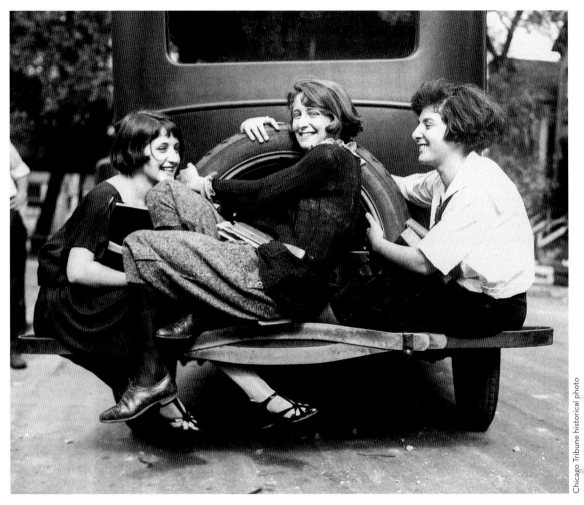

Chicago Tribune historical photo

Three girls steal a ride on the bumper of a car during the streetcar strike of 1922. **#vintagecars #theroaring20s #donttrythisathome**

Mr. and Mrs.
Bimner arrive at
a 1931 charity ball
at the Chicago
Auditorium.
#makeanentrance
#stylish
#highsociety
#1930s

Joe Louis' South Side admirers swarm over a streetcar in celebration of the crowning of the first African-American boxing champion since Jack Johnson in 1937. Louis had just won the famous match against James Braddock.
#vintageboxing #joelouis #jackjohnson #jamesbraddock #jimbraddock #chicagoboxing #worldchamp

▶ Time to wake up: The renowned Abbott Dancers of Chicago's Palmer House form a human clock in 1933. **#abbottdancers #palmerhouse #itsabouttime #1930s**

Chicago Herald and Examiner

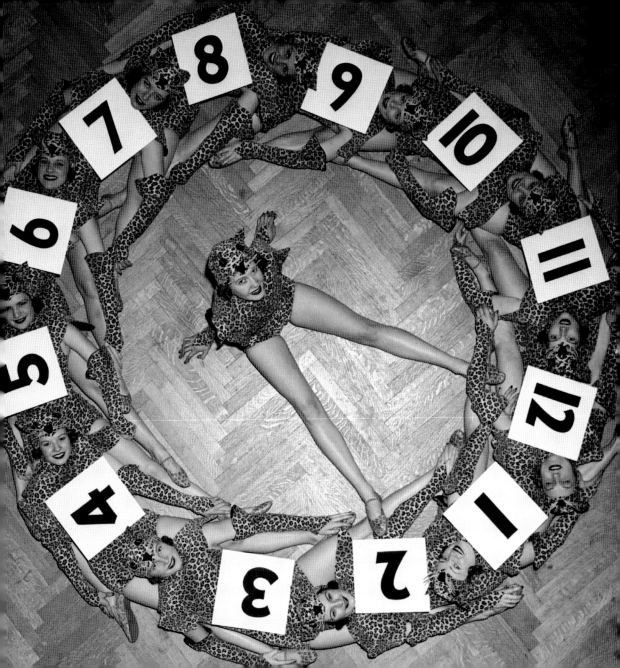

Ann Gerry appears to sleep in the arms of Mike Gouvas in January 1931. They were one of two couples who had been dancing for more than 500 hours without a rest at the White City Amusement Park. **#marathon #dancehistory #1930s**

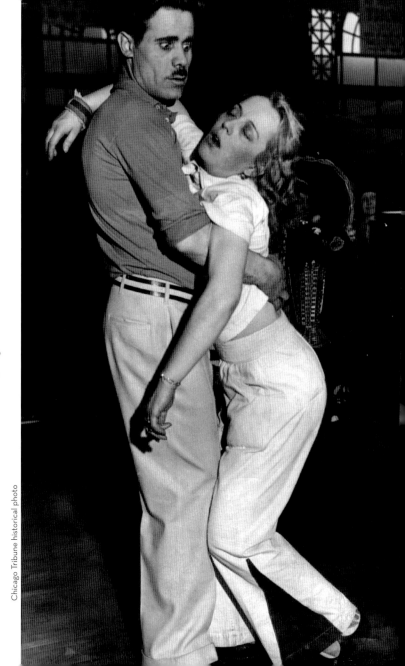

Chicago Tribune historical photo

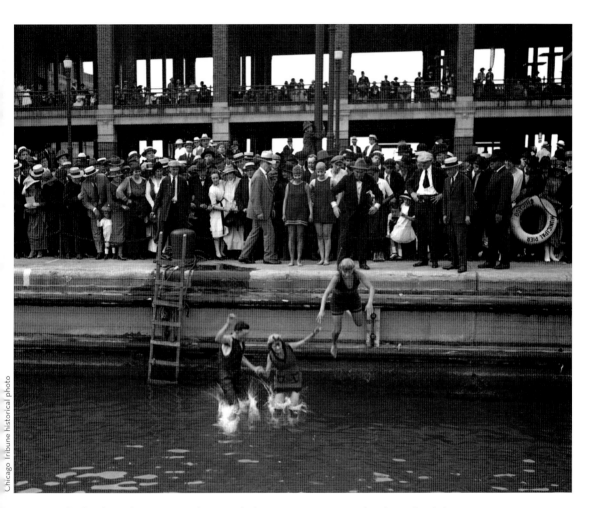

Swimmers take the plunge during Municipal Pier's early days as an amusement park in this undated photo. The pier is now called Navy Pier. *#navypier #municipalpier #lakemichigan #chicagosummers*

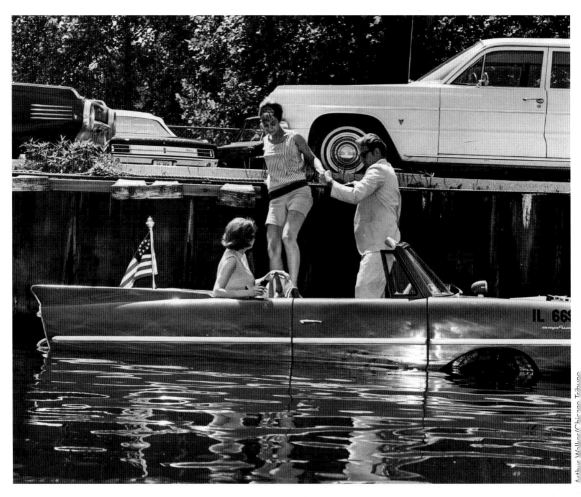

Amphicar club member Bud Buetler helps Harriet Leff jump aboard his craft in 1965. Already seated was Susan Colitz of Skokie.
#amphicar #1960s #nicefins #thewaterisfine

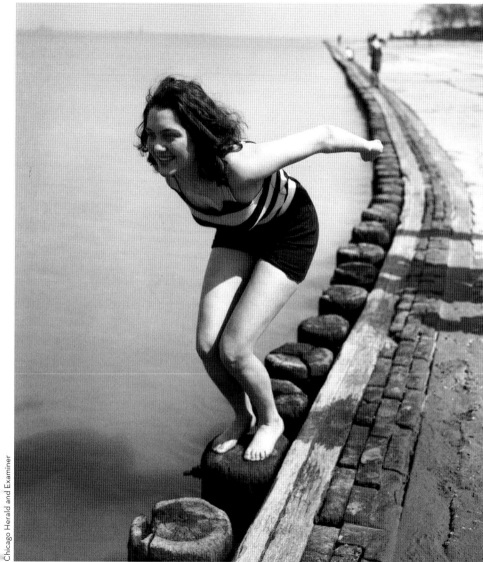

The only information provided for this 1929 photo is: "Joan Hagen, girl art student at the Art Institute." **#artinstitute #lakemichigan**

Setting their courses for Mackinac Island, Great Lakes yachtsmen maneuver for advantageous positions July 29, 1975, as the Chicago-to-Mackinac race begins. A fleet of 236 yachts competed. **#racetomack #chicagosailing #lakemichigan**

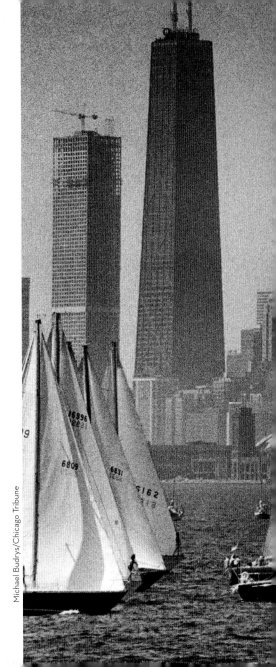

Michael Budrys/Chicago Tribune

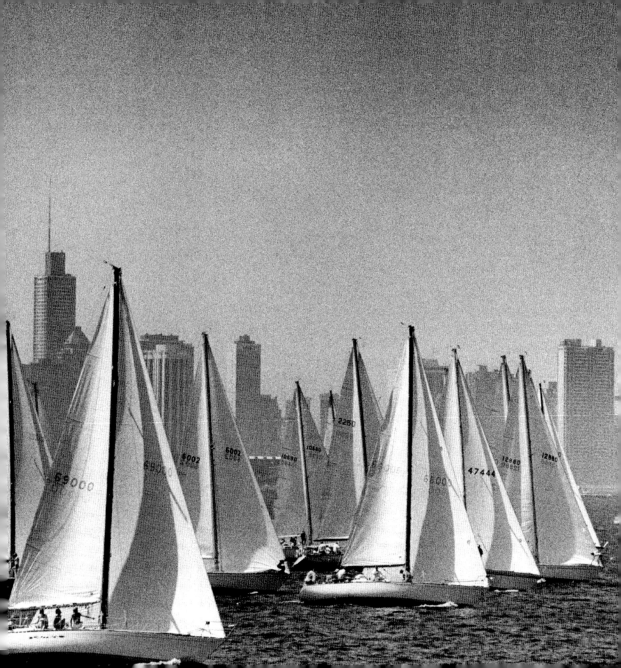

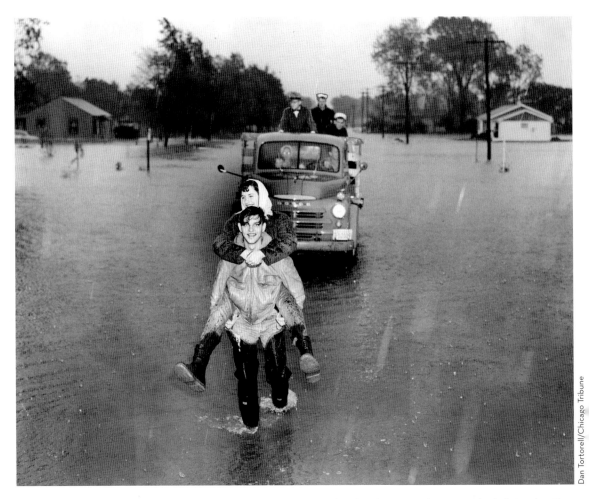

B. A. Mylosh carries his wife to a dry spot on 119th Street on Oct. 10, 1954, after their home at 118th Street and Pulaski Road in Alsip was flooded. **#alsip #rain #flooding #chicagoweather**

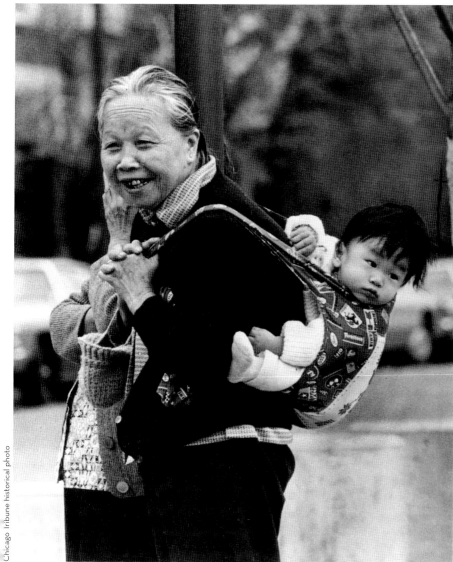

A woman carries a baby on her back in Chinatown in 1981. **#chinatown #babysack #babywearing**

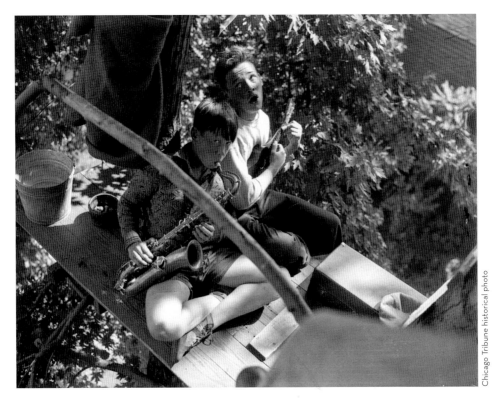

Jack Harris, 10, left, and Truman "Pat" Kirkpatrick, 16, play music in their tree fort as they compete for a tree sitting endurance record in July 1930. The boys ended their record attempt July 15, 1930, at the request of their parents after having spent 115 hours in an oak tree in Truman's backyard at 608 Belleforte Ave. in Oak Park. They each had earned $4.50. **#oakpark #oakparkhistory #treesitting #endurancecontest #depression #1930s**

▶ Doris Brosnan, of Chicago, eats while trying to set a record for the longest time spent sitting on a flagpole in 1927. Yes, this was actually a pastime. **#flagpolesitting #treesitting #endurancecontest #musthavebeenbored**

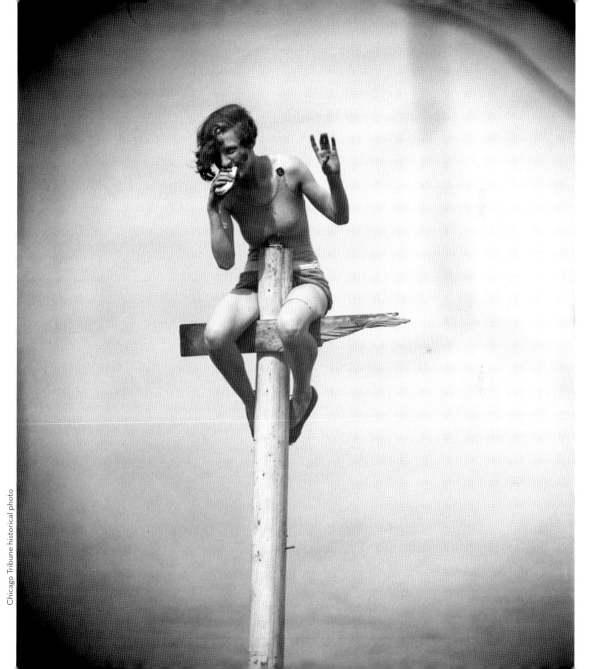

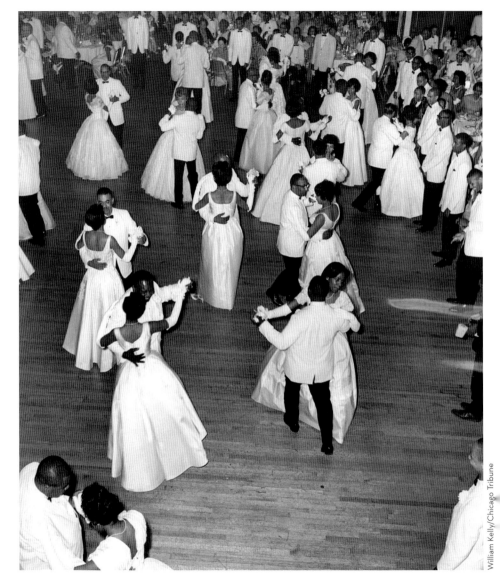

Debutantes dance with their fathers at the Links Cotillion in the Grand Ballroom of the Palmer House in June 1964. **#debs #shallwedance? #1960s #palmerhouse**

William Kelly/Chicago Tribune

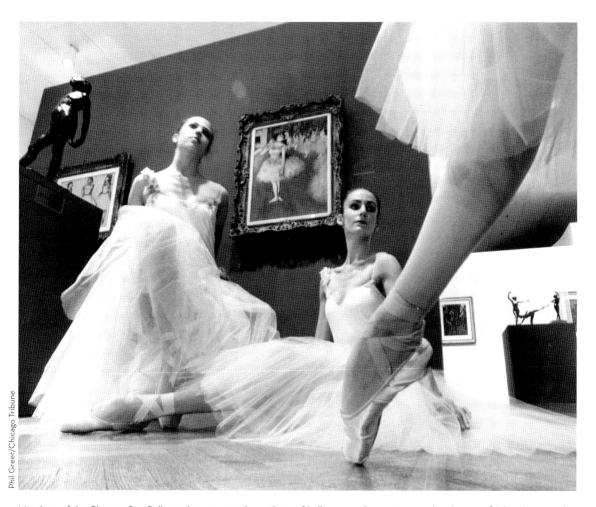

Phil Greer/Chicago Tribune

Members of the Chicago City Ballet strike poses similar to those of ballerinas in the paintings and sculptures of Edgar Degas at the Art Institute of Chicago in 1984. **#ballet #degas #artinstitute #strikeapose #1980s**

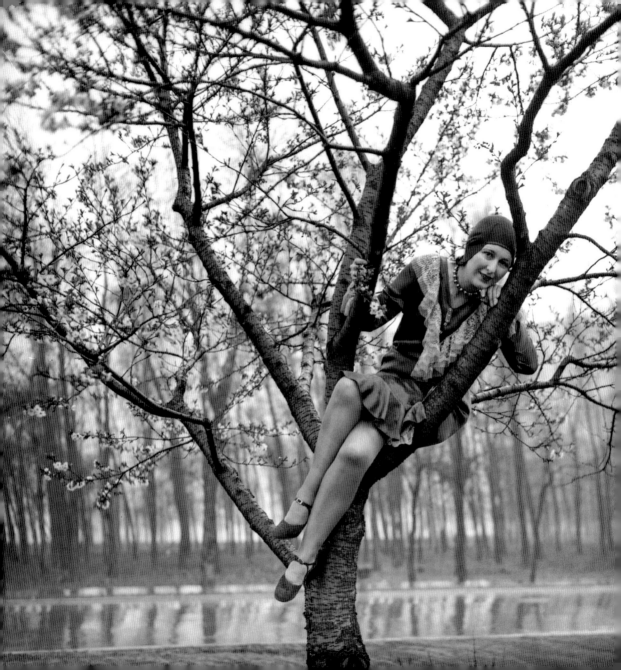

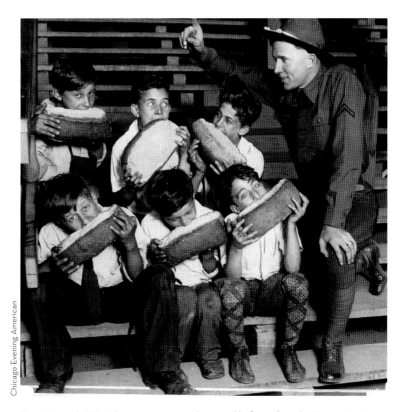

Counting carbs? Not these young men, who posed before a bread-eating contest during a military exposition at Soldier Field in June 1930. Cheering on the boys was Lance Cpl. Charles Houk. **#soldierfield #doughboys #competitiveeating #1930s**

◀ Bess Mullen sits in a cherry tree at 71st Street and Central Park Avenue in Marquette Park in 1929. **#cherrytree #marquettepark #chicagoparkdistrict #chicagoparks**

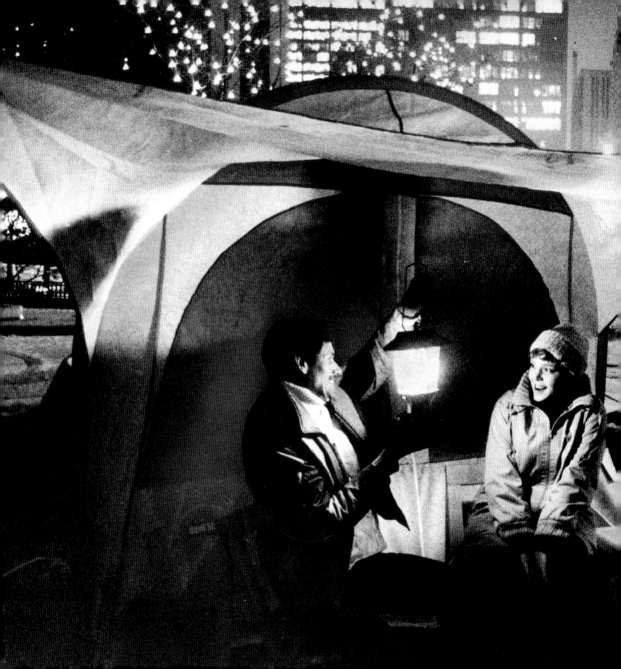

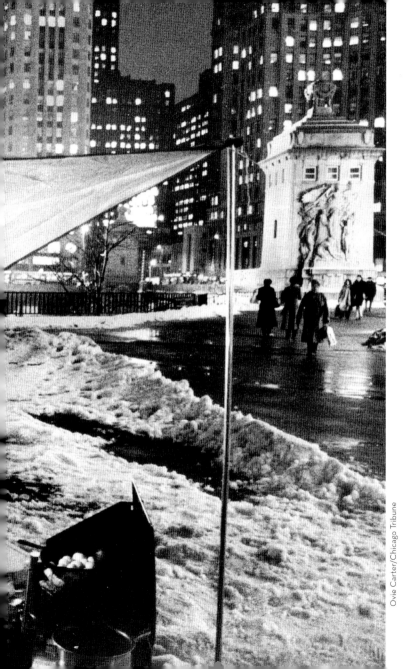

In 1980, Mike and Rhonda Toppel talk by the glow of their lantern as they camp out in Pioneer Court on Michigan Avenue to promote the Chicago Boat, Sports and RV show. **#greatoutdoors #boulmich #pioneercourt #camping #1980s**

Ovie Carter/Chicago Tribune

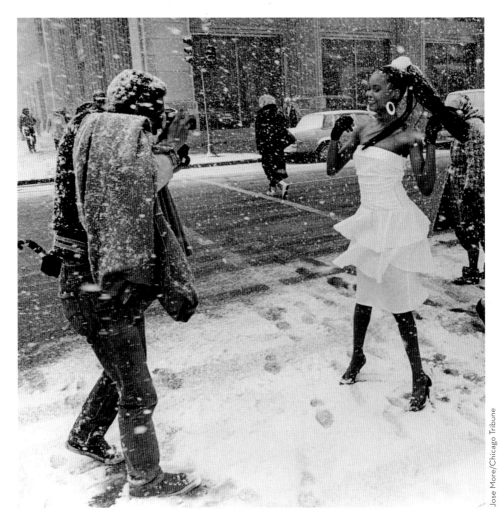

Photographer Paul Mainor makes fashion shots in flurries as model Sherry Lewis braves the cold in April 1987.
#chicagoweather #aprilflurries #1980s #gettheshot

Jose More/Chicago Tribune

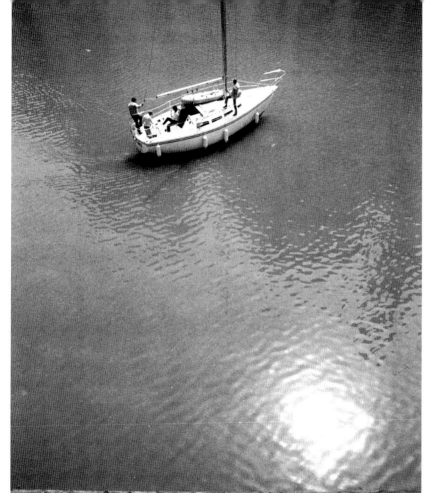

A sunbather bares his chest to the sky in April 1983 while a sailboat and its crew drift on the Chicago River, waiting for the Michigan Avenue Bridge to be raised. **#relaxin #1980s #ontheriver**

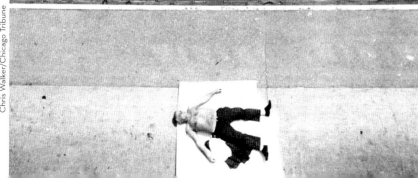

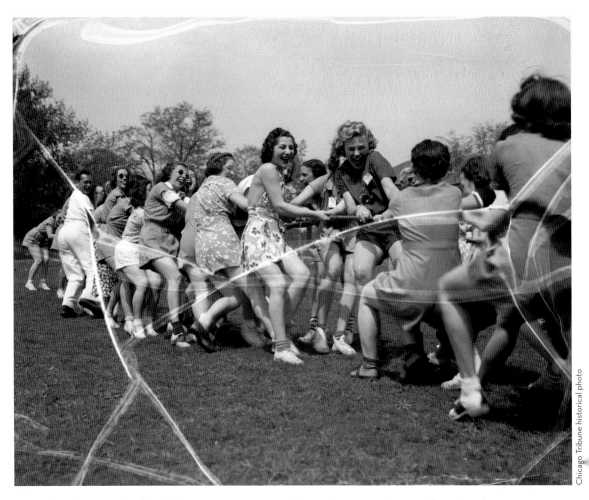

Women from the National College of Education compete in a tug of war May 3, 1938, in Evanston. The college, for young women who wanted to teach early education, was renamed National Louis University in 1990. Note the heat damage to the negative.

#evanstonhistory #evanston #nationalcollegeofeducation #nationallouisuniversity #teachingcollege #tugofwar #summerfun

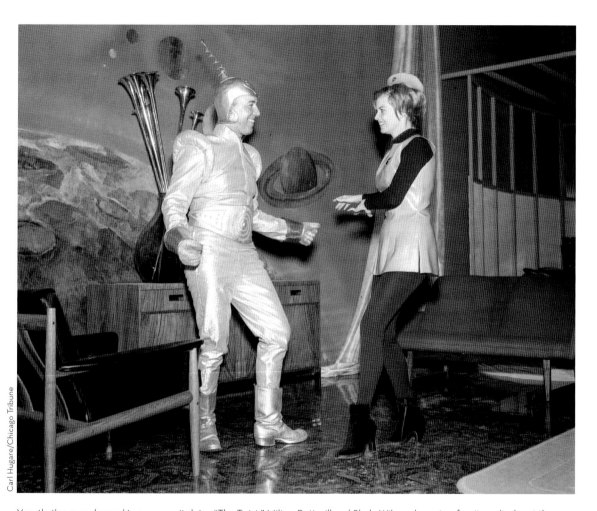

Carl Hugare/Chicago Tribune

Yup, that's a man dressed in a spacesuit doing "The Twist." Milton Botterill and Shela Wilson dance in a furniture display at the Merchandise Mart in 1962. **#merchandisemart #vintagespace #spacerace #thejetsons**

Dancers Del Mar and Renita demonstrate "Ouch, the Senorita Polka" in August 1944. The two created the dance and showed it off at the Chicago National Association of Dance Masters. The dance allegedly combined Spanish steps with polka. **#alltherightmoves #dancefever #ouch #1940s**

Attendees dance away the blues at the second annual Chicago Blues Festival in June 1985. **#bluesfest #1980s #grantpark #chicagoblues**

Michael Budrys/Chicago Tribune

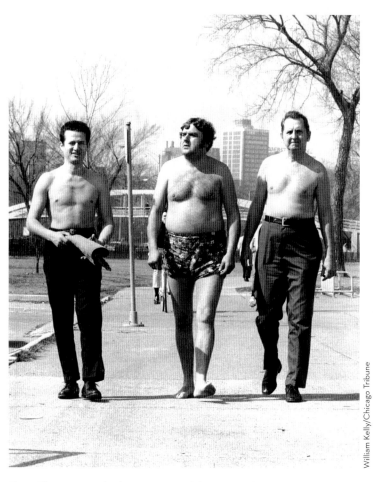

William Kelly/Chicago Tribune

Three Chicagoans go shirtless in unseasonably warm weather March 11, 1972.
#sunsoutgunsout #daring #1970s #chicagoweather

▶ Second-grade students from Lace Elementary School in Darien crawl on a jungle gym nicknamed "the dome" in 1985. **#gymtastic #hive #playgrounds #1980s**

James Mayo/Chicago Tribune

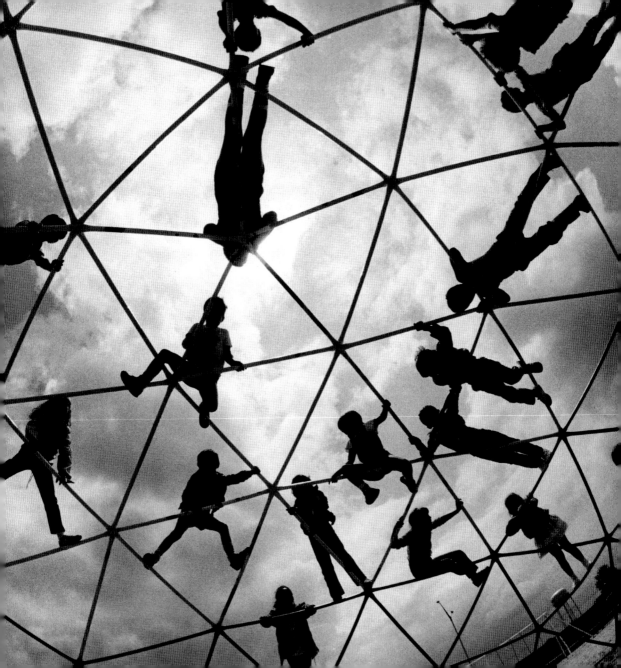

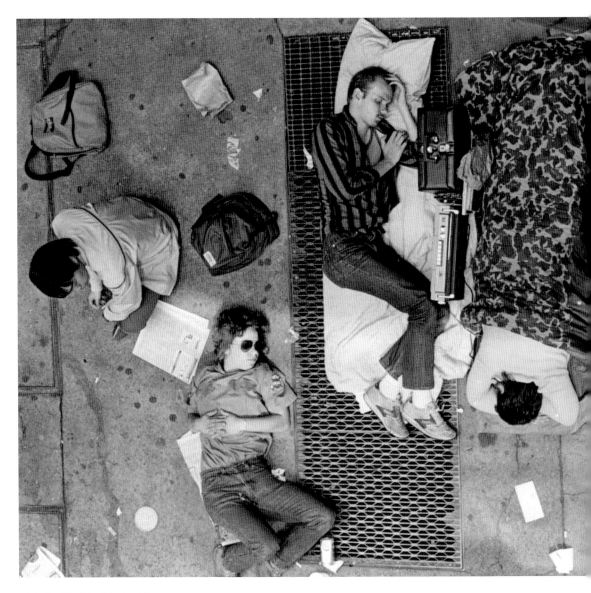

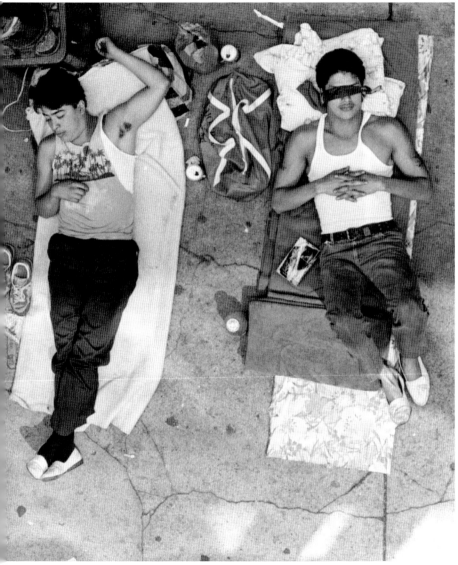

Bruce Springsteen fans camp out waiting for tickets to go on sale at a Loop ticket location in July 1985. **#theboss #springsteen #beforeonlinepurchase**

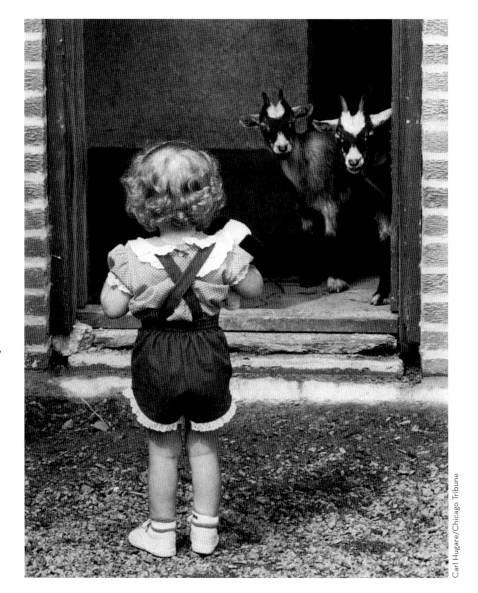

Becky Sebert, 2, visits the newly reopened Indian Boundary Park Zoo at 2500 W. Lunt Ave. on Aug. 13, 1985. **#getyourgoats #1980s #indianboundary #ohyoukids**

Carl Hugare/Chicago Tribune

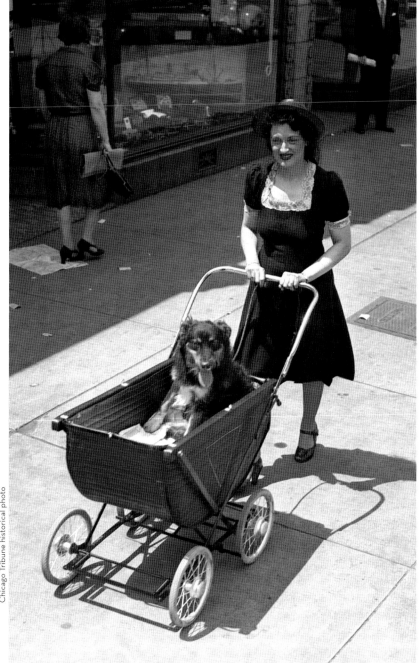

Dorothy Eagles gives a dog a ride in a baby carriage at 4506 N. Broadway in Chicago in the summer of 1941. The Tribune reported this account of how the dog got in the carriage: "The plight of one dog, a black collie, was reported to Mrs. Dorothy Eagles, founder of the shelter, and she spent four days trying to catch him, finally accomplishing it by borrowing a baby buggy and wheeling it through Lincoln Park because she saw that the bewildered animal tried several times to attach himself to nursemaids wheeling baby carriages." Eagles founded the North Side Animal Shelter. **#dorothyeagles #animalshelters #vintagepets #doginababybuggy #doglove #animalrights #chicagoshelters**

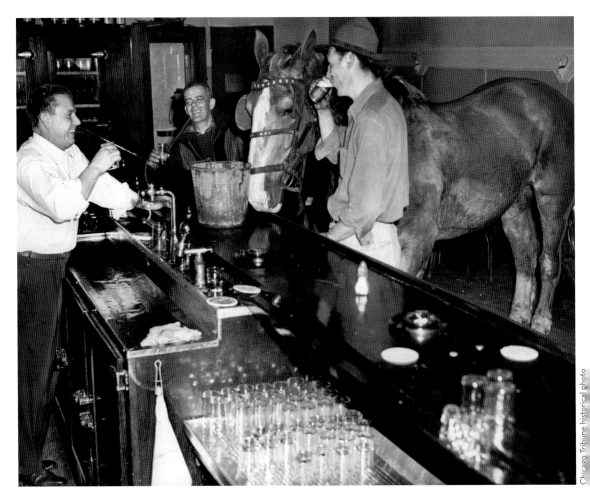

Hey, buddy, why the long face? Marshall Polo, right, in a tavern at 8901 Lowe Ave. on May 20, 1948, with his horse Admiral. Admiral, whose usual job was plowing the garden, received a bucket of water for refreshment. We presume that tavern owner Orval Hatton, left, provided Orville Rowe, rear, and Polo with something stronger. **#partyanimal #chicagotaverns #refreshments #acoldone**

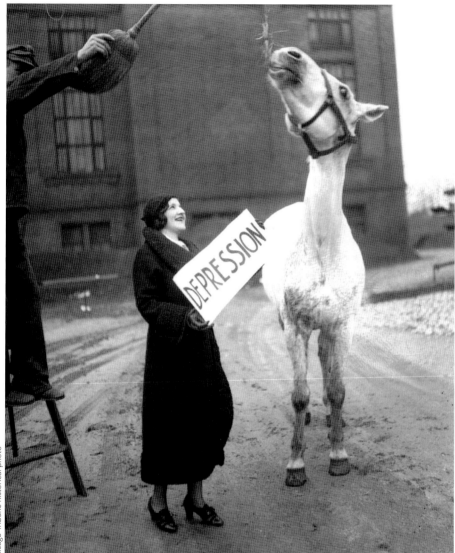

Frieda Friedman and
Mamie the horse at
South Park in 1932.
The original caption
says, "Horse laughs
at depression."
#ahorseofcourse
#horselaugh

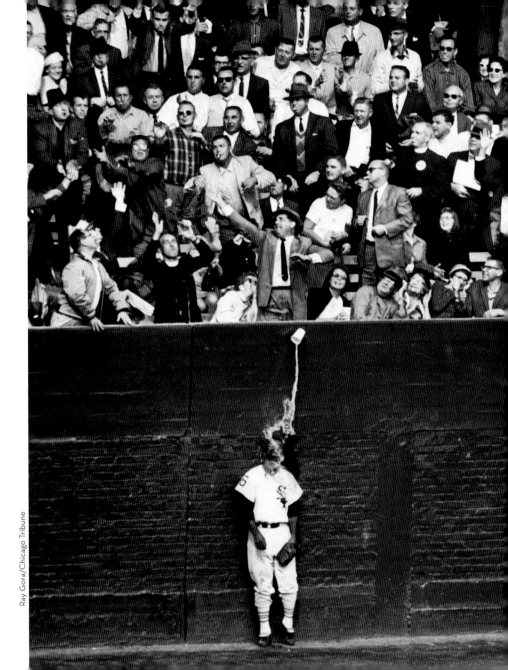

One of our all-time favorite images: White Sox left fielder Al Smith gets a beer bath while watching a ball hit by the Dodgers' Charlie Neal sail into the crowd during the second game of the 1959 World Series. **#beeroclock #gogosox #1950s**

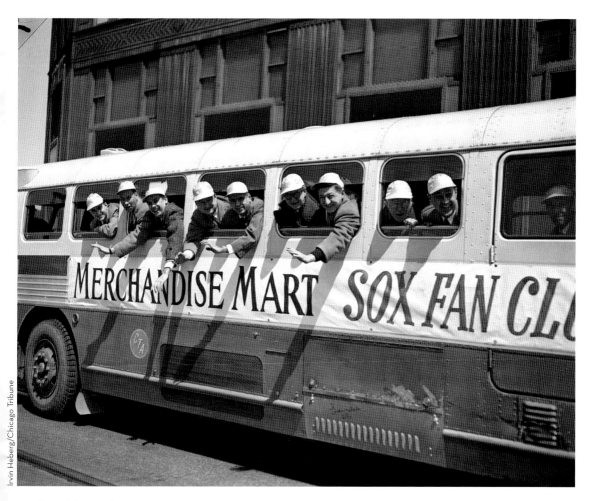

Members of the Merchandise Mart Sox Fan Club whoop it up as they leave for the opening game in April 1953.

#gogosox #chisox #mart #1950s

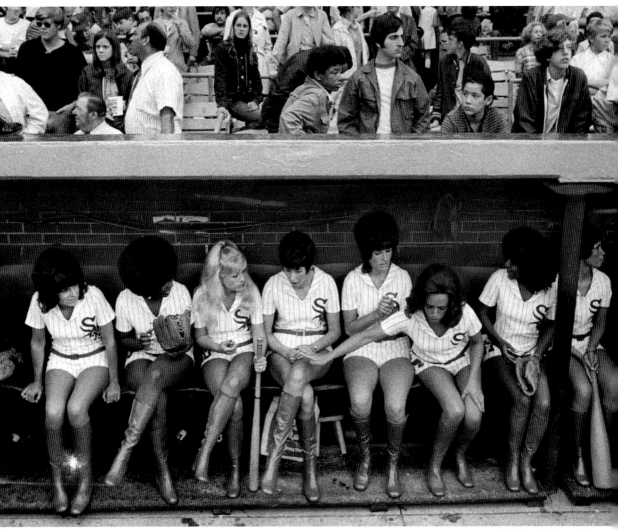

Wives of Sox players in the Comiskey Park dugout between games of a double-header against Oakland in June 1972. **#gogosox #1970s #comiskey #chisox**

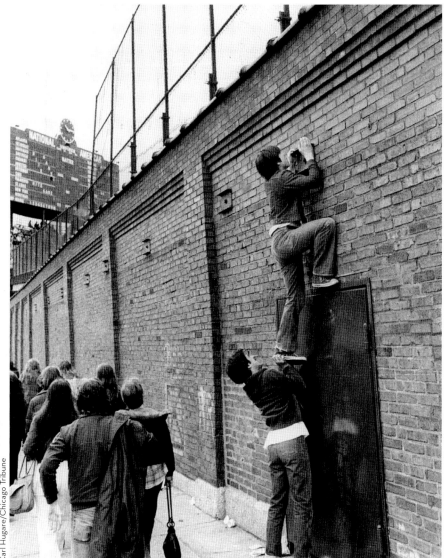

Cubs fans try to scale the wall of Wrigley Field on opening day April 14, 1978. **#gocubsgo #friendlyconfines #1970s #wrigley**

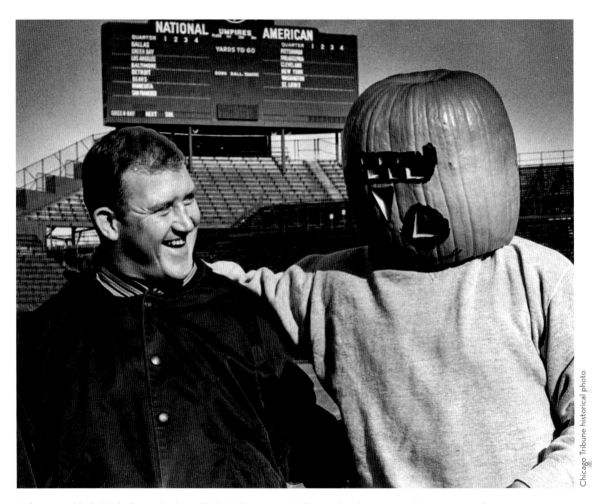

Defensive tackle Bob Kilcullen and tight end Mike Ditka, wearing Halloween headgear, pause during practice Oct. 26, 1965, in Wrigley Field as the Chicago Bears prepare to battle the first-place Green Bay Packers. **#vintagebears #wrigleyfield #chicagobears #mikeditka #bobkilcullen #goofinaround**

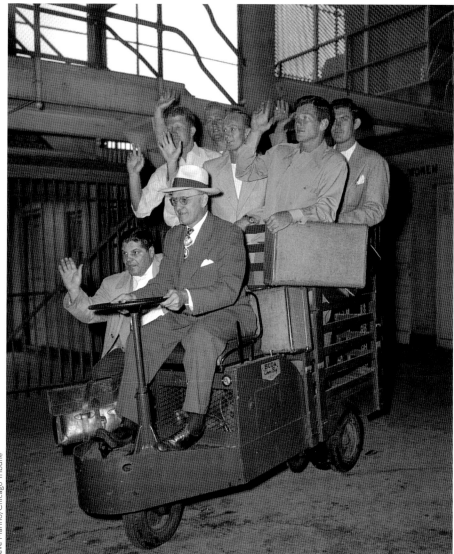

Members of the Chicago Bears leave for training camp Aug. 4, 1948, at Wrigley Field. Clockwise from center bottom are coach George Halas, Gene Ronzani, Joe Baumgardner, Bill Cromer, Joe Abbey, Allen Lawler and Jim Canady.
#chicagobears
#bearsfootball
#bearscamp
#bearshistory
#rookies

Jesse White stands ready to catch a tumbler from the Isham YMCA Boy Scouts during a show to call attention to the Lakeshore Park Air and Water Show, which was held at Chicago Avenue and the lakefront in 1974. **#chiairandwater #airandwatershow #lakemichigan #chicagosummer**

Mark Perlstein/Chicago Tribune

Mark Perlstein/Chicago Tribune

"I got it! I got it!": An anxious fan reaches for a foul ball during a July 1980 Cubs game against the Dodgers. He didn't catch it, BTW. *#gocubsgo #1980s #wrigleyfield #friendlyconfines*

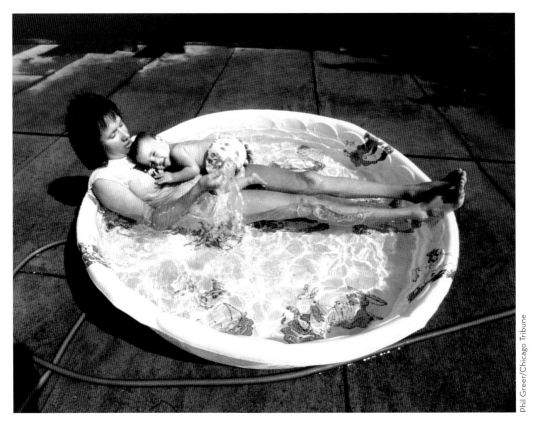

Becky Tomko and her daughter Bethany, 1, cool off in a small pool in the front yard of Tomko's apartment building in the 4900 block of North Magnolia Avenue in Uptown on Aug. 3, 1988. The temperature was 98 degrees at 10:30 a.m.
#chicagosummers #chicagoheat #heatwave #funinthesun

▶ OK, prepare yourselves for adorable: Children shade themselves with an umbrella at Chicago's 31st Street Beach in July 1936.
#31stbeach #chicagobeaches #1930s #summersgoneby

Chicago Tribune historical photo

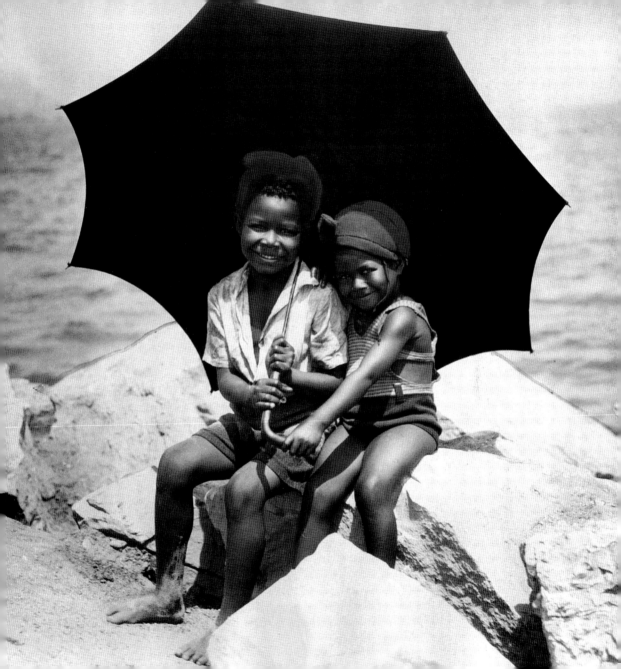

A referee is chased high onto the boards during a Stanley Cup game at the Chicago Stadium in 1962. Fighting for the puck are Reg Fleming (6) of the Blackhawks and Ron Stewart (12) of Toronto. **#chicagoblackhawks** **#vintagehockey** **#stanleycup** **#chicagostadium** **#blackhawkshockey**

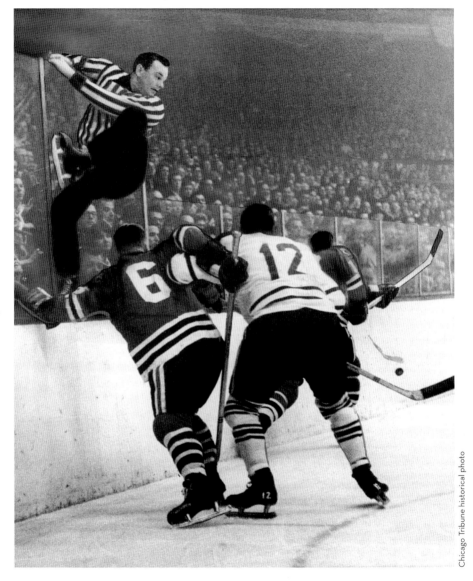

Chicago Tribune historical photo

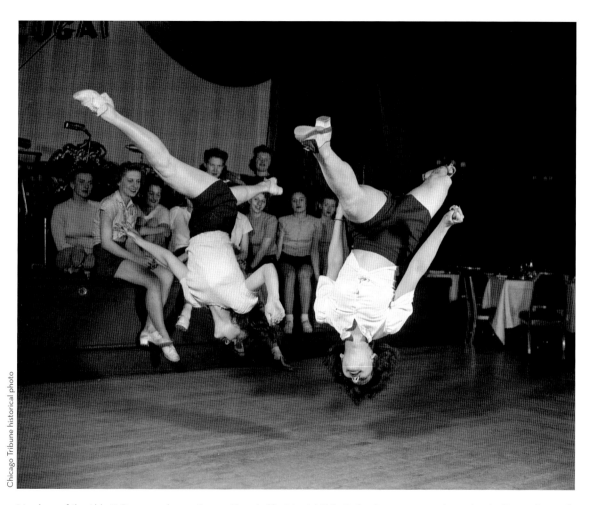

Members of the Abbott Dancers rehearse in 1942. Founded by Merriel Abbott, the dance group performed in the Empire Room of the Palmer House for 24 years. **#abbottdancers #hoofers #palmerhouse #chicagodance #jumpforjoy #empireroom**

Bess Mullen during the opening of golf season at Jackson Park in 1930. With Mullen is caddy Jack McAndrew.
#jacksonpark
#chicagogolf
#golfhistory

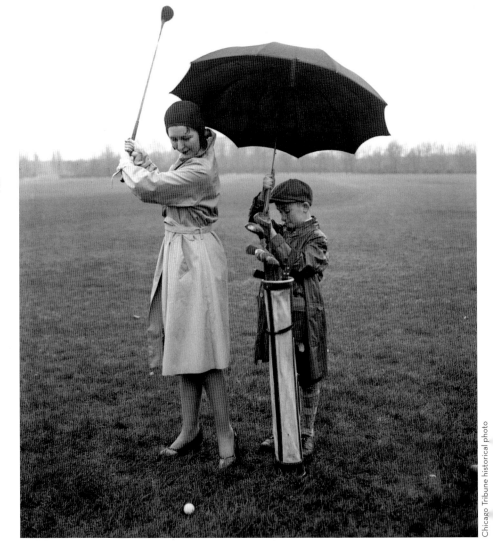

Chicago Tribune historical photo

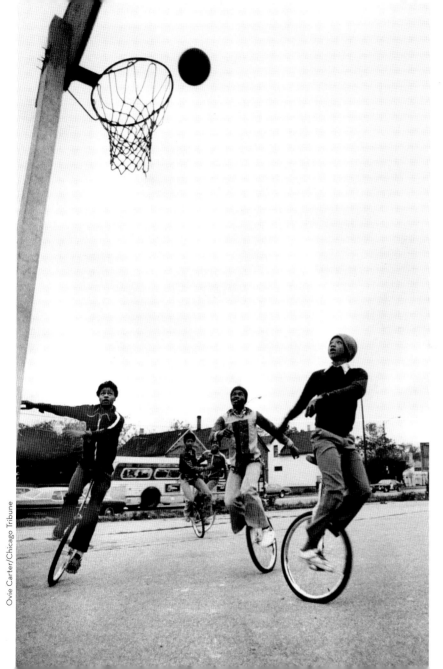

Teens, inspired by a unicycle act in the Ringling Bros. circus, practice in a South Side lot in 1976. **#cycling #onewheel #southside #1970s**

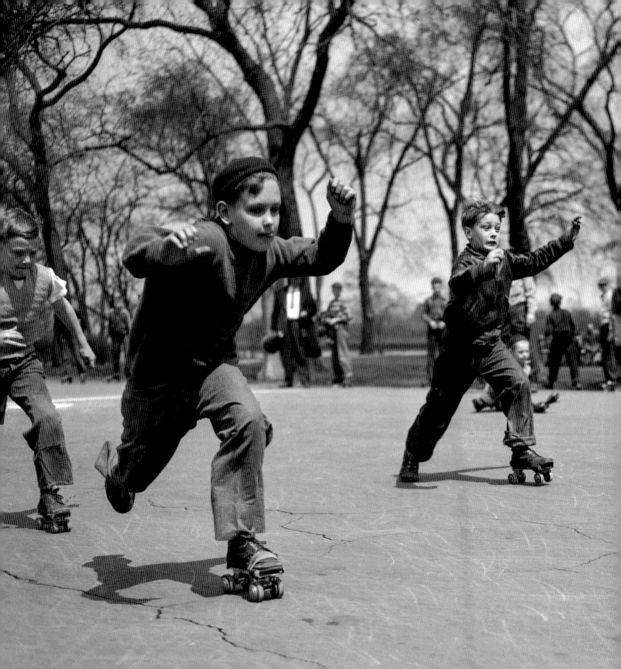

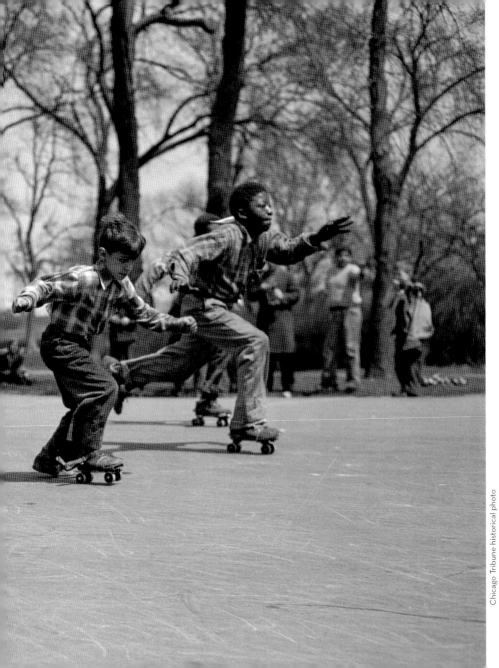

Boys compete in roller-skating races at Lincoln Park on April 25, 1950. **#rolling #lp #1950s #andtheyreoff**

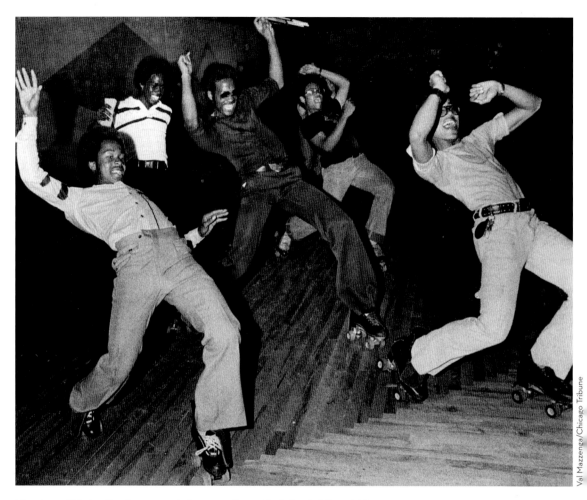

Men show off their roller disco moves in June 1979. **#1970s #hotwheels #disconights**

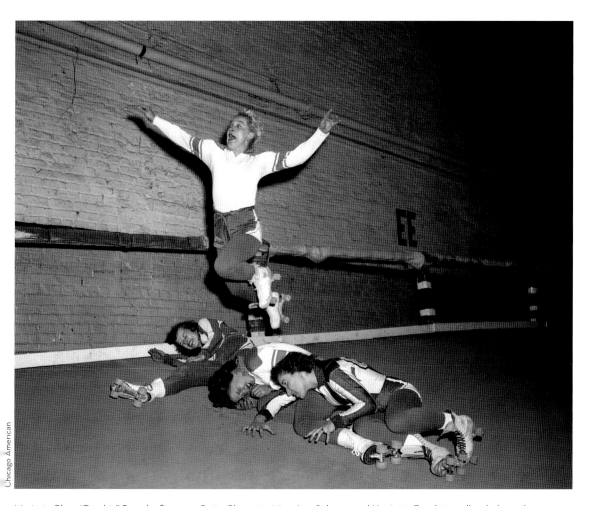

Chicago American

Marjorie Clare "Toughie" Brasuhn flies over Betty Clements, Mary Lou Palermo and Harriette Topel at a roller derby at the Coliseum in Chicago in 1953. Brasuhn, who played for teams in the 1940s and '50s, was the sport's most recognized player. **#rollerderby #windycityrollers #toughie #roughie**

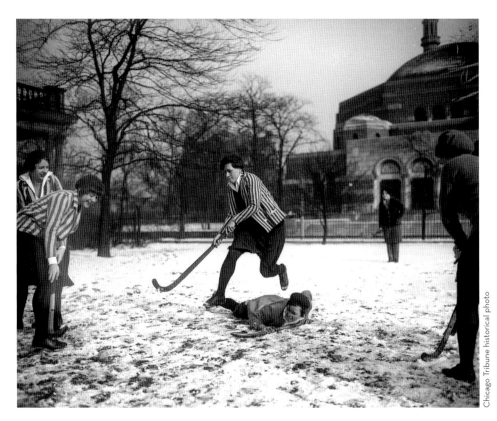

Chicago Tribune historical photo

Chicago Normal Hockey players Eloise Anderson, team captain, and Eloise Hartman, on the ground, show their moves in December 1928. Field hockey was a popular sport for girls in the 1920s, with many teams coming from the North Shore Hockey Association. **#fieldhockey #chicagonormalhockey #girlshockey #northshorewomenshockey**

▶ Phyllis Jones enjoys the sun, music and roller skating with her dog, Lugur Ali, near Ohio Street and Lake Michigan in April 1982. **#oakstreetbeach #1980s #rollerskates #keeponrolling**

Anne Cusack/Chicago Tribune

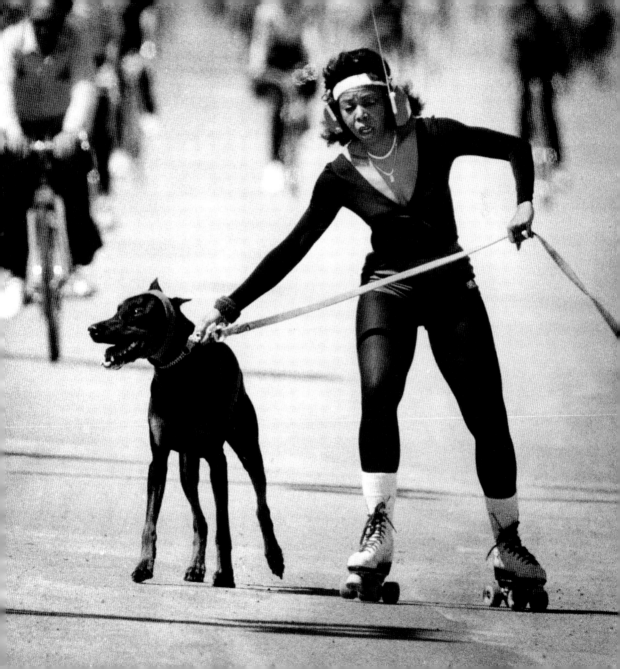

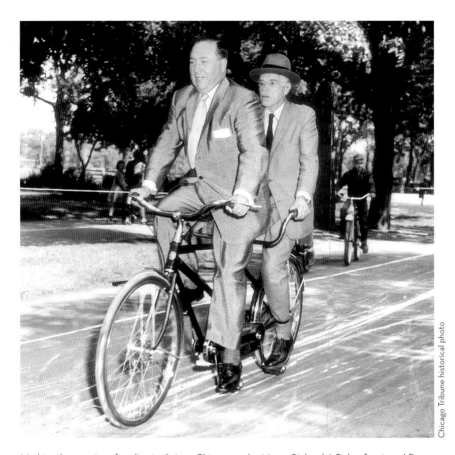

Chicago Tribune historical photo

Marking the opening of cycling trails in 15 Chicago parks, Mayor Richard J. Daley, front, and Dr. Paul Dudley White, a heart specialist, ride a tandem bike in Ogden Park. The original caption from June 1956 says the trails were "designed to promote safety . . . require single-file riding, ban speeding and racing and require cyclists to dismount when crossing streets and roadways." **#bikes #cycling #builtfor2 #1950s #damare #chicagoparks**

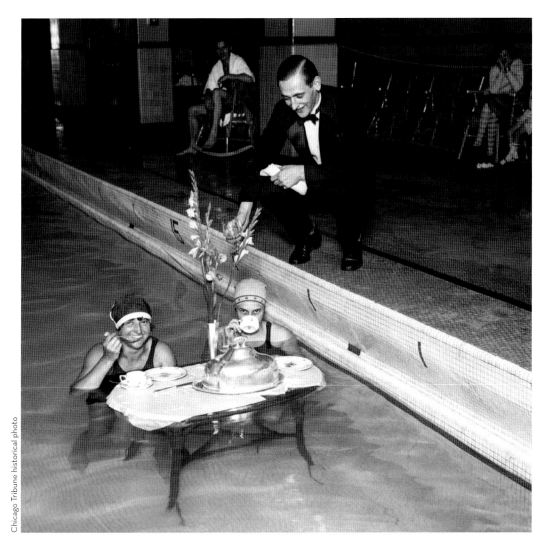

Betty Schmidt and Elizabeth Peterson are waited on by George Gietz in 1928. There is no location information with this glass-plate negative. **#poolparty**

Anna Pohl and Edna Murphy try a new Pabst brew in this undated photo. **#drinkingbuddies #pabst #beer #pbr**

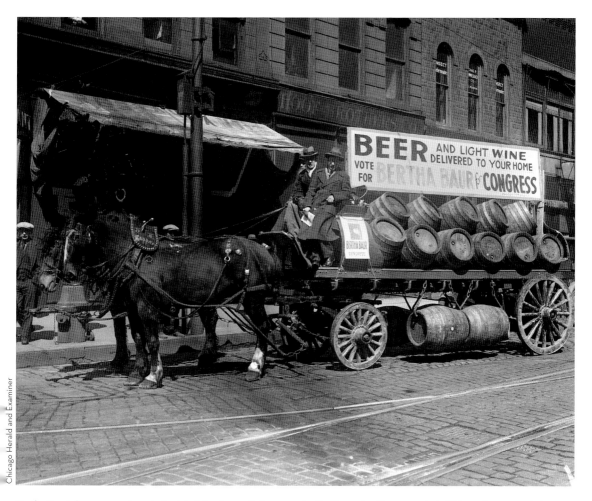

Bertha Baur's beer wagon in a photo dated April 11, 1926. Baur marched in the 1916 suffrage parade in Chicago for women to have the right to vote. Her later campaign for Congress was unsuccessful. **#morebeer #beerdelivery #1920s #hitchyourwagon**

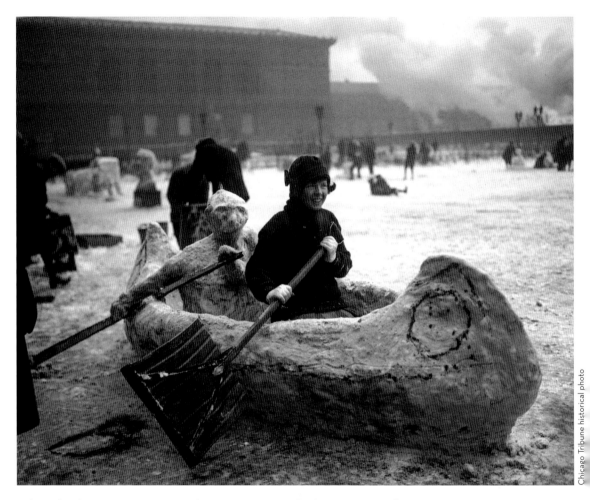

In this undated image, Mary Duzan pretends to row in a canoe made of snow in Grant Park.
#snowsculpture #doyoucanoe? #grantpark #wintersports

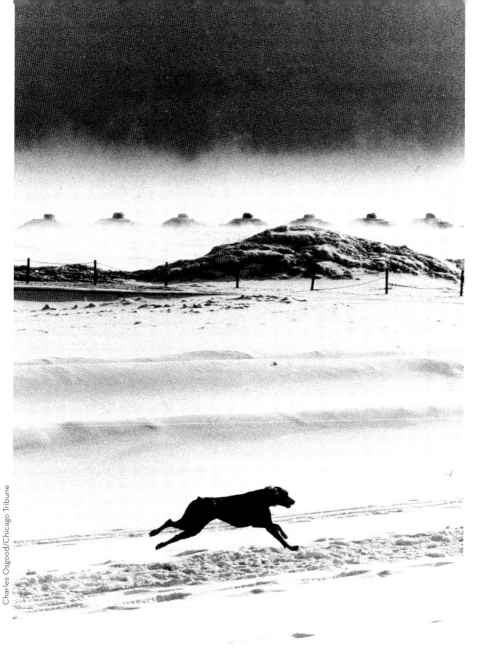

A dog romps along the ice-locked lakefront in December 1983.
#roomtoromp #joy #runforit #lakeeffect

Charles Osgood/Chicago Tribune

Ted Brown practices flips on castaway mattresses near Sherman Park at 52nd and Ada streets in April 1985. **#spring #flippingout #1980s #southside #chicagoweather**

Frank Hanes/Chicago Tribune

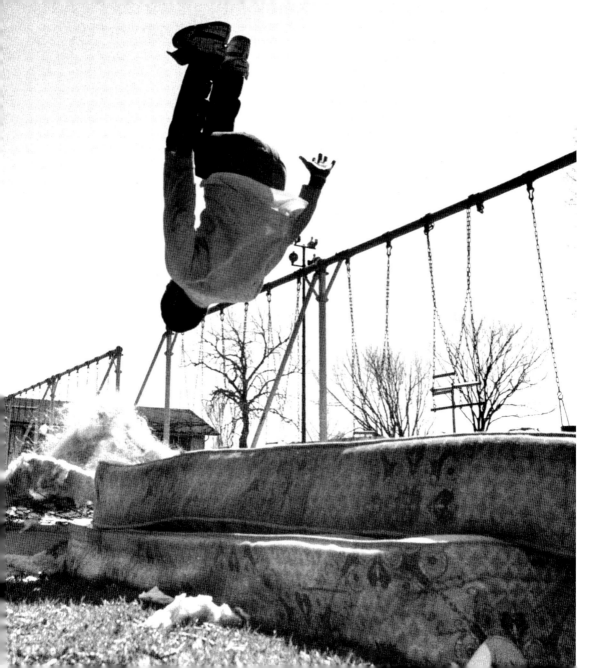

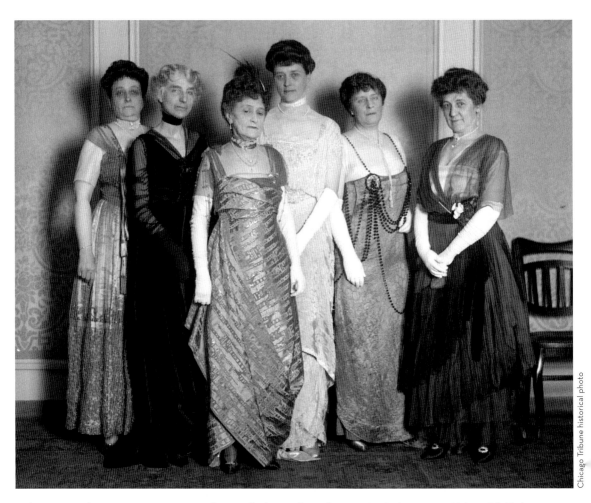

High society in Chicago: Mrs. Moses Wentworth, Mrs. Charles Gordon Fuller, Mrs. J.M. Dickinson, Mrs. Hobart C.C. Taylor, Mrs. Jos. Coleman and Mrs. Charles C. Adsit were "patronesses at the Serbian Ball" in this undated photo. **#chicagosociety #highsociety #serbia #serbianball #theseladiesmeanbusiness**

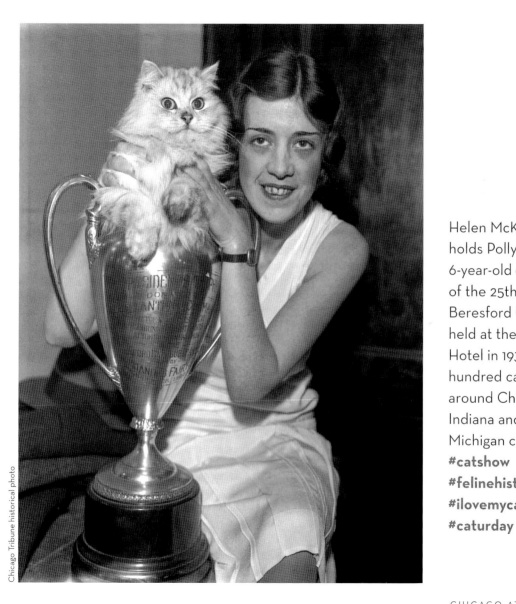

Helen McKenna holds Polly Pat, the 6-year-old champion of the 25th annual Beresford Cat Show held at the Sherman Hotel in 1931. Two hundred cats from around Chicago, Indiana and Michigan competed. **#catshow #felinehistory #ilovemycat #caturday**

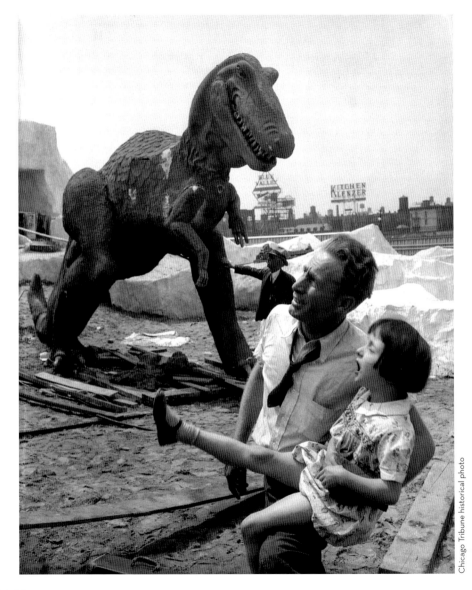

Catherine Gaffney, 7, reacts to a T-rex model at the Sinclair exhibit at the Century of Progress Exposition.
#centuryofprogress #trex #sinclair #dino-mite

Edith Perkins punches a 45-pound sausage at the 24th annual convention of the Institute of American Meat Packers, held at the Drake Hotel on Oct. 22, 1929. **#drakehotel #meatpackers #meathistory #packingmeat**

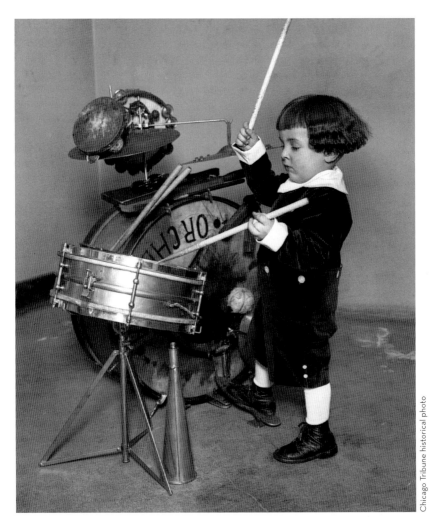

Little Ray Bullard with drums in 1929. **#drummer #littledrummerboy #thathaircut**

Mr. and Mrs. John Barnes, part of Chicago's "high society," stroll down Lake Shore Drive on Easter Sunday with their dog, Dandy, in 1932. **#sundaystroll #chicagosociety #highsociety #lakeshoredrive**

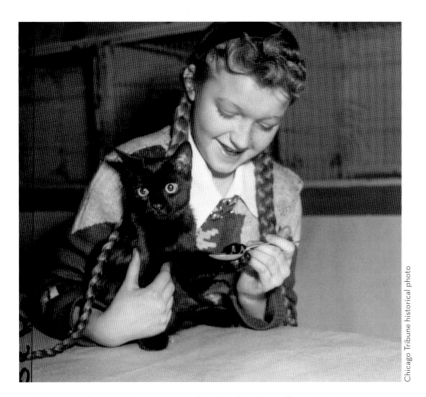

Janell Jones, 11, feeds Mr. Bones catnip so he will behave himself at an Anti-Cruelty Society cat show in 1950. *#anticrueltysociety #catshow #vintagefelines #cathistory*

▶ George Randall, left, George Buckingham and George Black make up a portion of the winning freshman team at a pajama race at Northwestern University in October 1941. *#lotofgeorges #1940s #northwesternuniversity #wildcats #campushijinks*

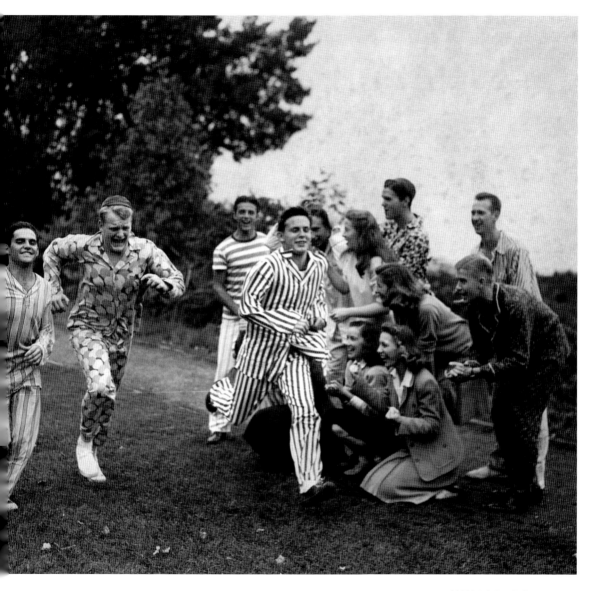

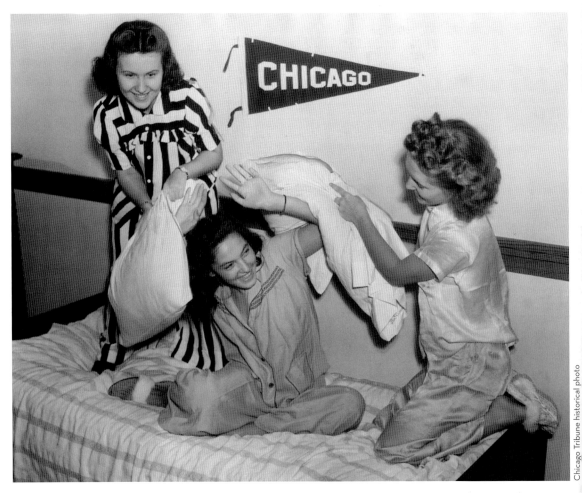

Telling fortunes and pillow fights were two of the amusements at "newcomers' parties" at the University of Chicago dorms in September 1940. Pictured are Rosemary McCarthy, from left, Ruth Pollack and Shirley Smith.
#universityofchicago #pillowfight #dormlife

University of Chicago senior Frank Calvin is the winner of the school's annual mustache race. Calvin is congratulated by co-eds Orva Prange, left, and Kay Wiedenhoff, circa 1931. **#mustache #vintagehipster #coolerthanallofus**

James Scheibler is tossed into the botany pond at the University of Chicago on May 12, 1931. Since Scheibler grew the least amount of upper lip hair in preparation for U. of C.'s mustache race, the traditional dunk was in order. **#chicagorituals #uchicago #mustache #collegelife #hazing**

Chicago Tribune historical photo

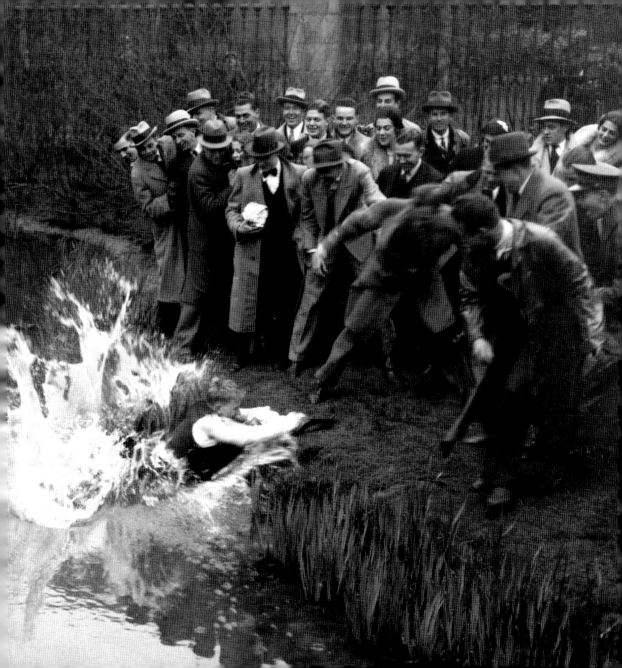

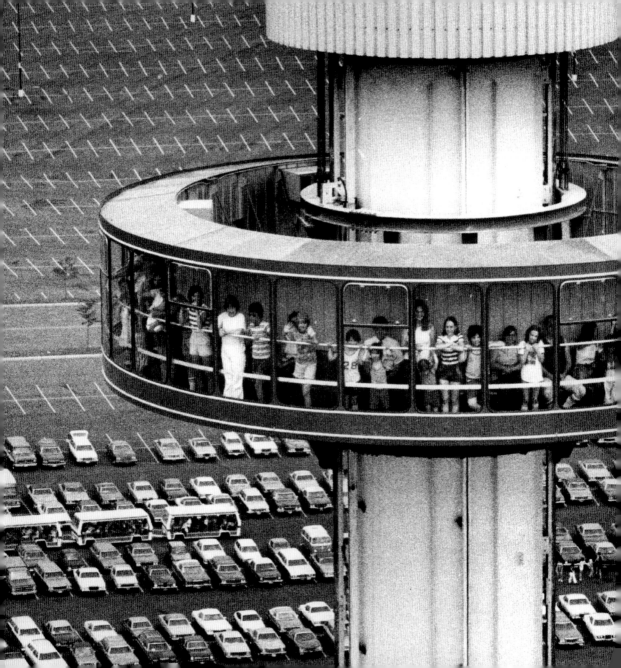

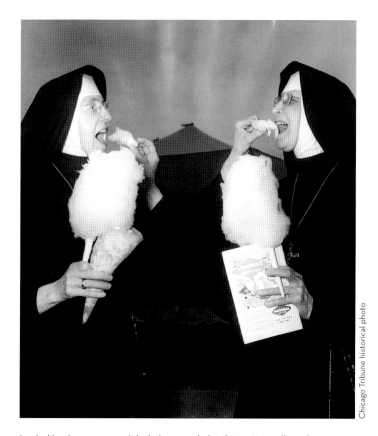

Looks like these nuns can't kick the sugar habit: Sister Antonella and Sister Margarite enjoy cotton candy in July 1962. Both nuns were from St. Francis Hospital in Blue Island. **#sweetsisters #cottoncandy #blueisland #habitforming #1960s**

◄ Visitors to Marriott's Great America theme park in Gurnee ride the Sky Trek Tower in June 1977. **#MGA #greatamerica #1970s #skytrek**

An exuberant entrant in a September 1966 parade commemorating the 156th anniversary of Mexican independence. **#1960s #mexicanamericans #chicagolatinos #parade**

Cy Wolf/Chicago Tribune

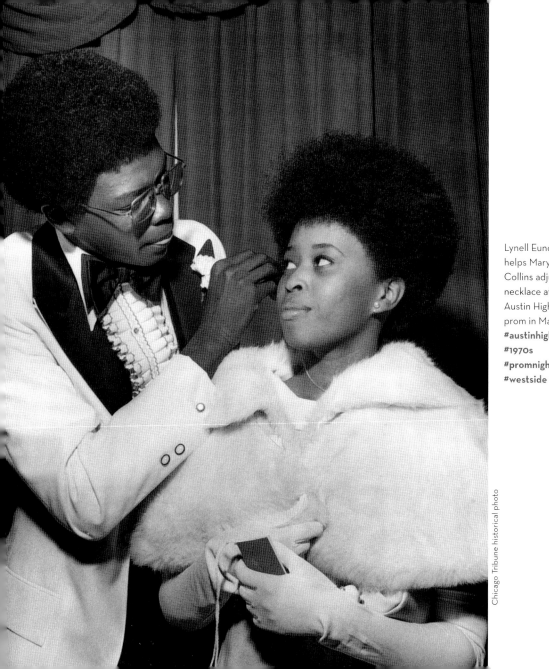

Lynell Eunches
helps Mary
Collins adjust her
necklace at the
Austin High School
prom in May 1971.
**#austinhighschool
#1970s
#promnight
#westside**

Ray Daunenberg, from left, Renee Smith and Irene Lakic at Woodfield Mall in Schaumburg in 1984. Said Smith: "Sometimes we just come and hang out."
#fasttimesatwoodfield
#schaumburg
#chicagomalls
#feathering

Chuck Berman/Chicago Tribune

Katherine Collins, left, and Medora Pelouze on board The Medora during the Lake Geneva summer races in 1930. Pelouze's father was Commodore William Nelson Pelouze, who owned a manufacturing company in Chicago, a home in the city and another in Lake Geneva, Wis. **#americana #yachtclub #boatraces #lakegeneva #iwouldlikeaboatnamedafterme**

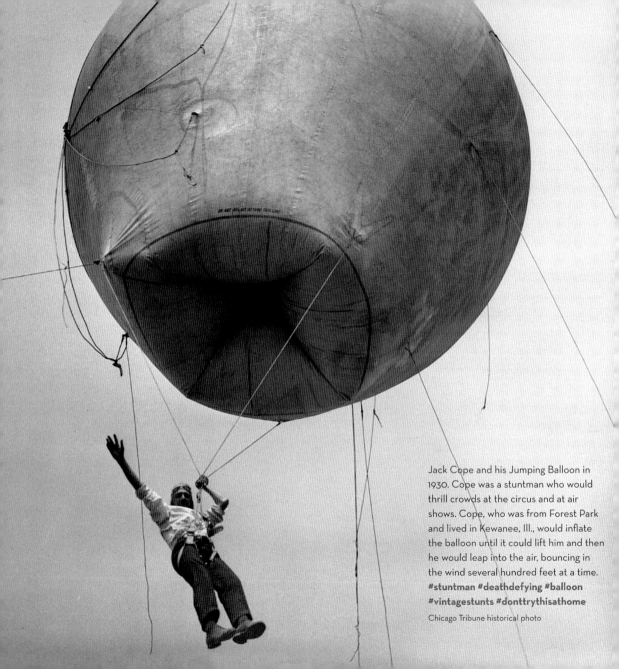

Jack Cope and his Jumping Balloon in 1930. Cope was a stuntman who would thrill crowds at the circus and at air shows. Cope, who was from Forest Park and lived in Kewanee, Ill., would inflate the balloon until it could lift him and then he would leap into the air, bouncing in the wind several hundred feet at a time. **#stuntman #deathdefying #balloon #vintagestunts #donttrythisathome**

Chicago Tribune historical photo

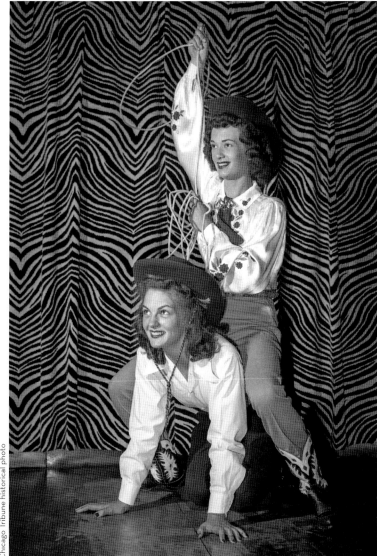

Model Toni Berry swings a rope as she "rides" model Betty Frost at the Rodeo Queen eliminations at Patricia Stevens Model Studio on July 12, 1947. The Rodeo Queen competition coincided with the Chicago Championship Rodeo held at Soldier Field that month. Pat Varner, 19, of 1535 Vincennes Ave., was the winner of the contest. **#vintagerodeo #rodeoqueen #thefunnythingspeopledo**

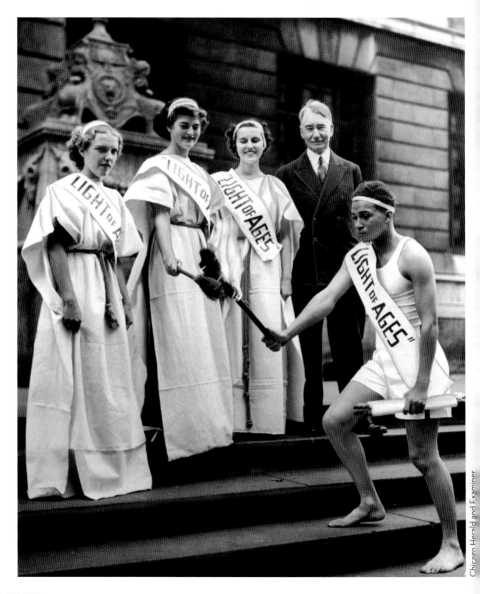

Costumed celebrants at the Light of Ages event in 1937, in honor of the 100th anniversary of the establishment of Chicago's municipal charter. **#chicagohistory #1930s #togaparty? #jubilee**

Chicago Herald and Examiner

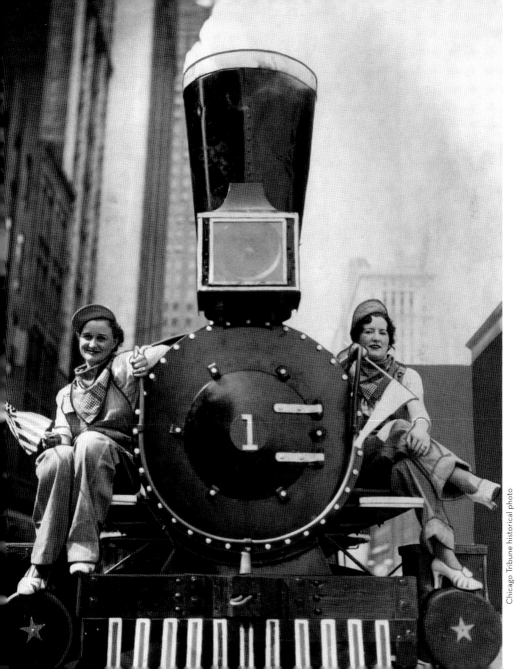

Alice Quast and Betty O'Rourke ride a locomotive down Michigan Avenue in a 1935 parade celebrating Railroad Week. **#railroadweek #michiganave #trainhistory #railhistory**

U.S. Army 1st Sgt. George Becker of the 131st Infantry (1st Infantry, Illinois National Guard) kisses his 6-year-old daughter, Marlene, goodbye before heading off to Camp McCoy, Wis., in 1940. **#wwII #illnationalguard #chicagoinwartime**

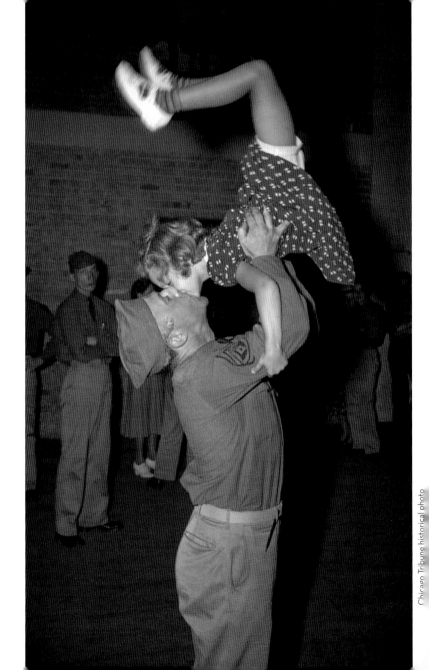

Chicago Tribune historical photo

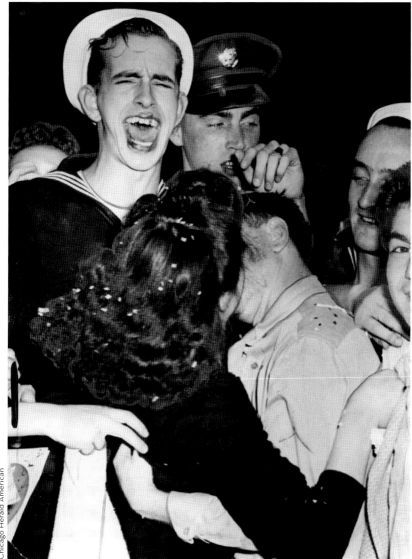

Lipstick-smeared faces were a common sight during Loop celebrations Aug. 14, 1945, after Japan surrendered unconditionally to the U.S. and Allies, ending World War II. **#wwll #besamemucho #VJday #1940s**

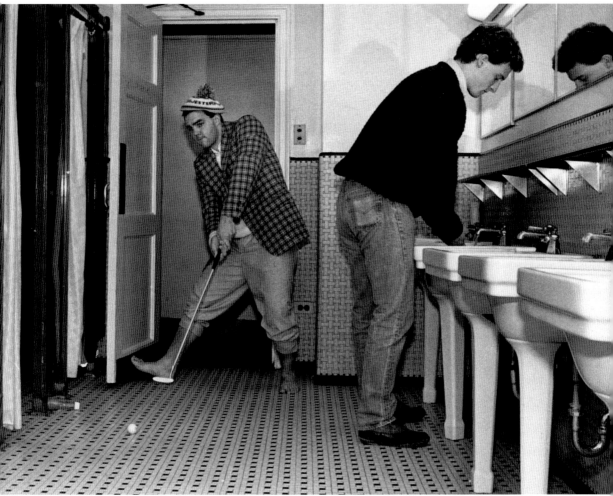

Chuck Berman/Chicago Tribune

Water hazard: Jack Ludden appears unfazed as Mark Ledogar plays the tortuous sixth hole of Willard Residential College's miniature golf course Jan. 18, 1988, at Northwestern University. Evans Scholars next door could have provided some tips. **#puttputt #minigolf #collegehijinks #northwesternuniversity #bathroombreak**

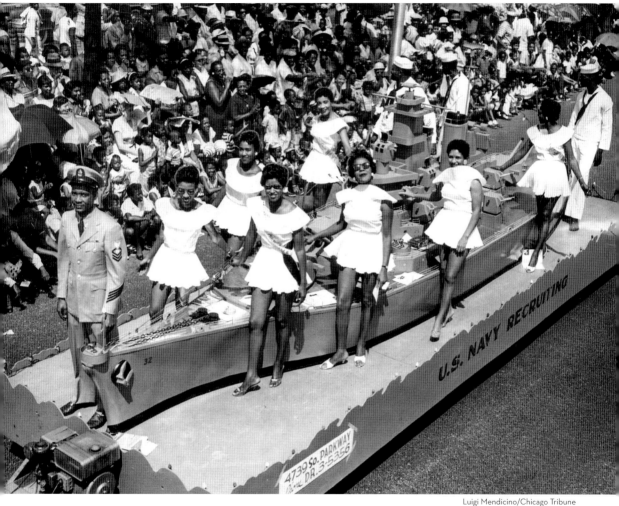

Luigi Mendicino/Chicago Tribune

A U.S. Navy recruiting float in the Bud Billiken Parade passes 49th Street and South Park Way in August 1958. South Park Way is now King Drive. **#budbilliken #usnavy #recruiting #1950s**

Linda Srodon, her son, Greg, Julie Veline and Colleen Stahl soak up sunshine in a park at Addison Street and Lake Shore Drive on March 24, 1963. *#chicagoweather #lakeshoredrive #idreamofsunshine*

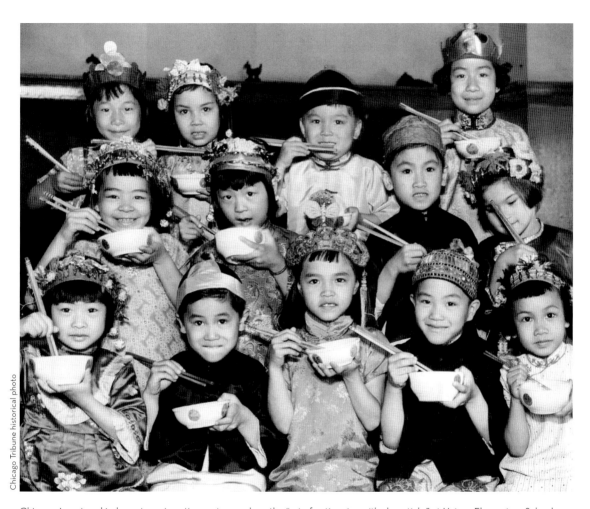

Chinese-American kindergartners in native costumes show the "art of eating rice with chopsticks" at Haines Elementary School in 1941. **#haineselementary #cps #chinatown**

When sparks fly: Illinois Institute of Technology students attempt to measure the power of puckering up with an electric kiss-o-meter in May 1948. **#besamemucho #1940s #feelingpeckish #smooches**

▶ Lisa Marie Asch, 5, meets Monica the jaguar Oct. 28, 1966, at Lincoln Park Zoo during Halloween festivities. **#halloweenchicago #LPzoo #1960s #seeingspots**

John Austad/Chicago Tribune

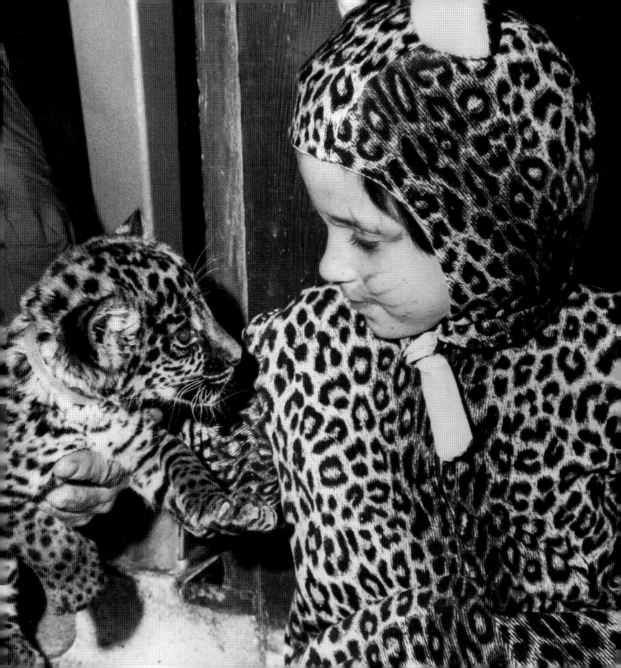

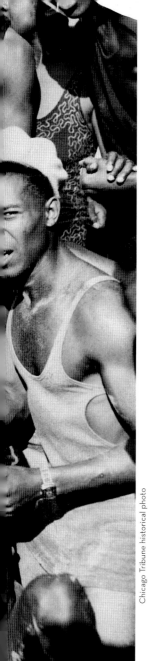

◀ Ukulele in hand, Ralph Fairchild starts to serenade Louise Winston as a crowd gathers June 18, 1931, at 31st Street Beach, where a new bathhouse had just opened. **#lakeeffect #serenade #romance**

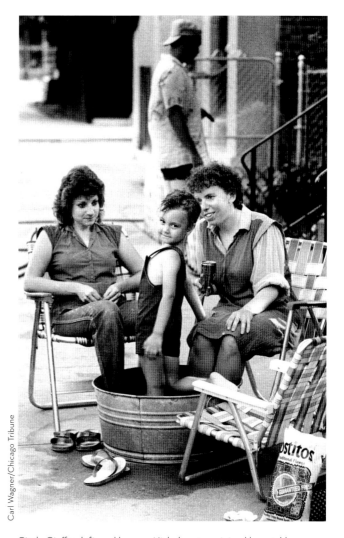

Cindy Giuffre, left, and her son Nicholas, 4, are joined by neighbor Mari Beth Kelly in the 1600 block of North Cleveland Avenue in September 1985. **#coolingoff #1980s #oldtown**

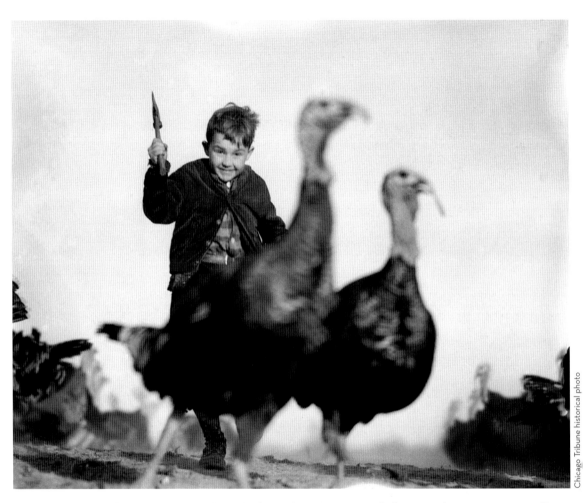

Friedman Law, 10, runs after turkeys with a hatchet on his family's farm in Mount Carroll, Ill., in November 1940. **#mountcarroll #thanksgiving #turkeyday #happythanksgiving #thisisasetup**

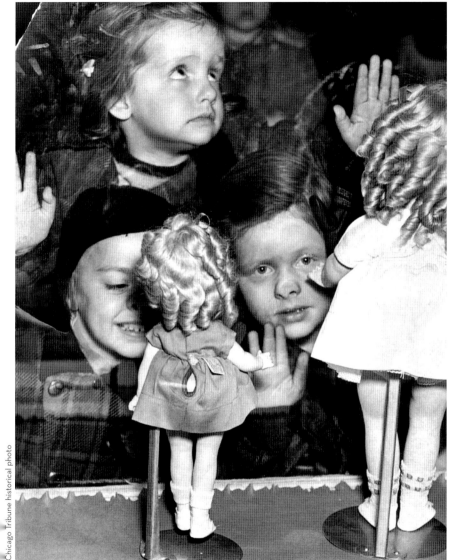

Children press themselves against a Loop store window during the 1936 Christmas season. (Note: We can't confirm this, but we think those are Shirley Temple dolls.) **#chicagoholidays #starstruck #christmaswishes #1930s**

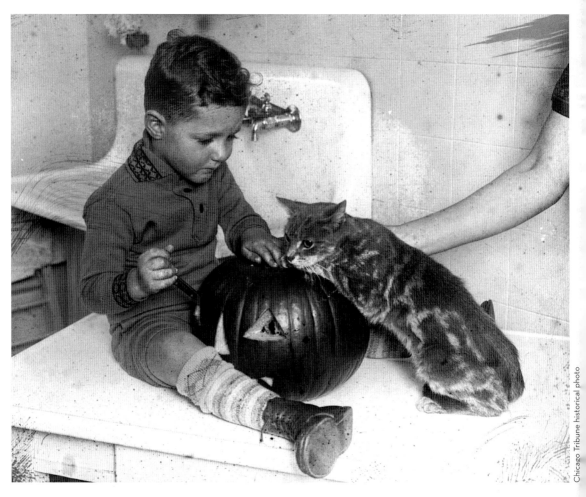

Earl Rubin, of 5954 Lakewood Ave., poses with a jack-o'-lantern and a cat in October 1925.
#pumpkincarving #jackolanterns #halloween

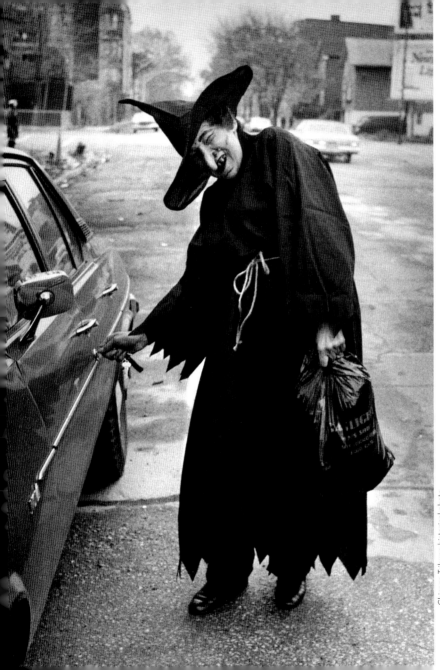

Esteline Grassi opts to drive a car instead of a broom at the Latin School in Chicago on Halloween in 1983. **#halloween #chicagoweather #witchywoman #allhallowseve**

Theadora Dugan
paints Easter eggs in
1929. **#vintageeaster**
#chicagoeaster
#eastereggs #easter

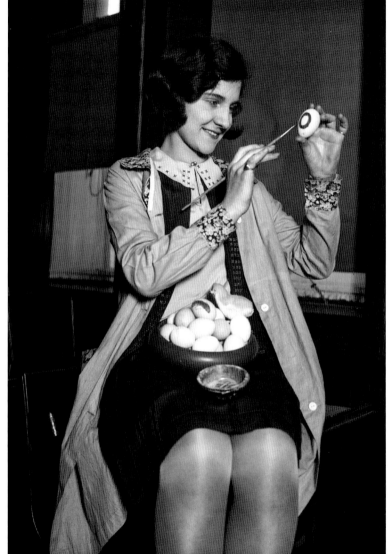

Chicago Tribune historical photo

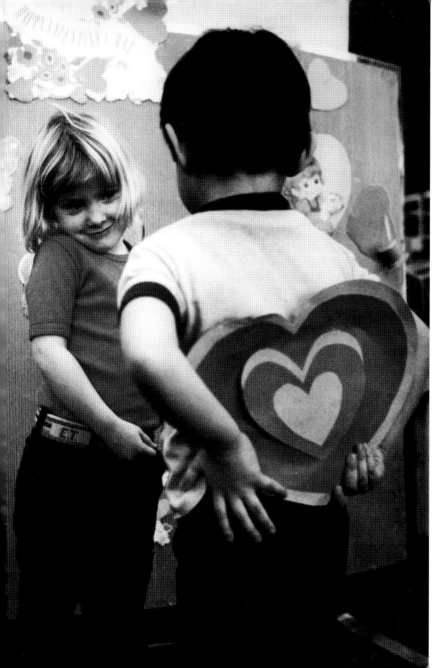

Eduardo De Jesus, 4, gets ready to present classmate Kara Conliss with a valentine at Walt Disney Magnet School on Feb. 9, 1983. **#valentinesday #1980s #sweethearts #disney**

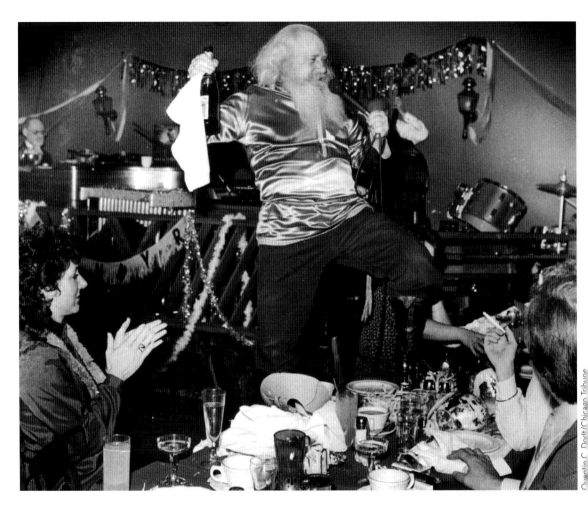

Singer Isaak Rubinchik helps partygoers celebrate Serbian New Year in 1984 at Miomir's Serbian Club, 2255 W. Lawrence Ave. Owner and operator Miomir M. Radovanovich died in 2002, and the Tribune obituary noted: "The club, which closed in 1992, offered ethnic fare and live entertainment, including a Gypsy orchestra, Russian dancers and singers who crooned in 20 languages."
#partydown #1980s #happynewyear

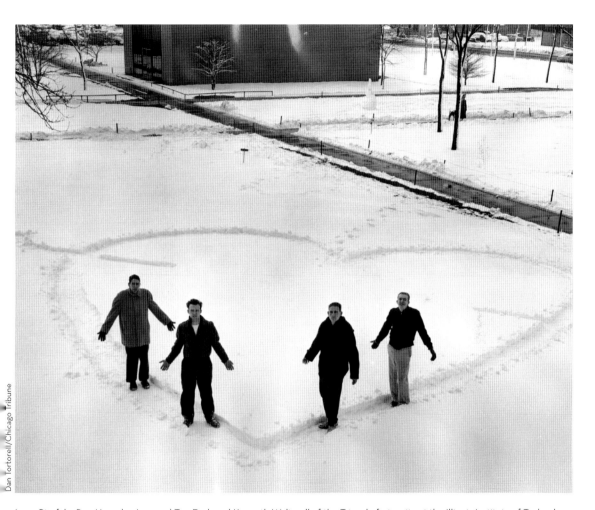

Dan Tortorell/Chicago Tribune

Leon Pirofalo, Ron Hansche, Leonard Ten Eyck and Kenneth Wylie, all of the Triangle fraternity at the Illinois Institute of Technology, stomp their Valentine's Day message in the snow beneath the windows of their lady loves at a sorority house on campus Feb. 12, 1956.
#valentinesday #willyoubemyvalentine #IIT

Mary Joe Wolf, 3, is shown in the arms of Santa Claus, aka Isaac Newman, while her mother, J. A. Wolf, shops in Chicago in December 1930. **#santaclaus #christmas #vintagesanta**

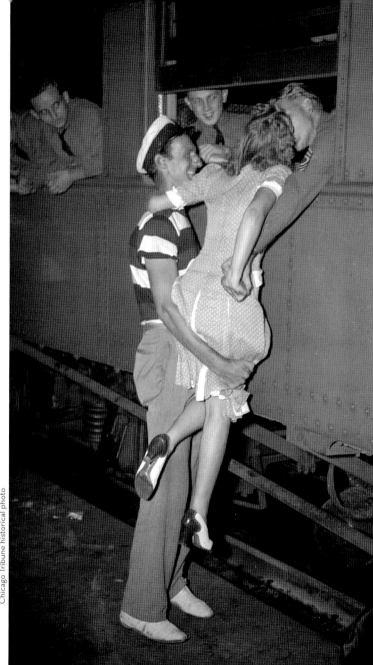

A young woman gets a boost to plant a goodbye kiss on her boyfriend before he departs Aug. 11, 1940. He was a member of the 131st Infantry. **#smooch #thegoodbyelook #warromance #wwII**

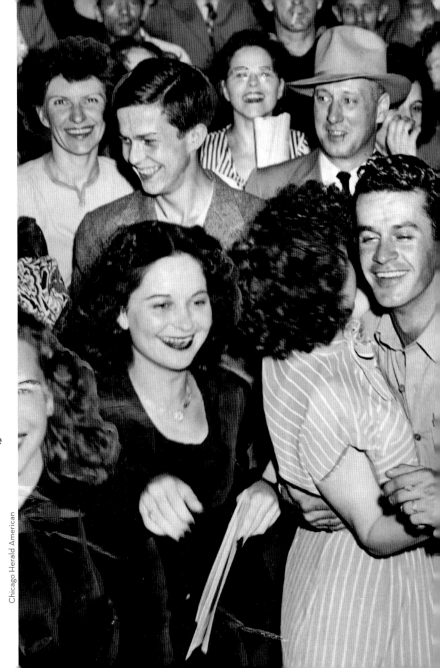

GIs and friends turn the intersection of State and Madison streets into an impromptu dance floor in August 1945, upon news of the Japanese surrender in World War II. **#wwII #victorydance #VJ #1940s**

Chicago Herald American

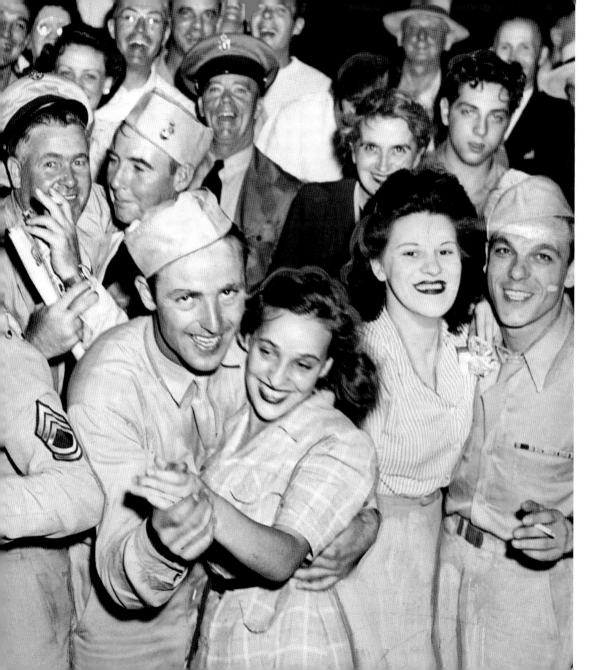

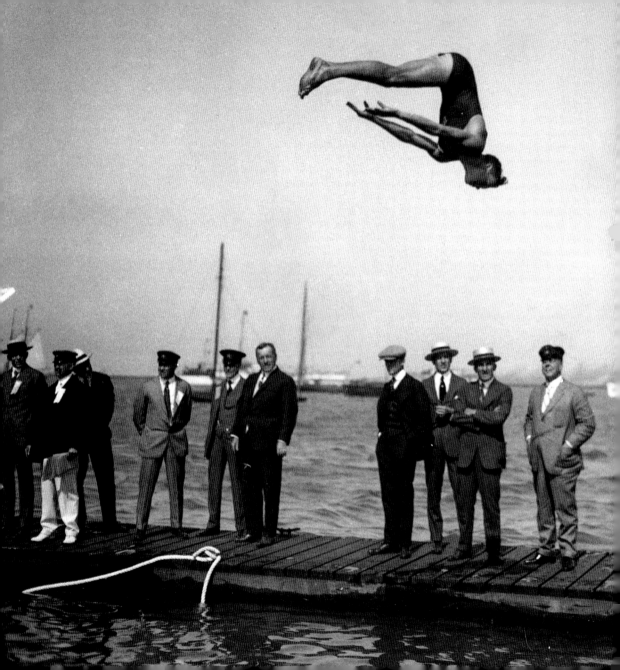

We have no other information on this undated photo, but it is beautiful: G.A. Carunh, fancy diving in Chicago. **#fancydiving**

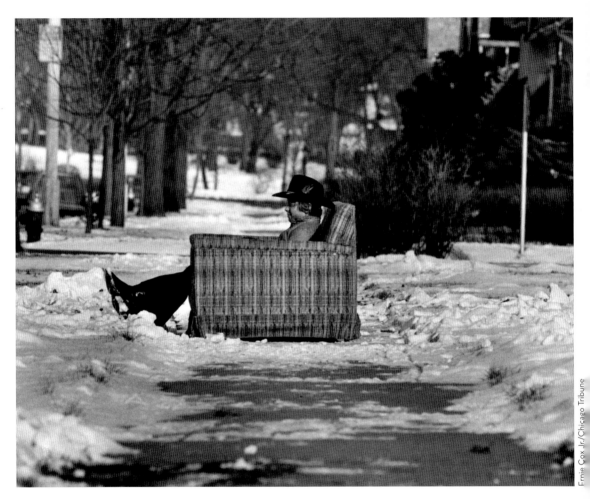

Kevin Saunders, 11, finds a comfortable outdoor resting place on a sofa as he and his parents, formerly of Arkansas, move into their new home in December 1980. **#chicagowinter #lawnfurniture #movingday #rudeawakening**

Ernie Cox Jr./Chicago Tribune

CHARACTERS

CHICAGO'S HEART AND SOUL

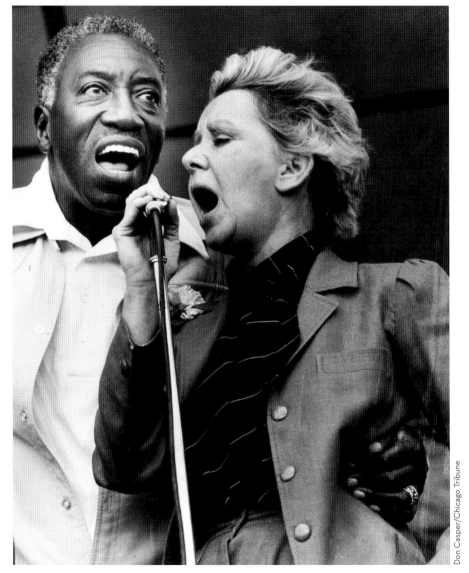

Jazz singer Joe Williams is accompanied onstage at Columbus Park on July 11, 1982, by Mayor Jane Byrne in a rendition of "Chicago." Williams' appearance was part of the Neighborhood Festival schedule featuring Big Band-era performers. **#janebyrne #sweethomechicago #joewilliams #mayorbyrne #chicagomayors #femalemayors**

Don Casper/Chicago Tribune

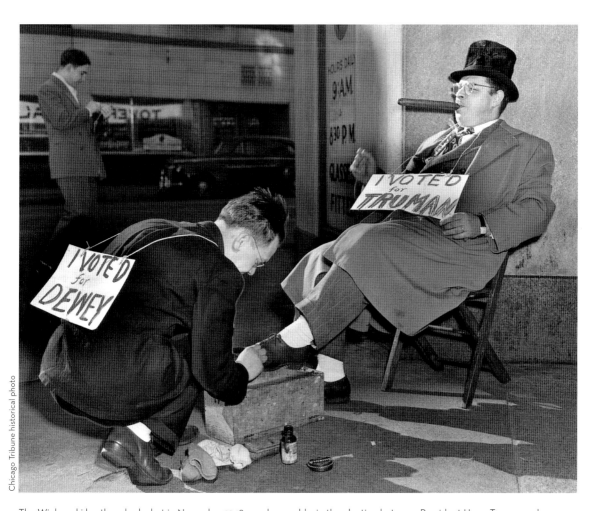

The Winkowski brothers had a bet in November 1948 on who would win the election between President Harry Truman and Republican challenger Thomas Dewey. The loser—in this case, Martin—had to shine the shoes of the winner, Alexander, in the same spot in downtown Chicago every Sunday for six months. **#vintagevoting #illinoisvoting #votinglines #vote #elections #electionbets #deweyvstruman**

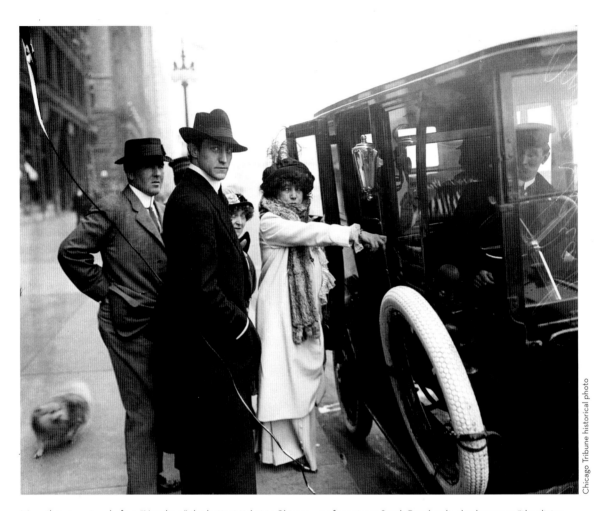

More than a century before "Hamilton," the hottest ticket in Chicago was for actress Sarah Bernhardt, also known as "the divine Sarah." This broken glass-plate negative shows Bernhardt, center, getting into an automobile in either 1906 or 1912 in Chicago. She is surrounded by an entourage and, of course, a dog. **#sarahbernhardt #hamilton #thedivinesarah**

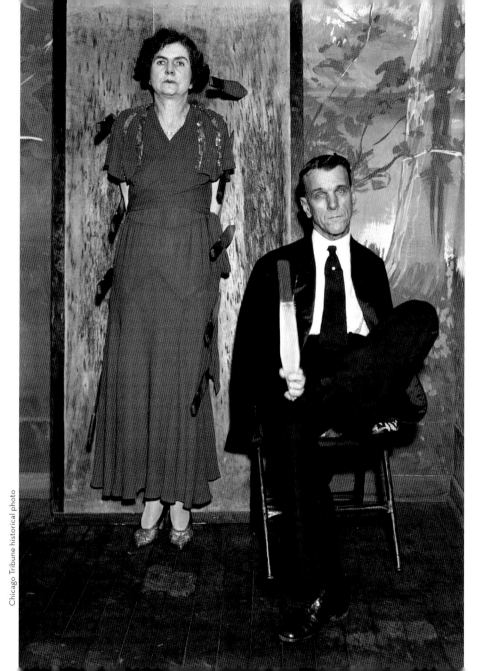

Paul DeSmuke, the "Armless Wonder," with wife Mrs. Paul DeSmuke (Mae Dixon), who is surrounded by eight knives he just threw at her with his feet in an undated photo. DeSmuke was a judge from Texas who joined the circus and, eventually, Ripley's Odditorium at the World's Fair in Chicago in 1933-34. #pauldesmuke #ripleysbelieveitornot #ripleysodditorium #centuryofprogress

291

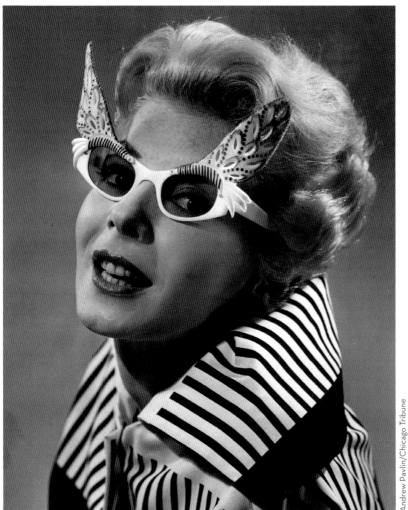

An early innovative use of the print medium: A pedestrian at Daley Center Plaza uses a newspaper for shade against the sun Aug. 7, 1979. The temperature peaked at 92 degrees that day. **#chicagoweather #hotstuff #1970s #allthenewsfittowear**

Andrew Pavlin/Chicago Tribune

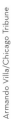

Armando Villa/Chicago Tribune

The original caption for this beauty said, "Soaring sun glass frames of white plastic engraved and etched in gold and set with sparkling white rhinestones." October 1957. **#vintagefashion #1950sfashion #chicagosummer #ineedthese**

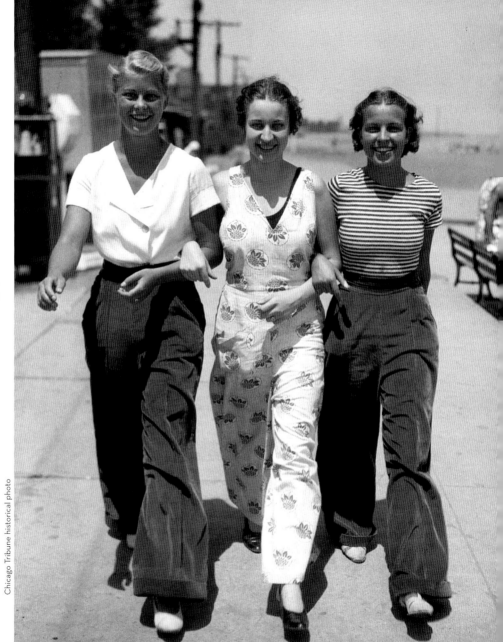

Beach beauties
Elsie Johnson,
Muriel Bunn and
Irma Zinn in 1932.
#chicagosummer
#chicagofashion
#lakemichigan

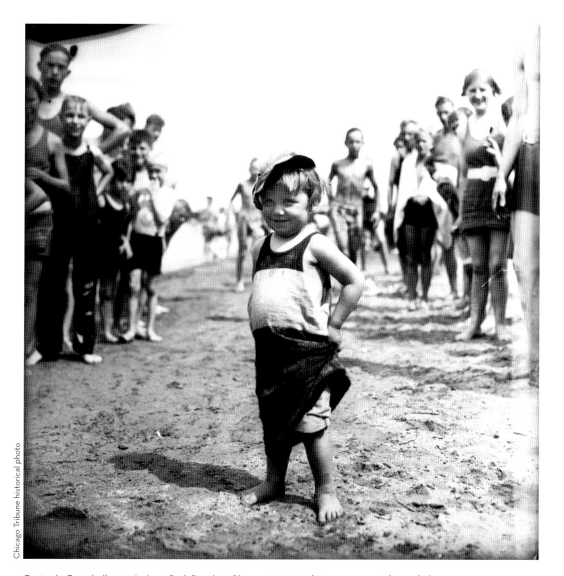

Gertrude Campbell, 3, at Jackson Park Beach in Chicago in 1928. **#chicagosummer #chicagokids**

Actress Dolores del Rio tries to feed a bear at the Hotel Sherman in Chicago in 1928. Del Rio starred that year in the film "Revenge," about a bear-taming heroine who "yearns for a man to conquer her own wild self," according to the Tribune. The movie had a synchronized score and was in color, although no actors talked in the film. Del Rio would become one of the first Mexican actresses to have huge success in Hollywood. **#doloresdelrio #hollywood #goldenage #hotelsherman #poorbear #myhowthingschange**

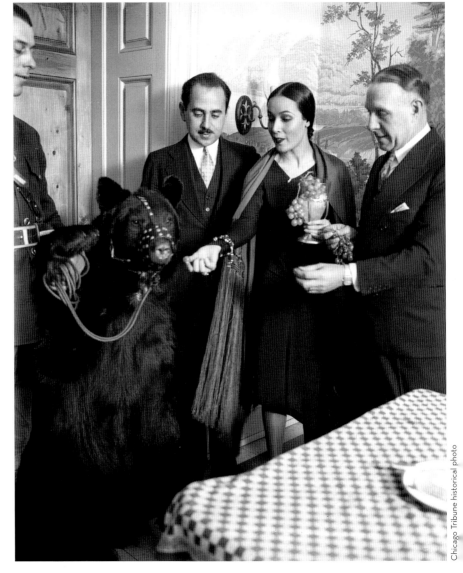

Chicago Tribune historical photo

Gabby Hartnett, left, and Charlie Grimm of the Chicago Cubs, circa 1935. We know nothing else about these hijinks. **#nowords #gocubsgo #1930s #chicagocubs**

Bill Veeck takes a smoke break in March 1977 while watching his White Sox during spring training in Sarasota, Fla. **#whitesox #1970s #veeck**

Edward Wagner Jr./Chicago Tribune

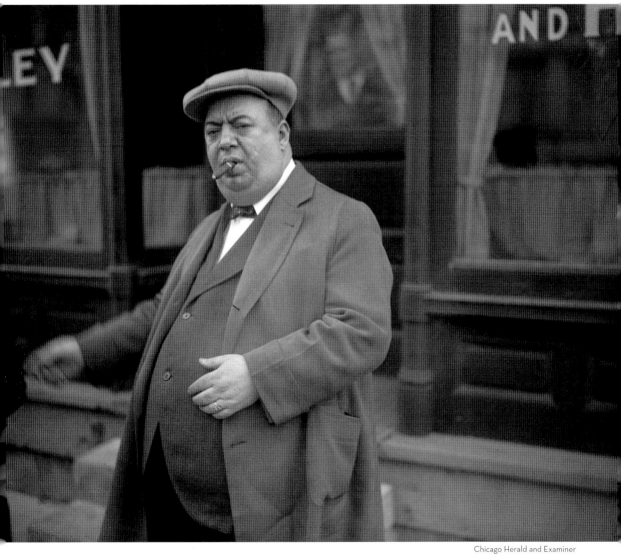

Saloonkeeper Pete Kelly in an undated photo. **#taverns #vice #liquor**

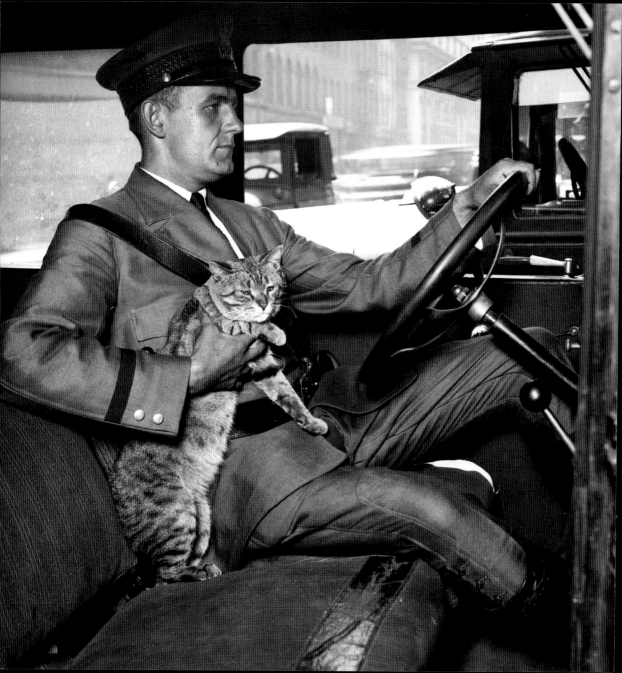

Punky Carlson poses with a duck Nov. 13, 1941, at the University of Chicago. The duck was to be raffled off at the Reynolds Club open house at the university. **#prepunkybrewster #reynoldsclub #juststandingaroundwiththisduck**

◄ Rex Johnson in summer 1929 with Bum, a Wacker Drive cat so named because of his habit of sleeping on the seats of parked cars with rolled-down windows. When a motorist gets ready to leave, Bum promptly moves to another car. **#bummedout #incorrigiblekitty #1920s #catnaps**

Chicago Herald and Examiner

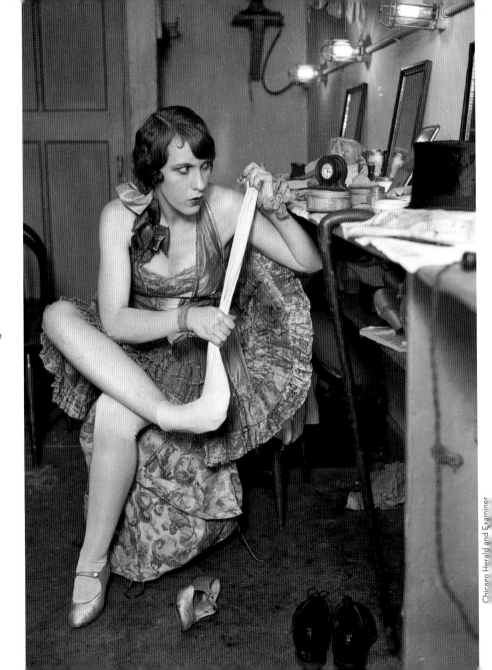

Dancer and
showgirl Petra
Olsen in 1926.
#vintagetheater
#vaudeville
#showgirls
#wishweknewmore

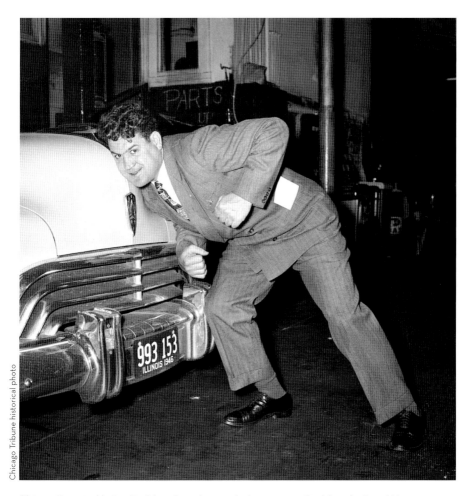

Chicago Bears tackle Joe Stydahar shows his muscle June 19, 1946. Stydahar, the Bears' No. 1 choice in the first NFL draft in 1936, was inducted into the Pro Football Hall of Fame in 1967. **#monsterofthemidway #chicagobears #drafted #nfl**

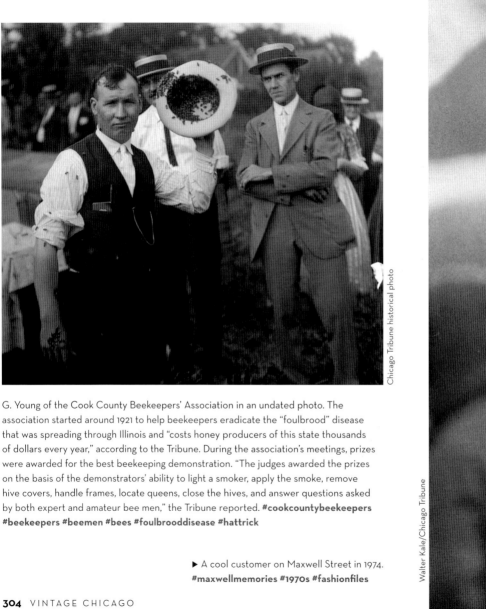

G. Young of the Cook County Beekeepers' Association in an undated photo. The association started around 1921 to help beekeepers eradicate the "foulbrood" disease that was spreading through Illinois and "costs honey producers of this state thousands of dollars every year," according to the Tribune. During the association's meetings, prizes were awarded for the best beekeeping demonstration. "The judges awarded the prizes on the basis of the demonstrators' ability to light a smoker, apply the smoke, remove hive covers, handle frames, locate queens, close the hives, and answer questions asked by both expert and amateur bee men," the Tribune reported. **#cookcountybeekeepers #beekeepers #beemen #bees #foulbrooddisease #hattrick**

▶ A cool customer on Maxwell Street in 1974. **#maxwellmemories #1970s #fashionfiles**

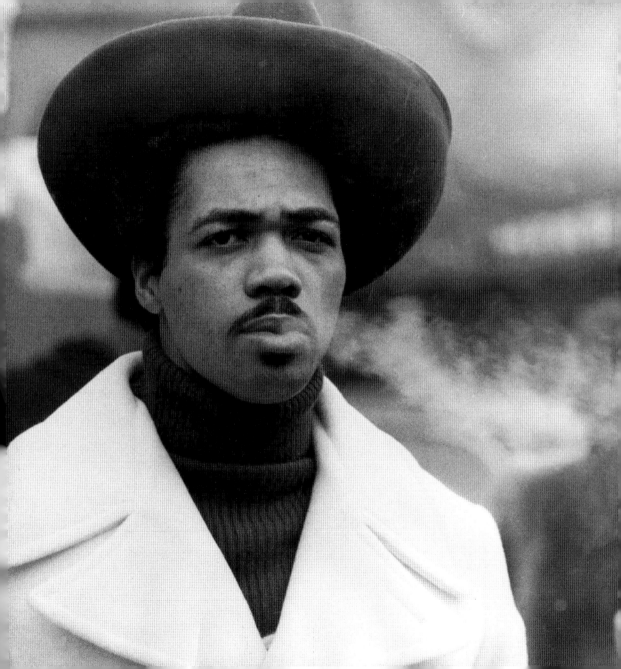

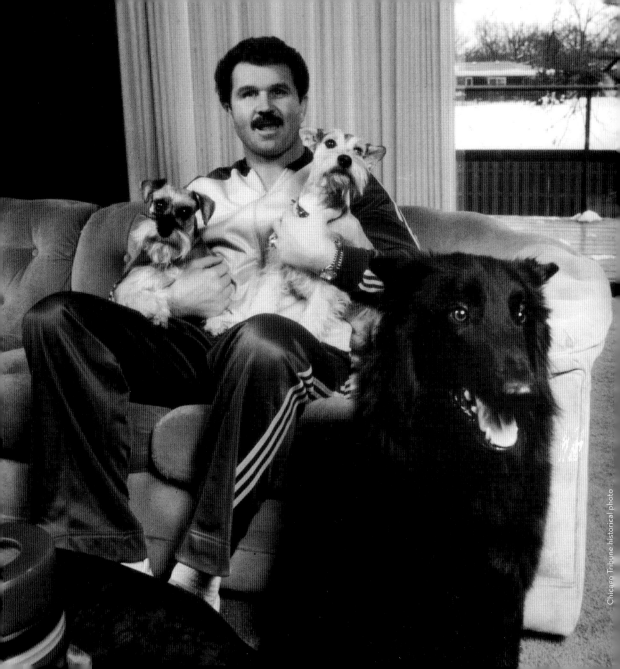

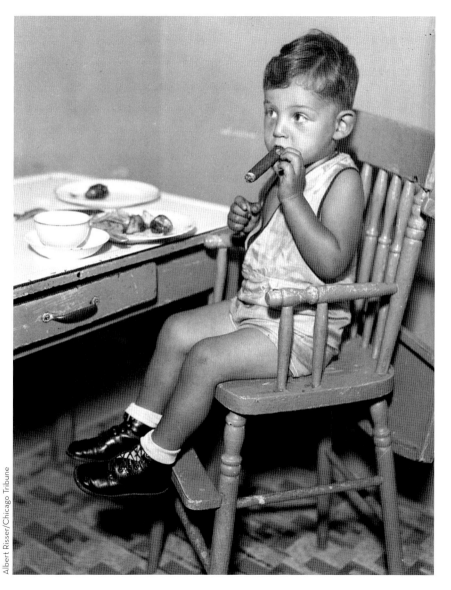

◄ Chicago Bears Coach Mike Ditka with his canine companions, circa 1983. **#dacoach #chicagobears #ditka #1980s**

A toddler smoking a cigar? Only in 1933 could this happen. Say hello to Darwin "Doo-Doo" Shapiro, smoker at age 2. **#childsmoker #vintagecigar #thisiswrong #donttrythisathome**

Albert Risser/Chicago Tribune

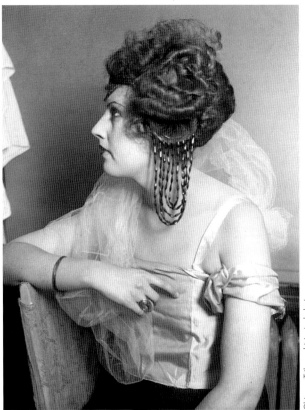

The only information on this glass-plate negative is: Mrs. Josephine LaFever. We failed to find any information on her and her fabulous 'do. **#vintagechair #vintagestyle**

▶ Hairstylist Jimmy Bastable puts the final touches on Carlotta McGuire's hair in 1988. **#withstandthewind #hairfiles #1980s #stylin**

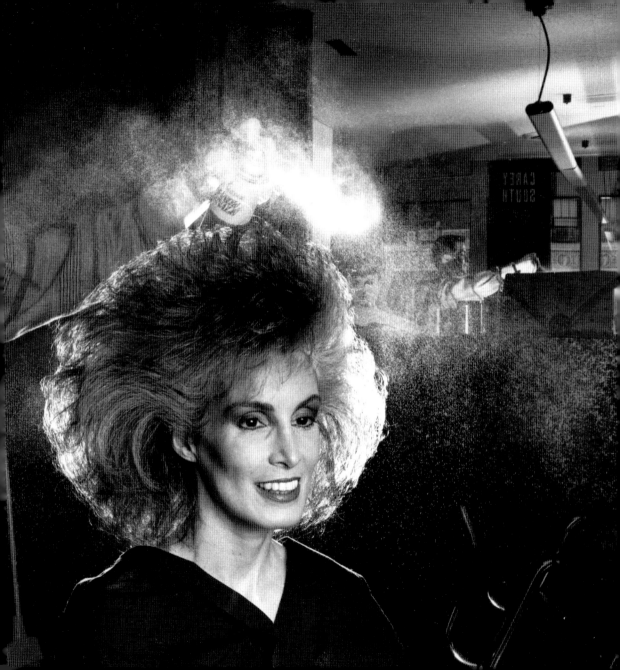

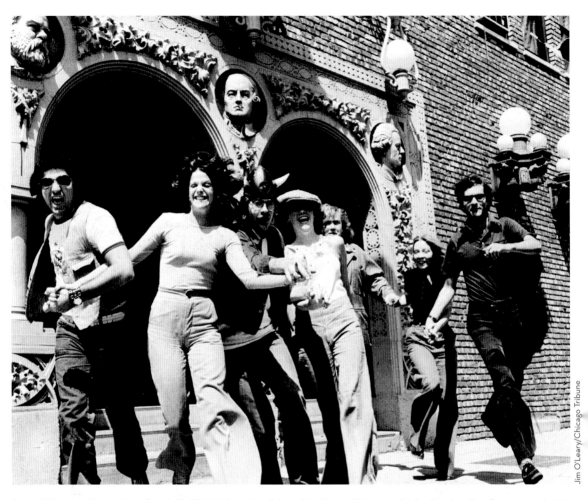

Second City stars Eugene Levy, from left, Gilda Radner, Dan Aykroyd, Catherine O'Hara and John Candy gather for a group shot in 1974 in Chicago's Old Town neighborhood. **#starstruck #weknewthemwhen #1970s #oldtown #secondcity**

Jim O'Leary/Chicago Tribune

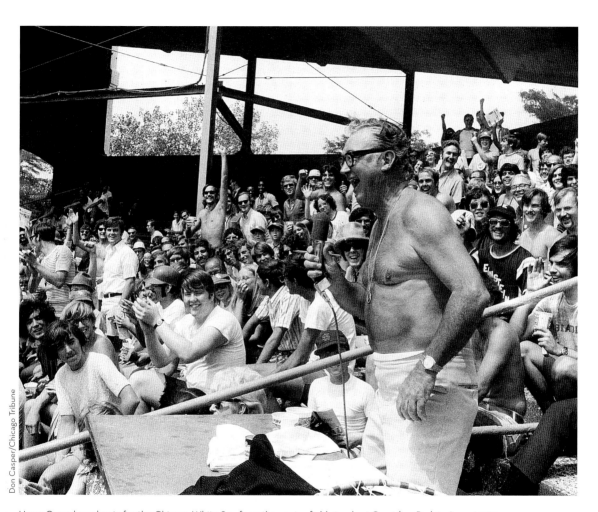

Harry Caray broadcasts for the Chicago White Sox from the center field stands at Comiskey Park in August 1972.
#chisox #comiskey #holycow #itmightbe #1970s

Chicago Mayor Anton J. Cermak under his sunlamp at City Hall in March 1932. **#fightSAD #sunbath #chicagomayors #1930s**

Chicago Herald and Examiner

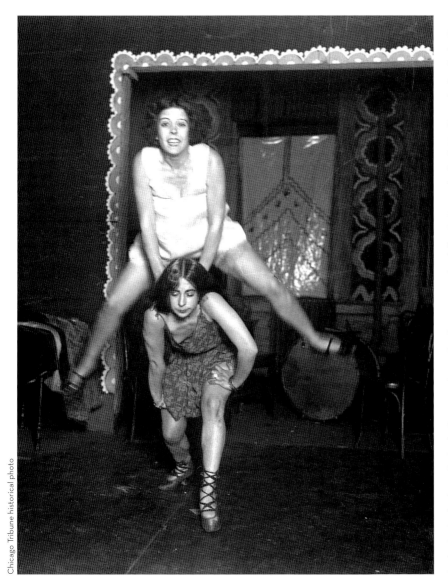

May Charlotte Gilchrist, bottom, and Lillian Collier, the "Leap Frog Girl." Gilchrist, an "art for art's sake" model, was sued for divorce by her husband, Lawrence Case Gilchrist (after he discovered a 100-page photo scrapbook of Charlotte in nude poses). Collier was the owner of the Wind Blew Inn, 116 E. Ohio St., a hangout raided numerous times in the 1920s for being a "disorderly house." A Tribune story from Feb. 12, 1922, said: "The Wind Blew Inn, you must know, is the soul of Bohemia; the rendezvous of the artist who cannot afford tonsorial attention, the flapper ne plus ultra, the modernist and the futurist." Chicago police Sgt. Charles McGurn said: "When we arrived we found men and women singing and shouting. Bottles whose contents and labels were peculiarly pre-Volsteadian were in evidence. So we pinched the joint." **#americasgottalent #leapfrog #pinchedthejoint #disorderly #1920s**

We really dug for information on this one but came up with nothing. Regardless, this photo of Hugh Cummings, Roy Bartlett and Bobby Kaufman in 1928 is fabulous! Hopefully these "girls" are on the right side of those bars. **#somelikeithot #dragqueens #dragshow #gaychicago #whosthatgirl #chicagopride**

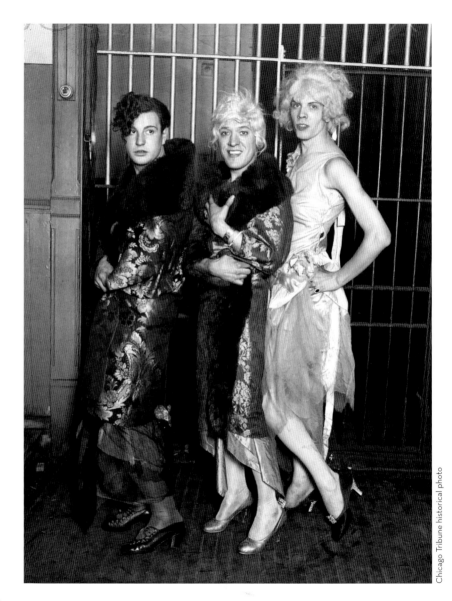

Chicago Tribune historical photo

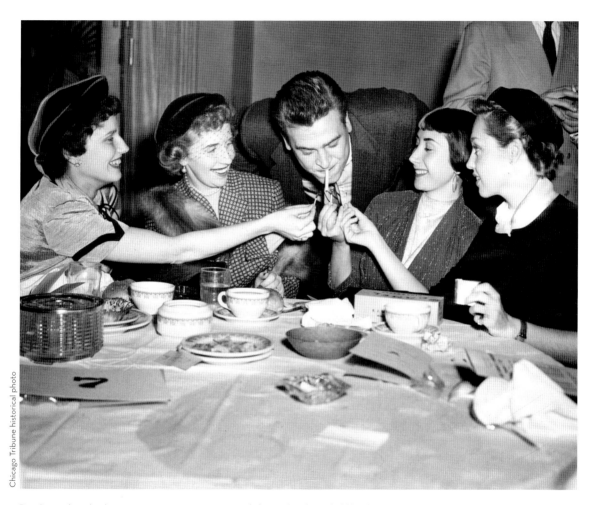

Dan Rostenkowski, then a state representative, gets a light at a luncheon held by the Cook County Young Democrats at the Hamilton Hotel on Oct. 29, 1953. From left are Mrs. Nicholas Comerford, Mrs. Harry Comerford, Mrs. Louis Farina and Mrs. Renee Martin. **#demchicagoans #1950s #gotalight? #chicagopolitics**

Dancer Frances Allis entertains a crowd in an undated photo. Allis earned a reputation in the 1930s and '40s as a maverick in Chicago modern dance. She studied with renowned Chicago artists, including dancer and choreographer Adolph Bolm, and danced with the Abbott Dancers during the 1920s. In the 1930s, Allis established a modern dance troupe called New World Dancers and performed at the Goodman Theatre. In a 1935 Tribune review, she was described as an "interesting artist because of her unfailing exuberance and vitality." She was a dance teacher for more than 60 years.
#francesallis #moderndance #chicagodance #newworlddancers #goodmantheatre

Chicago Tribune historical photo

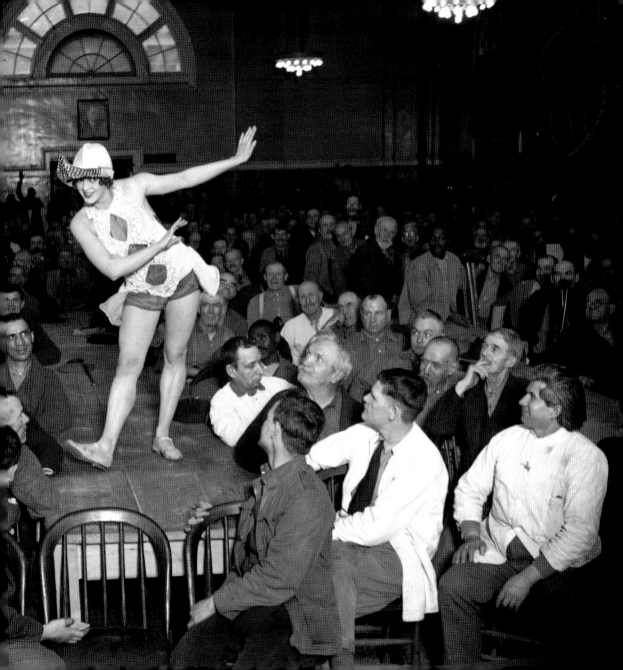

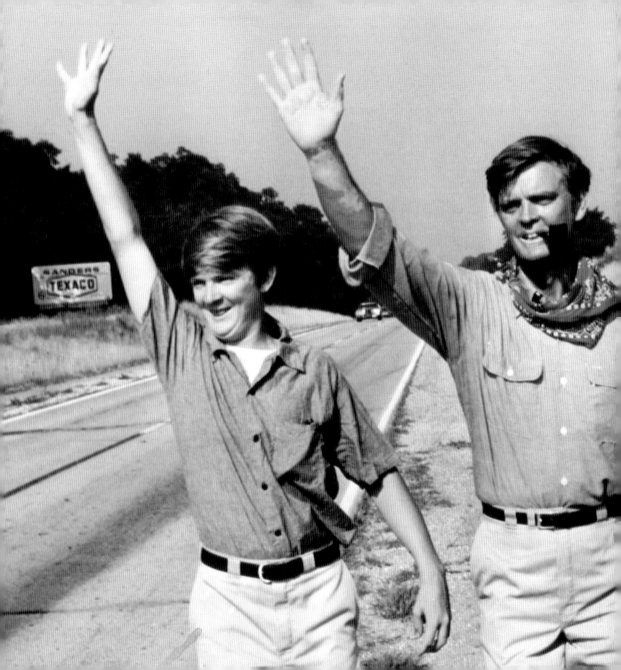

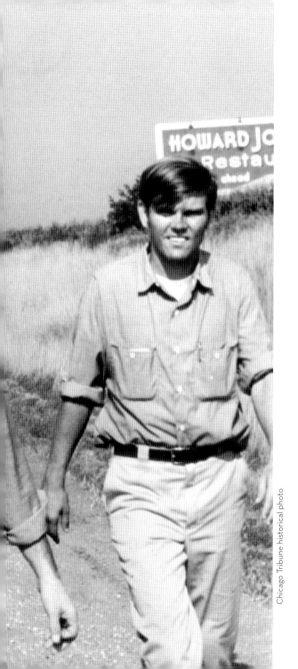

Chicago Tribune historical photo

Dan Walker, center, and his sons Charles, 16, left, and Dan Jr., 22, right, walked through the state of Illinois during the summer of 1971 to raise awareness for Walker's campaign for governor. Walker, who was governor from 1973 to 1977, was one of the most energetic campaigners in state history. With a red bandana around his neck, hiking boots on his feet and a lock of hair falling across his forehead, the political unknown campaigned for governor by walking 1,197 miles across Illinois, then astonished the pundits by upsetting veteran politicians in the primary and general election in 1972. #danwalker #illinoisgovernors #govwalker #walkforwalker

Mayor William Hale Thompson officially opens the straightened channel of the Chicago River from Polk to 18th streets in December 1929. Aboard the steamship Material Success, the mayor cut the band of ribbon stretched across the new channel, constructed at a cost of about $9 million. **#mayorthompson #bigbillthompson #chicagoriver #mayorsinfur**

Mrs. Joseph Holt, 80, of Chicago Heights, takes her first air ride in 1930, proving that flying should not be reserved for the youth. She had long wanted to go up in a plane, but there were always objections. She achieved her ambition, however, when she boarded a plane and flew to Columbus, Ohio, where she was to visit a niece. **#flyinggrandmas #airplanehistory #ambition**

Cindy Bernal, 24, left, of Bolingbrook, and Renee Healey, 23, of Villa Park, attended ChicagoFest on Aug. 10, 1982, to see Joan Jett, with Healey noting, "(Frank) Sinatra was before my time." Sinatra was the headliner on the main stage, and Joan Jett & the Blackhearts played at the same time on the rock stage. The white paint was added by a Tribune photo tech. **#chicagofest #joanjett #franksinatra #chicagomusic #chicagosummerfests #WWJJD**

Sally Good/Chicago Tribune

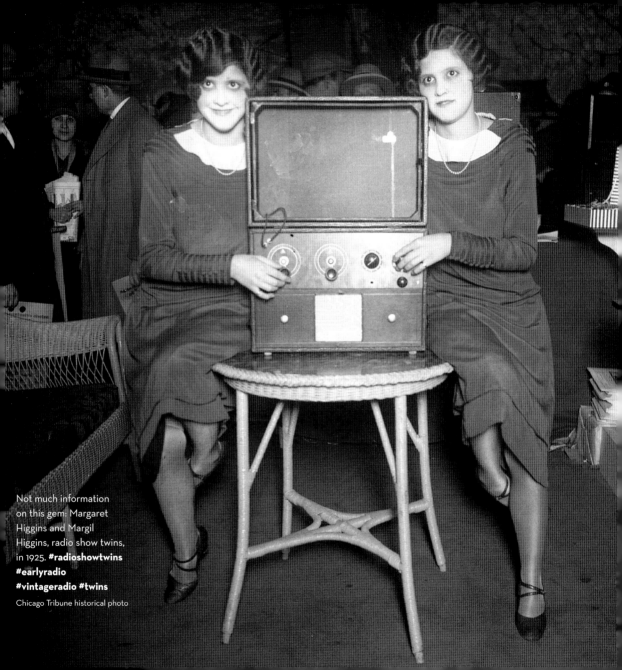

Not much information on this gem: Margaret Higgins and Margil Higgins, radio show twins, in 1925. **#radioshowtwins #earlyradio #vintageradio #twins**

Chicago Tribune historical photo

The famous "Manny the Great Lover Cat" in 1945 with cat lover Ruth Nelson, who is a friend of the owner, Loretto Chrisman. Manny, who is 11 years old, has helped sell over $3 million worth of bonds and also helped gather cigarettes for soldiers. *#catlovers #mannythegreatlovercat #felinehistory #warbonds #mannycat #howdoesacatgetcigarettes #happycaturday*

Chicago Tribune historical photo

Mrs. Hirna Novicki with Snowball the dog in 1928. **#snowballthedog #snowballnumberone**

Chicago Tribune historical photo

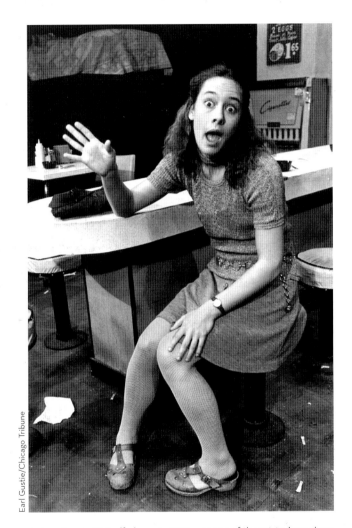

◄ Chicago fire Chief Arthur Seyferlich in October 1927, less than a month before he resigned from office. Seyferlich had been a fixture in the department for more than 30 years. **#cfd #chicagofire #seyferlich**

Earl Gustie/Chicago Tribune

Actress Laurie Metcalf, shown in 1980, was one of the original members of the Steppenwolf Theatre Company, which began in a suburban church basement. **#steppenwolf #1980s #chicagotheater**

Find us on Instagram at **@vintagetribune** for more vintage photos from the Chicago Tribune's vast archive.